Merry Christmas, Kelly!
Awesome Photos of Some Amazing Places!

Regina

Merry Christmas, Kelly!
Awesome Photos of Some Amazing Places!

2018

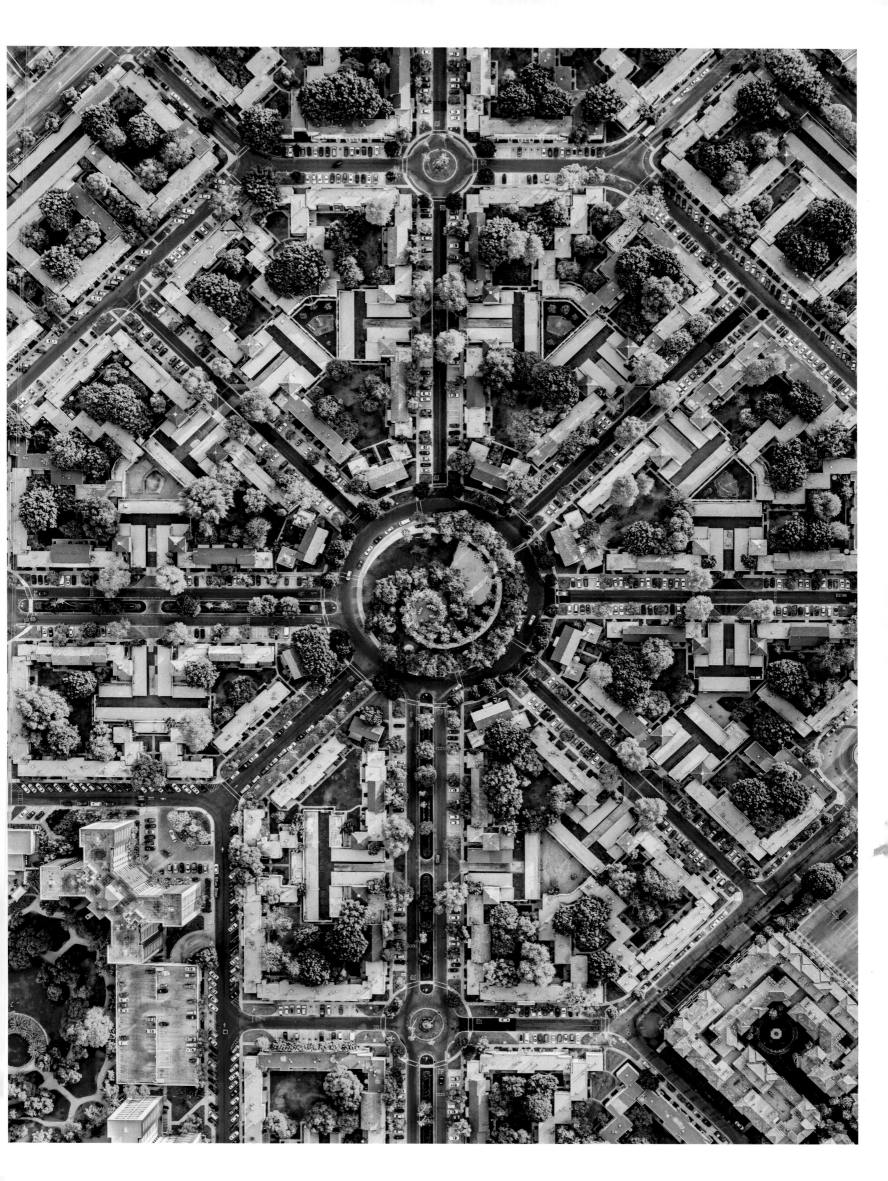

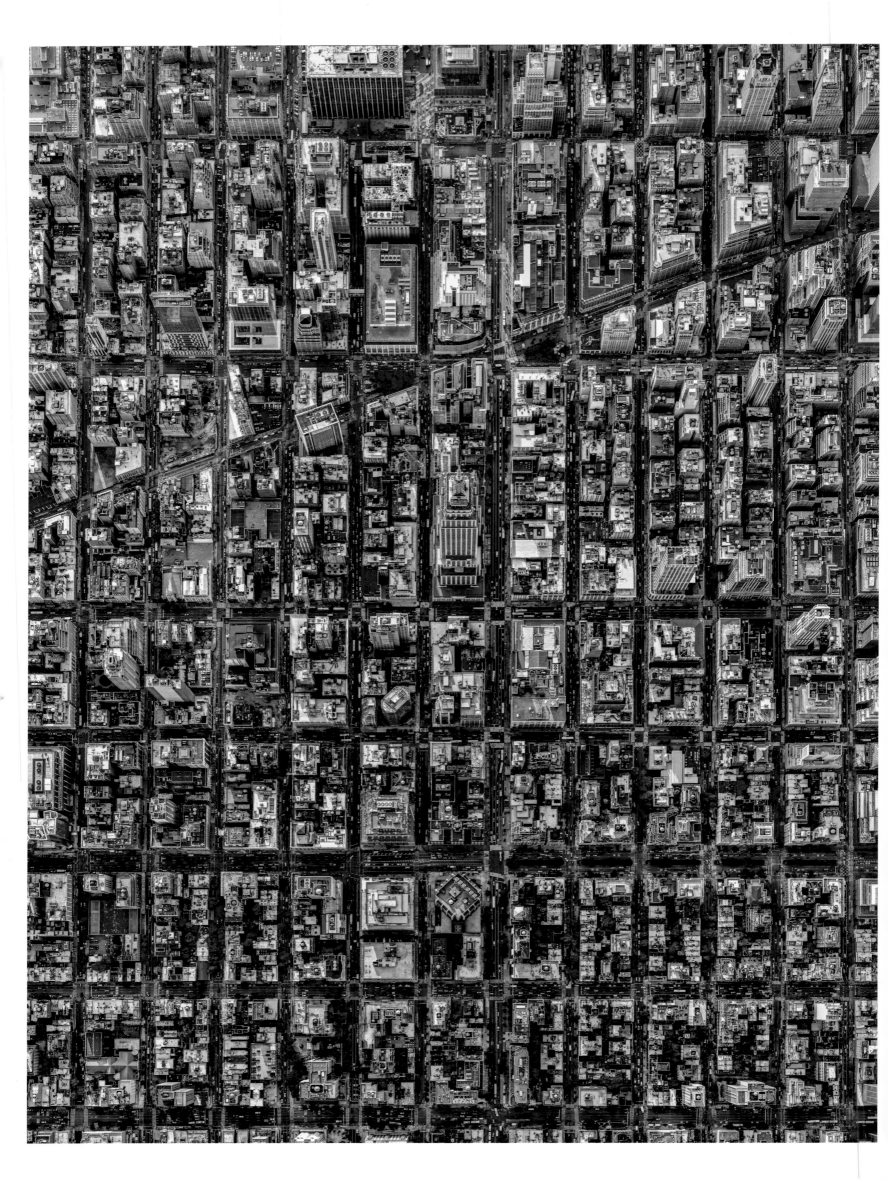

LANY

AERIAL PHOTOGRAPHS OF LOS ANGELES AND NEW YORK

JEFFREY MILSTEIN

FOREWORD BY JAY MAISEL

INTRODUCTION BY OWEN HOPKINS

Thames & Hudson

CONTENTS

FOREWORD

JAY MAISEL

I met Jeff Milstein in 1996 when he was my student at the Santa Fe Photography Workshop. I liked him. He worked hard, looked, listened, and came up with some good images. They were strong on structure so I was not surprised when I found that architecture was part of his background.

Fast-forward twenty years. I heard about an exhibit he had of aerial photographs. Now, I've shot aerials for over fifty years. I know the work of many of the great old guys like Bill Garnett and Georg Gerster, and some of the new guys like Vincent Laforet, Cameron Davidson, George Steinmetz, and of course, Yann Arthus-Bertrand.

I knew all about aerial photography.

I was wrong.

What I saw at that exhibit and in the book you're holding in your hands astonished me. I felt like a kid at Christmas. There were so many presents and as many as there were, I wanted more.

The best of art is not only beautiful, it surprises, it delights, and it challenges our past perceptions. It adds new comprehension to our life. It needs no curatorial explanation as to origin or intent. At its best it is intellectual, sensual, surprising, and rewarding. Someone said, "It's not enough to look, you must see." Degas said, "It's not enough to see; the artist must make others see."

Jeff Milstein makes us see. He makes us aware of the subject in a new way. The absolute rigorous demands he makes of himself pay off with amazing images. I like to think of my taste as eclectic. I love the amorphous work of Mark Rothko, the calligraphy of Cy Twombly, the vitality of de Kooning, and many others who deal in passionate personal images.

However, there is for me a delight in exactitude, in the detailed, well-rendered, intensely observed images that contain vast bits of information. I love these works not so much for the technical virtuosity but for the resultant revelation of content. It is this aspect of Jeff's work that leaves me breathless at the scope of his ambition and execution.

This is Jeff's love affair with what IS.

There is no editorializing, no manipulation of reality. This is a concept based on joy and sensitivity to what he beholds. I rarely see images that make me say, "Thank you."

This book contains many like that.

Thank you, Jeff.

NY, February 2017

PREFACE

JEFFREY MILSTEIN

My two cities are LA and NY.

LA is where I grew up and learned to fly as a teenager. NY is where I moved after university, to start my professional career as an architect and artist.

This book combines two of my life passions: flying and art.

From my earliest school days I was always the class artist—called on to do the yearbook covers, newspaper cartoons, and stage sets. I loved to draw and paint, and regularly won awards. But I was also a plane nut. I built models, and read everything I could about flying, and as soon as I was old enough, began lessons at Santa Monica Airport. The flight school let me sweep out a large hangar every Sunday morning, and in return gave me an hour in a Cessna 150.

After I got my license on my seventeenth birthday, I flew around the LA basin, taking 8mm movies from the air. The feeling of being above everything, being able to travel in any direction, and seeing how everything looked from above was endlessly fascinating.

I left LA to study architecture at Berkeley. There, one of my professors insisted we buy 35mm cameras and begin photography as an art form. It would be many years later that I would choose photography as my prime creative endeavor.

In the mid-'80s, after years of practicing architecture, I designed a set of six architectural notecards. This began a small company, Paper House Productions, that grew in size, and by the late '90s there were seven hundred SKUs and running it took all my time. Feeling the need to spend more time creatively, I attended a weeklong photography class in Santa Fe with the legendary photographer Jay Maisel. Jay was very inspiring and I left the class excited about the challenge of making photography my third career. In 2000 I sold the company and began to pursue photography as my profession.

Going back to my interest in aviation, I began photographing airliners directly underneath as they came in for landings at LAX. In 2008 Abrams published a monograph of the work, and in November 2011 the Smithsonian National Air and Space Museum mounted a yearlong exhibition of thirty-four large prints in the west wing.

After I had a dream, about six years ago, where I was at an art show looking at pictures of the tops of New York City buildings at night, I decided to turn my camera downward. I hired a helicopter to fly over NY as the sun was setting and the lights came on. This was the start of my aerial portfolio. Over the following years I would have many helicopter and aircraft flights all over NY and LA, photographing patterns of housing, skyscrapers in commercial districts, the amazing transportation systems of airports and freeways, and container ports, with all their machinery and chaotic organization: industrial recycling plants shredding metal products that had once arrived new in containers on the adjacent dock, turning them into heaps of ground-up scrap metal to be sent back overseas on ships. When seen from above, the layers and circulation systems in many ways seem like living organisms transporting cells and information through nerves and arteries.

This book of photographs is *LA NY* because they are the cities I have come to know and appreciate. The photographs are organized in four sections: neighborhoods; commerce; parks and recreation; transportation and industry. Within each section, LA and NY are juxtaposed—comparing and contrasting.

One can read a lot about our culture from the visuals. The book begins with images of housing in LA. The first is a blue-collar neighborhood in an industrial area. The overall color is brownish. The houses are tightly spaced and there is not a lot of greenery. The next photo has a greener cast and is in an area of pricey bungalows with bigger yards and more trees. As affluence increases, the color of the photos becomes greener and bluer from pools and tennis courts, and the roads become curved. This is a stark visual contrast to the trailer park with only one pool and a small tennis court. The Park La Brea housing development in LA is laid out in a geometric pattern based on Masonic geometry. Only from the air can you experience this unseen and unexpected beauty. The airport photos show many layers of information and circulation, with precise ground markings like a giant drawing to keep the aircraft and supply vehicles safely moving in and out. At public beaches, parks, and pools, people create a personal space around them and (mostly) everyone locates a distance to strangers based on how crowded it is.

TECHNICAL

The pictures were shot over a five-year period from a helicopter with the door removed or from a small plane. The cameras used were high-resolution medium and 35mm format digital cameras mounted on a gyro, which I hand-held while photographing.

To get the straight-down shots, I ask the pilot to make steep turns. It can be challenging: sometimes the wind causes my eyes to tear, making it hard to see; there are increased vibrations and added G's from the steep turns. Getting the pilot to the right spot while timing the shutter perfectly often requires many circles, sometimes with only minutes available for the best light.

The images were shot in raw format and processed in Photoshop. While I don't normally use Photoshop to alter content, I do use it to rotate, crop, and adjust for perspective as needed to create the flat symmetrical artistic palette that I like.

INTRODUCTION

OWEN HOPKINS

The world changes when you're in the air. Whenever I take a flight I always look forward to that moment when the plane is hurtling down the runway and then suddenly there's that amazing sense of weightlessness as the wheels lift off the tarmac. The ground begins to move away from you so quickly that in just a few seconds it's in the distance and the horizon expands at an ever increasing rate. As the plane's height increases, the world beneath begins to slow down and eventually stop: the people, the cars, the wind rushing through the trees and fields, the waves on the ocean. The sense of distance and detachment from the world as it becomes visible from all angles at once is physical, but also emotional, maybe even spiritual—and felt all the more acutely because it is so fleeting, lasting just a few seconds.

I'm always disappointed when the plane hits clouds or gets too high and that sense of detachment becomes one of isolation. Looking up from the ground in the middle of a bustling city at a plane hurtling along at 35,000 feet, it always strikes me that those inside that sealed container flying at hundreds of miles an hour are always unaware of where they are—focused just on where they're going.

It's only a narrow level above the ground where your view of the world changes but your connection to it remains unbroken. It's perhaps no coincidence, then, that it's at this height where photographer Jeffrey Milstein operates in capturing his views of cities from above.

"When I was young I had a love of planes and flying," he says. "My earliest aerial photographs were taken while flying a rented Cessna 150 around Los Angeles as a teenager. I was fascinated by how everything looked from above." Despite this early love of flight and of photography, Milstein opted to study at Berkeley and began a career as an architect. In the 1980s he switched to graphic design, starting his own successful company, which he eventually sold in 2000 to focus once again on photography. Flight—or, rather, planes—was never far from his mind, with an early project involving taking a series of photographs of airliners coming in to land at LAX, shooting straight up at their undersides. Soon the places of subject and photographer would be reversed, with Milstein taking to the air and turning his lens toward the earth.

It's only comparatively recently in human history that this viewpoint has been possible—and an even shorter time since it's been captured by photographers. In 1783, the Montgolfier brothers gave a series of public demonstrations of hot air balloons made of paper and fabric. Uncertain about the effects of exposure to the upper atmosphere, the brothers initially sent up a sheep, a duck, and a rooster in a test performed at Versailles in front of Louis XVI and Marie-Antoinette. All three animals survived, and a few weeks later the first flight with humans on board lifted off from the Château de la Muette. The richly decorated balloon reached a height of over 3,000 feet (around 900 meters)—higher, interestingly, than the Burj Khalifa, which has held the record as the tallest building in the world since 2008.

With the advent of photography in the late 1830s, photographers soon began to think about how this revolutionary new technology might be used to record views of the world from above that until then were available only to a select few. The first aerial photographs were taken as early as 1858 by Nadar, the pseudonym of Gaspard-Félix Tournachon, in a balloon over Paris. Unfortunately these no longer survive, but Nadar put down a marker for what was possible. The technology improved considerably during the First World War as all sides realized the usefulness of aerial photography for purposes of reconnaissance. Today, thanks to consumer drones, aerial photography and even live video is more accessible than ever before. At the same time, high-resolution satellite imagery of almost anywhere in the world is just a web search away.

To eyes that are now used to the generic renderings of Google Earth and its ilk, Milstein's photographs of LA and NY are a revelation, showing the world in which time has stopped for one passing moment. They are full of the vigor and animation of daily life: of people, traffic, noise. Yet they possess an extraordinary calmness and order, which is all the more remarkable given the lengths to which Milstein has to go to capture these images. "It's a little more complicated than your average photographic shoot," he explains. "You have to hire a plane or helicopter, get permission to be in controlled airspace, time the flight for best lighting, and you are working with a bunch of equipment in a tight space." The art of the photographer, like that of the writer, is to take something that's very difficult and make it appear effortless—and it is this that Milstein achieves.

Milstein's other identity, as an architect, is also highly visible in his work. His is both a photographer's and an architect's eye. We see this dualism play out in the consistency of his photographs, which are often composed at a 90-degree angle to what is immediately below. There's an abiding sense of geometry to them, an almost abstract quality, which is perhaps Milstein's third identity, as a graphic designer, coming through too. Milstein's interests, though, are not just what the world looks like, but what it means to look from above.

When we cast our eyes immediately downward, the world literally flattens out as vertical undulations become one smooth, uniform surface. In satellite imagery this serves to take them into the realm of the map or the schematic. The vagaries of life are ironed out. Unlike satellite imagery, in Milstein's photographs the flattening is both figurative and metaphorical, reveling in the strange geometries and occasional outliers that resist the camera's compression of perspective. The real and the abstract intermingle, allowing for juxtapositions between images of different parts of a city—or different cities entirely—that are strikingly visual, and meaningful, too.

Looking down at midtown Manhattan, we cannot escape the relentless grid plan and the separation of the city into blocks of identical size. Yet at the same time, we marvel at the amazing

variety of the arrangement of buildings inside each block. Every one is different: some are tightly packed with lots of small buildings, others reveal NY's characteristic "step-backs" as buildings increase in height, and in a few instances we see a block dominated by just a couple of buildings, sometimes even one single monster. We see how so often the roof is the forgotten plane of architecture, the place for hiding things away. This reveals some surprising contradictions in certain buildings, such as Rafael Viñoly's pencil-like 432 Park Avenue, the tallest residential building in the western hemisphere. Milstein's photograph shows how the top two floors of its unflinchingly regimented grid structure are actually used elegantly to conceal air-conditioning units, water tanks, elevator facilities, and those small cranes that swing over the side of buildings to allow window cleaners to work tens of stories in the air.

Although many of the buildings that define NY or LA are, like 432 Park Avenue, designed to stand apart, representative of their individual owners and occupants (as well as their architects), cities are mankind's greatest collective achievements—where our hopes, dreams, and ambitions live or die. We see this duality figured quite precisely in the succession of photographs of suburban residential neighborhoods in LA, where increasing affluence is made distinctly visible. At one end of the scale, we see trailer homes tightly packed together with just dirt and a few bits of scrub separating them. In the next shot, the still-identikit homes get larger and more permanent, and the space in between becomes bigger and greener. We begin to get more variety: houses of different sizes with differently colored roofs, many more trees and even the occasional swimming pool. Finally, we see what even from the air are clearly massive houses, with tennis courts and manicured hedges and lawns, hugging the contours of a hill rather than huddled together on the flat.

The differences between these neighborhoods would, of course, be apparent on the ground. But what Milstein's photographs reveal is the progression from one to another according to their inhabitants' increasing wealth and success, while remaining clear manifestations of the same way of living. As he notes, "They show both the image and reality of the American Dream."

These suburban neighborhoods provide a vivid illustration of the ways LA has expanded as its population has increased—in stark contrast to NY, and Manhattan especially, which has compressed and been forced upward. Yet Milstein still finds points of startling similarity, juxtaposing Park La Brea in LA with the near-contemporary Stuyvesant Town in NY to reveal their shared geometrical arrangement of mostly cruciform multistory blocks in comparatively open areas of trees and greenery. It is no surprise, then, to discover that both were built by Metropolitan Life Insurance.

Having lived in both cities and getting to know them well over a number of years, Milstein has an almost instinctive feel for the best places to photograph—and when. Central Park is recorded through several different facets: from the sweeping paths and baseball triangles of its southern section that contrast with the tight order of the surrounding street grid, to the incursion on its east side by the Metropolitan Museum of Art, and the throngs of people straining to see a green inflatable dinosaur as it makes its way in the Thanksgiving parade alongside the autumnal hues of the park.

Apart from the big set-piece cultural institutions like the Met in NY, or the Getty Center in LA, it is interesting to observe how many of the places of leisure that Milstein records in both cities are in their physical extremities, where land meets water. This includes the beach, of course, but also a number of other types of public space. One of my favorite photographs appears, on the face of it, to be actually one of the least urban in the book: a green, open space littered with rugs and people watching a movie on a big screen, which is artfully positioned at the apex of a spur of land jutting out into the bay. That this is taking place where it is, however, is entirely a function of the density and lack of open space in the surrounding city and the respite that being by the sea offers. The image is in fact as urban in its meaning and implications as any in the book.

It's fitting that Milstein ends with the airports—this is, after all, where the project started for him all those years ago, and where each photographic trip begins and ends. All through the book we are witness to the seemingly never-ending competition between order and chaos—in the airports we have a sense of both at perhaps their most extreme. We see an agglomeration of buildings, added piecemeal over the years, a mass of supporting vehicles buzzing around the planes as they are quickly turned around for their next flight, and then we see one break away from the disorder and begin its route to the runway, perfectly aligned with the runway marker. In Milstein's words, "Airports have all the character and energy of living organisms."

When looking at photographs of residential neighborhoods, it's usually very easy to identify which city is which, even if the area is unfamiliar. However, when faced with the docks, shipping containers, and especially the airports, the differences dissolve. This is a consequence of these being the most functional areas of cities, but it is also powerfully symbolic. Airports are where global cities connect to each other, where after getting on a flight in NY one can, in just a few hours, arrive in LA, or indeed any city in the world.

While flight brings these cities together, it is also the means by which Milstein reveals not only their similarities and points of connection, but, as we see across the book, their contrasts and discontinuities too—both within themselves and between each other. Turning one page after another, it is hard not to be struck by the abundant joy in each image; these are cities that Jeffrey knows and loves for all their contradictions, idiosyncrasies, and inequities. This book is at its heart a celebration of cities—which, along with the miracle of flight, are surely the greatest invention in the history of humanity.

NEIGHBORHOODS

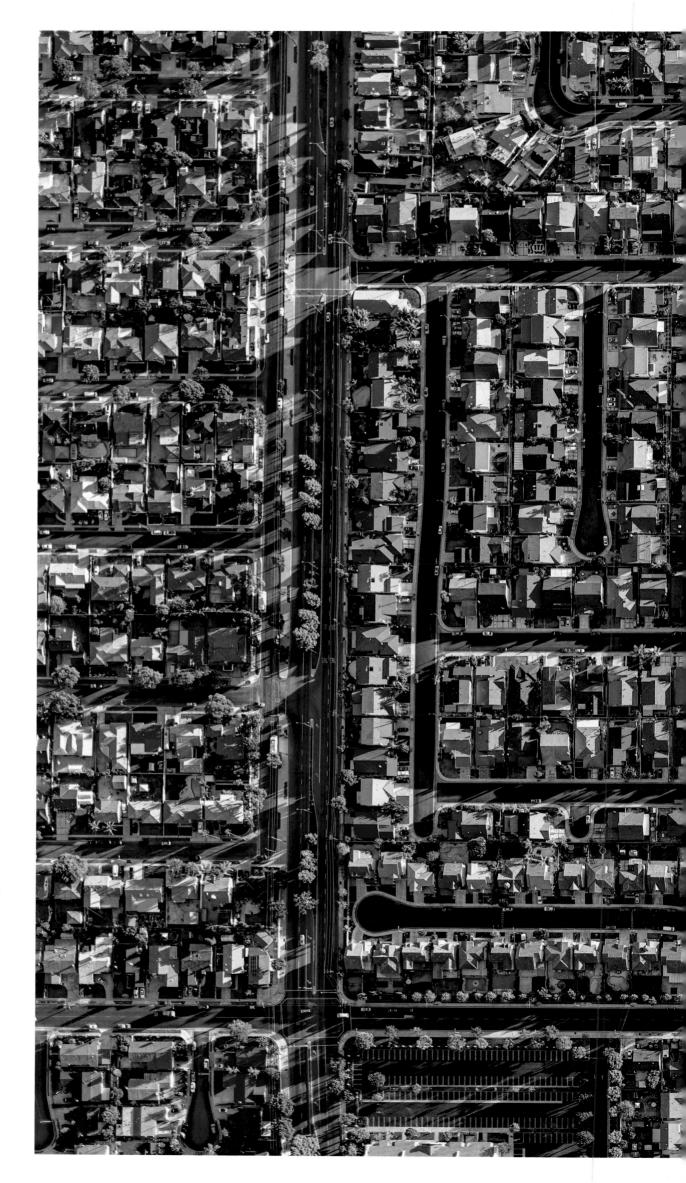

Carson, LA

PAGES 10–11
Mar Vista, LA

In LA, the socioeconomics of neighborhoods are evident in the color and patterns of the aerial images. The hue shifts from browns toward greens and blues in the increasingly wealthy neighborhoods, which have more trees, pools, and tennis courts, and the roads become more curved. The American Dream of owning one's own single-family home can be seen at one extreme in the most affluent LA neighborhoods, where nearly every house has its own pool and tennis court, often just feet from their neighbors.

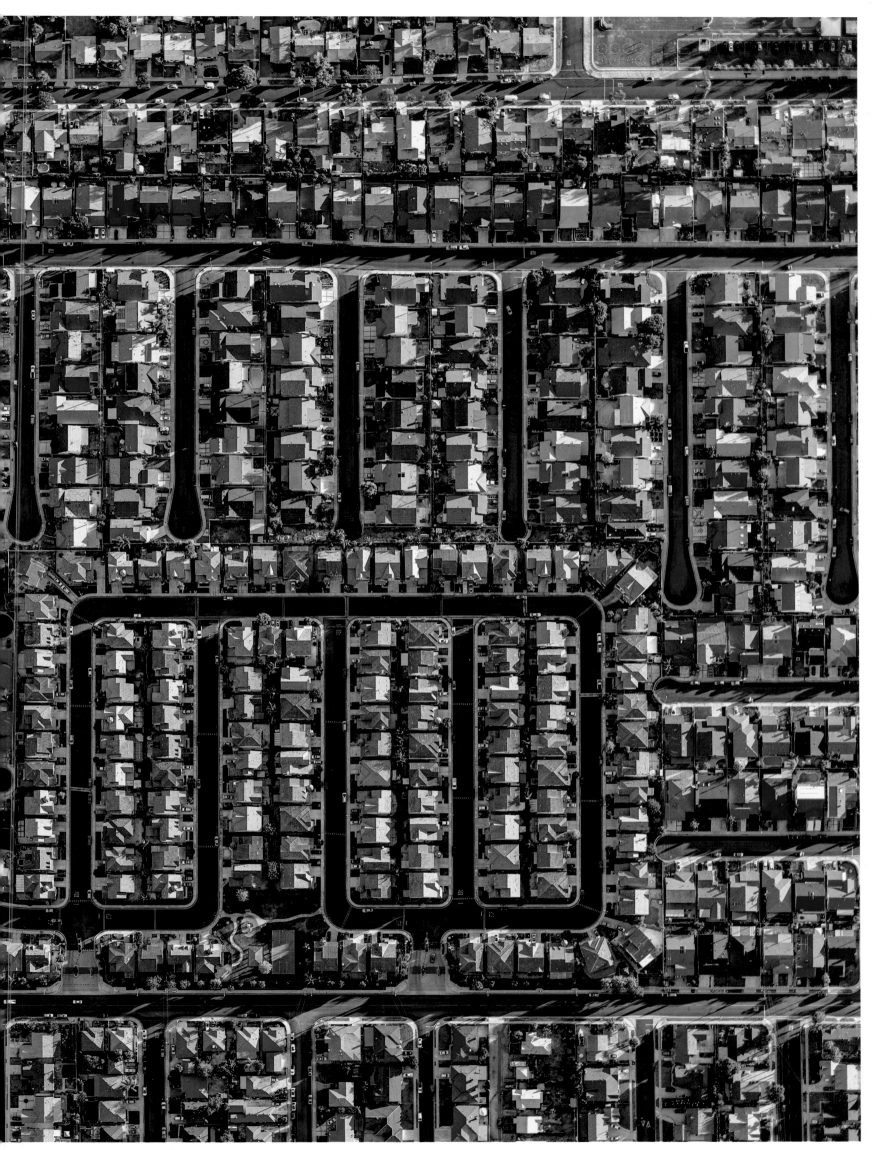

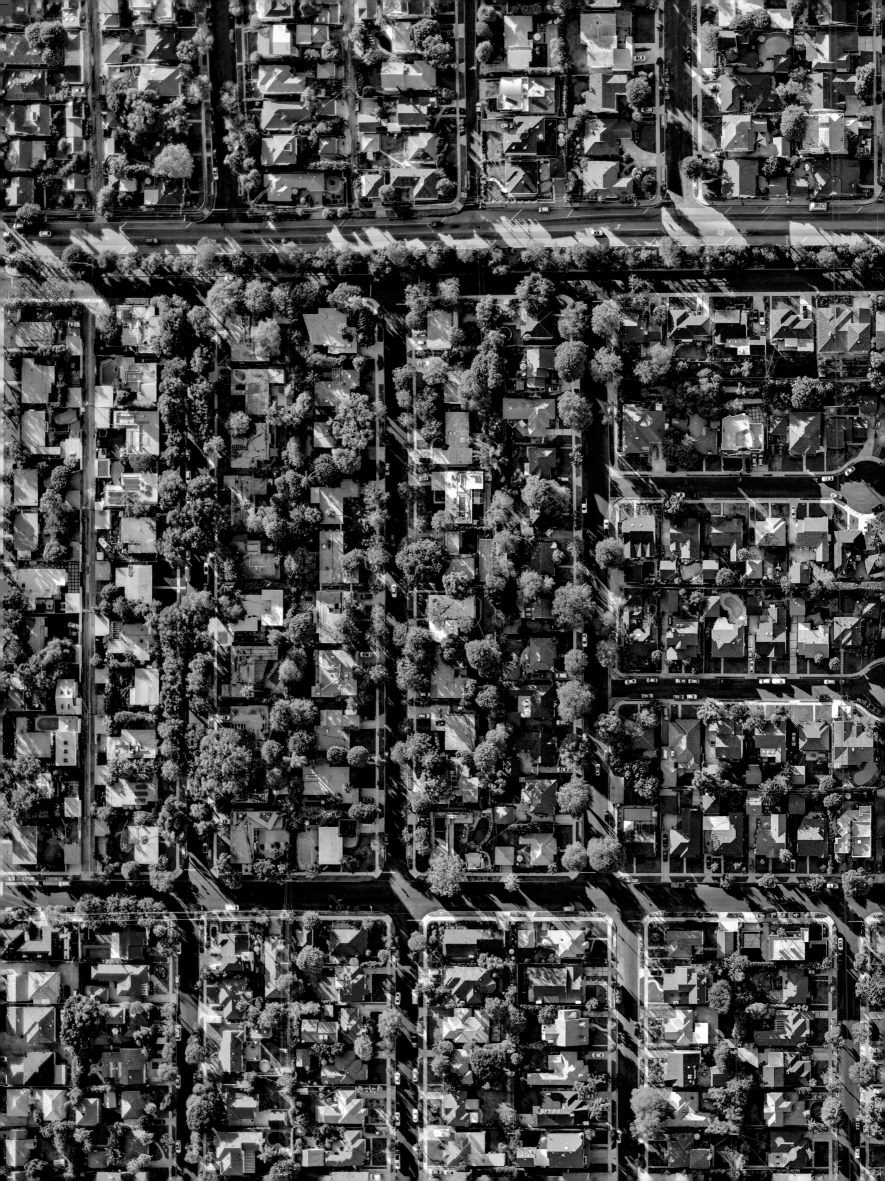

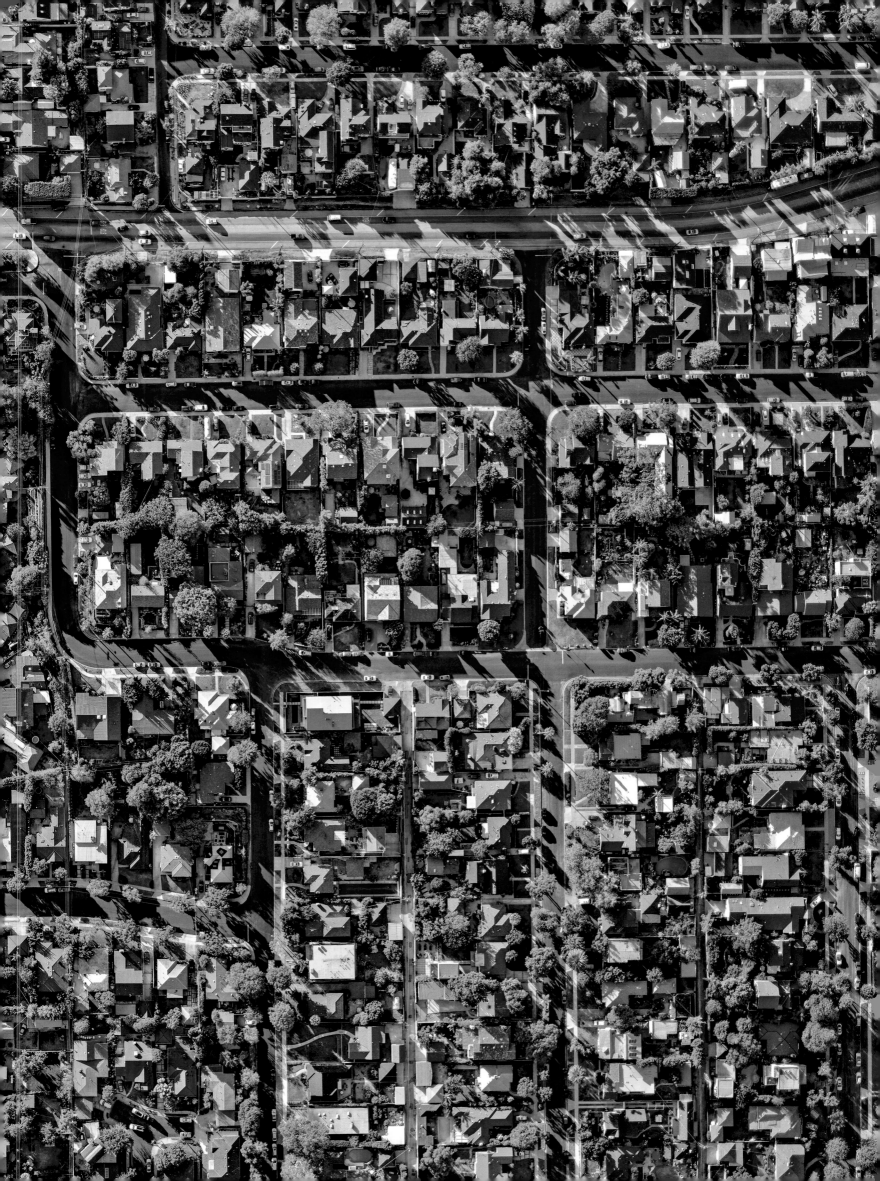

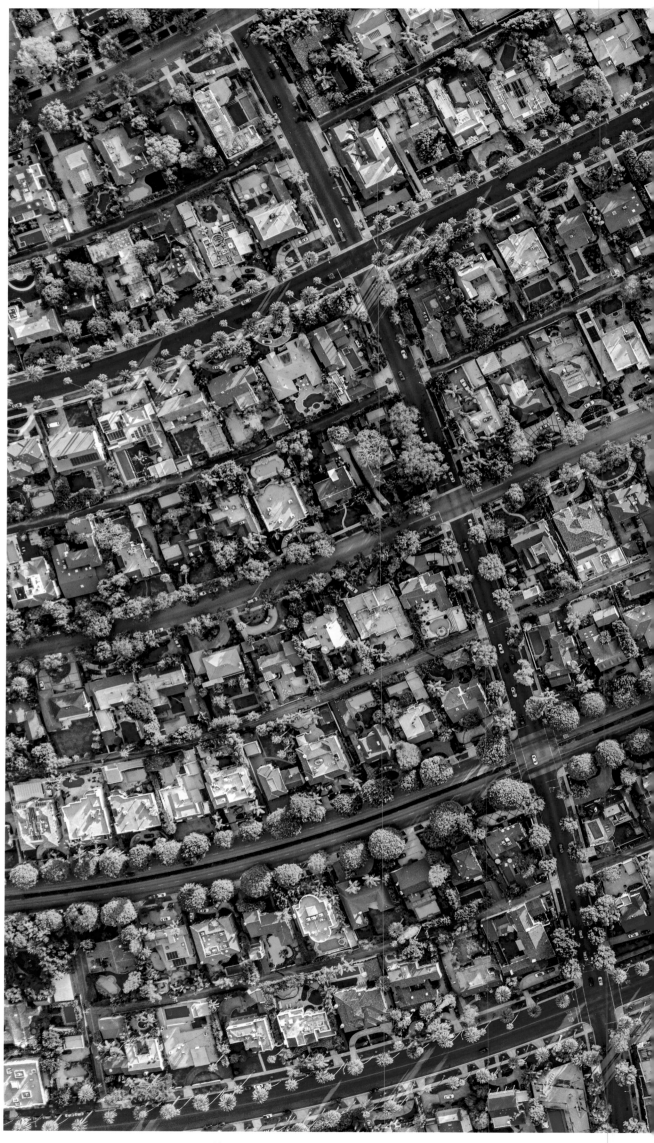

Beverly Hills, LA

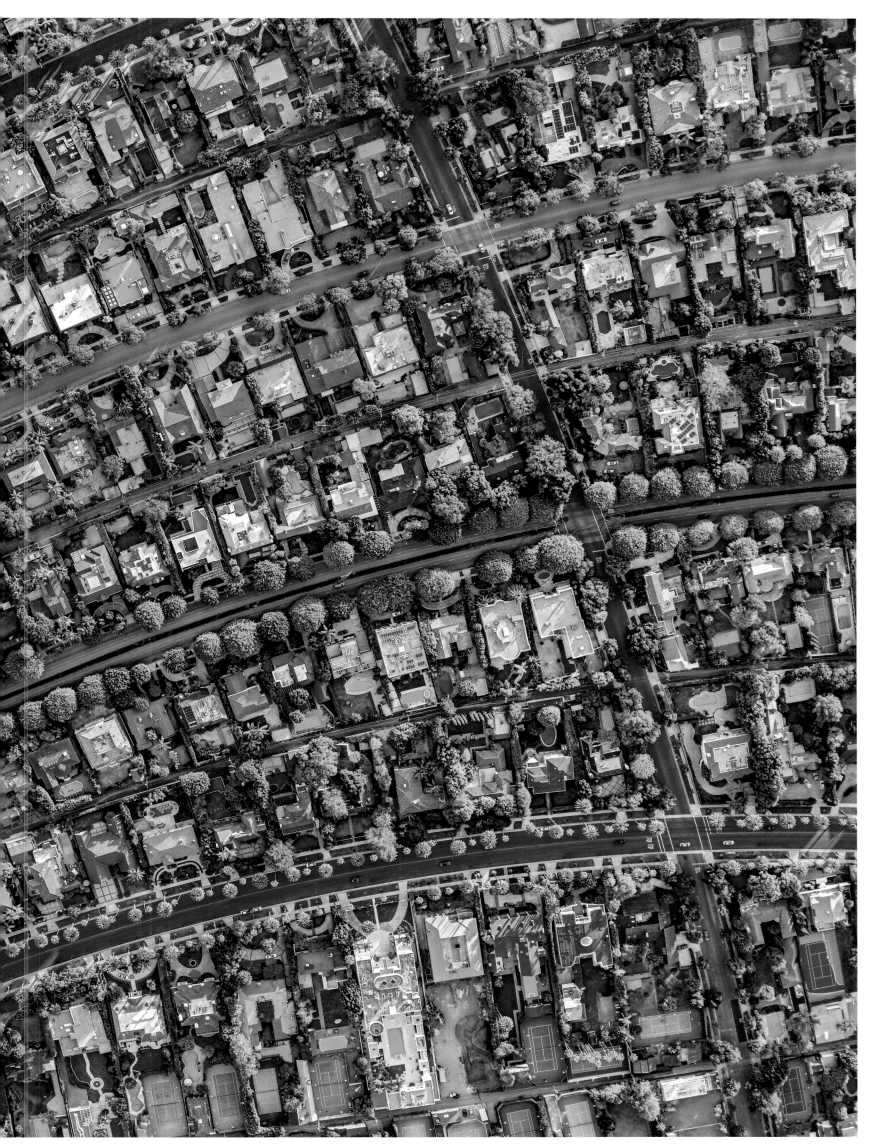

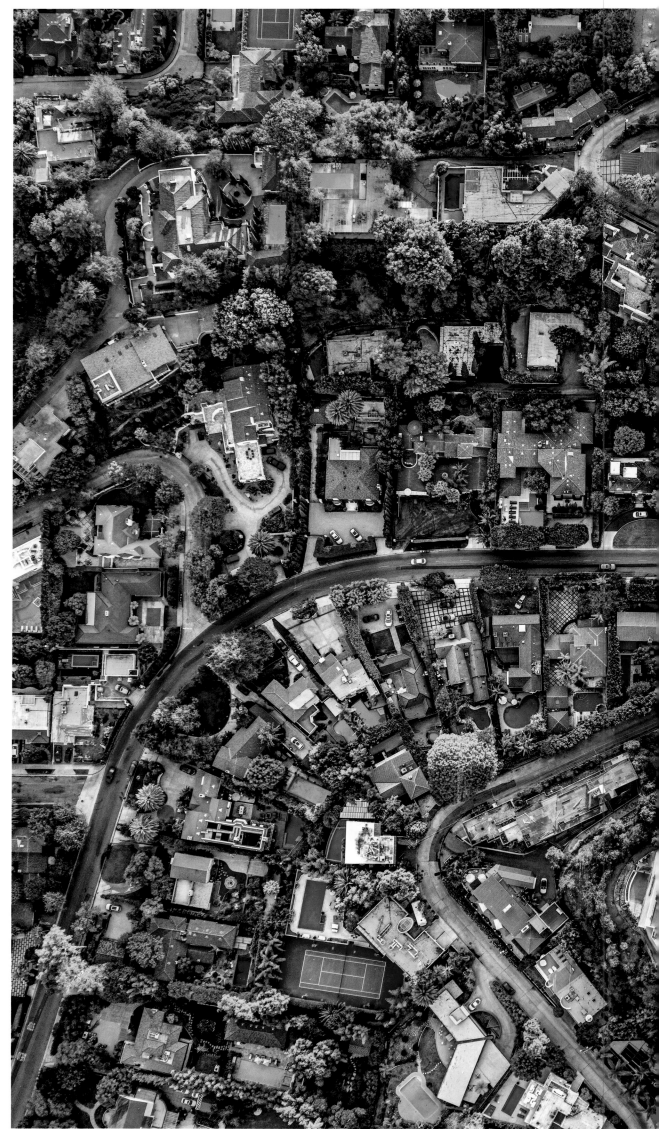

N. Doheny Drive, West Hollywood, LA

PAGES 16–17
Monroe Manor, Monroe Township, NJ

Coast Mobile Home Park, Harbor City, LA

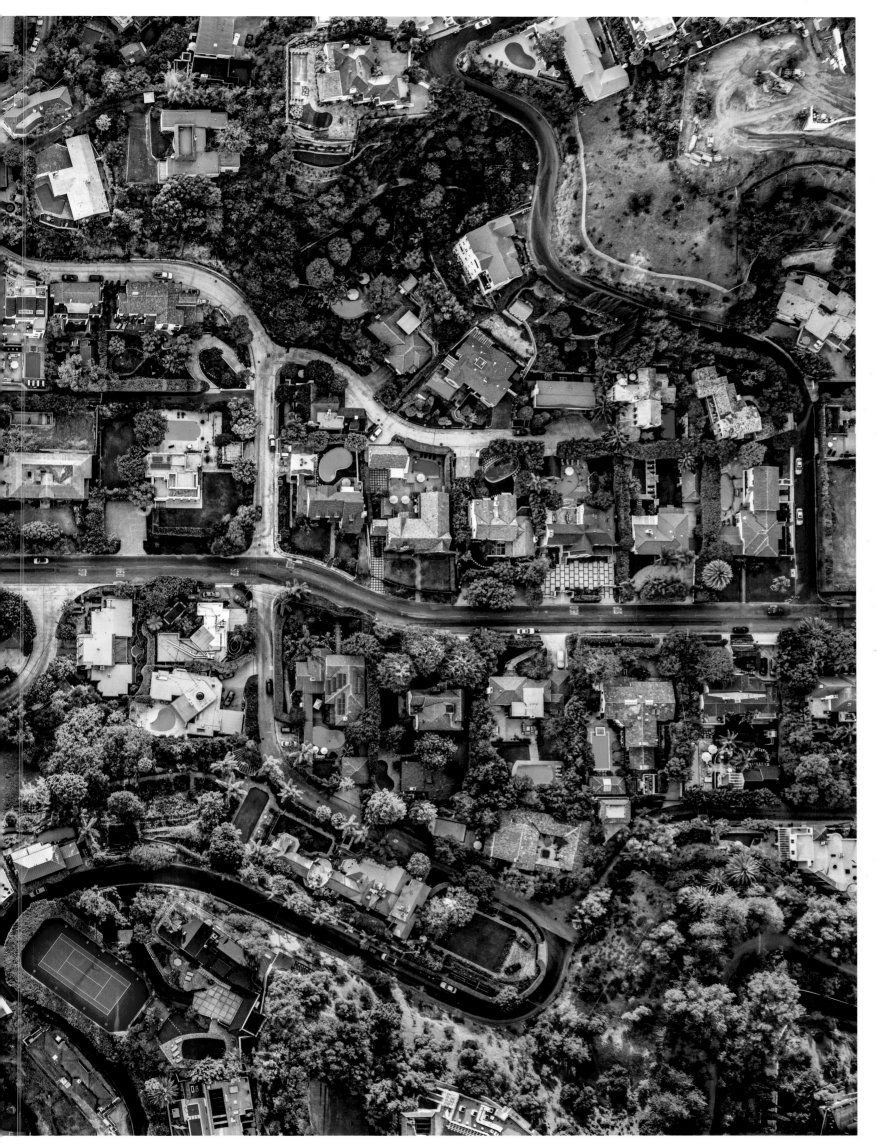

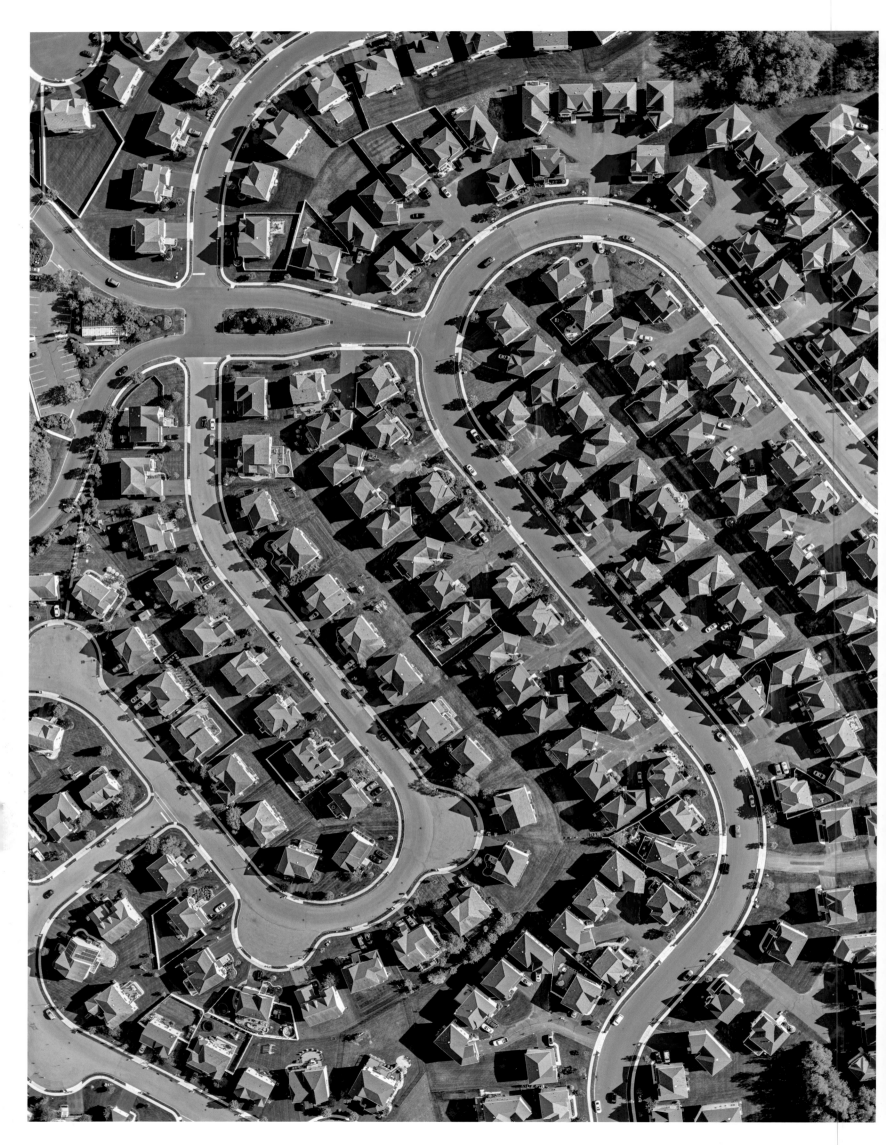

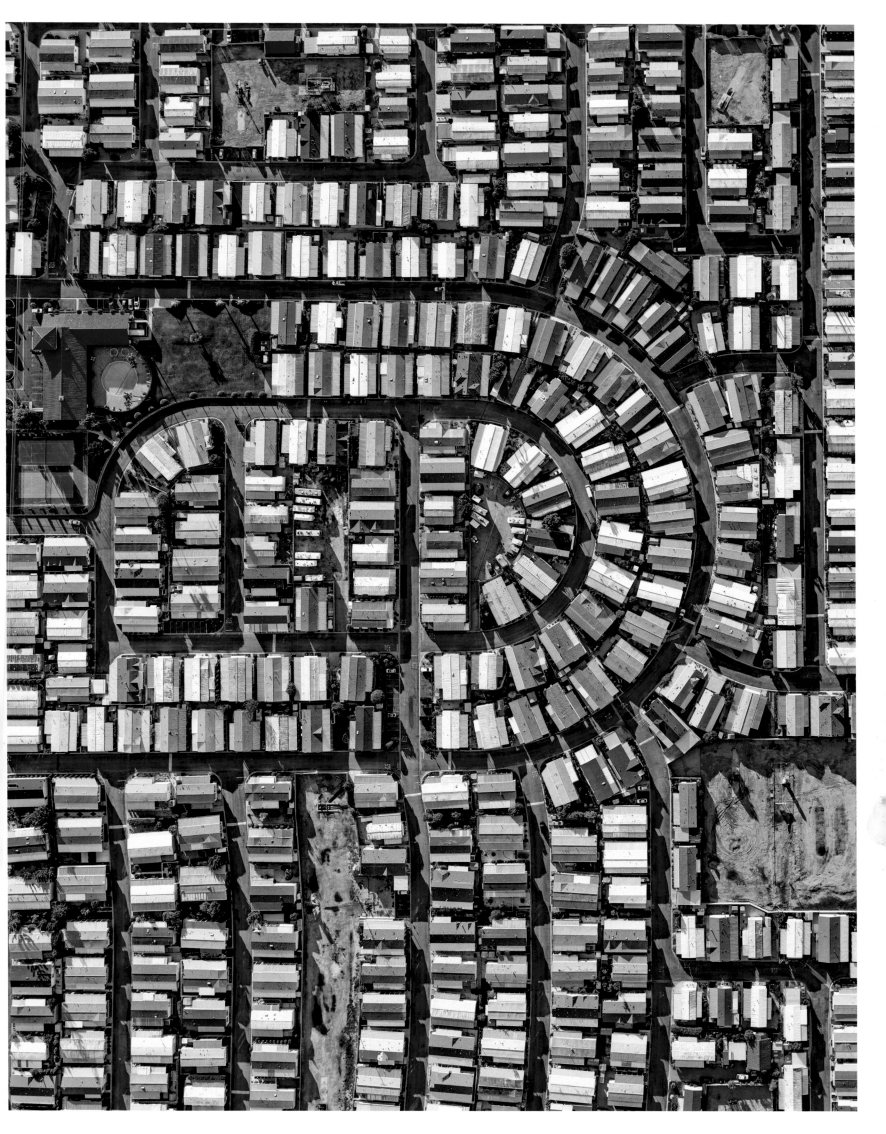

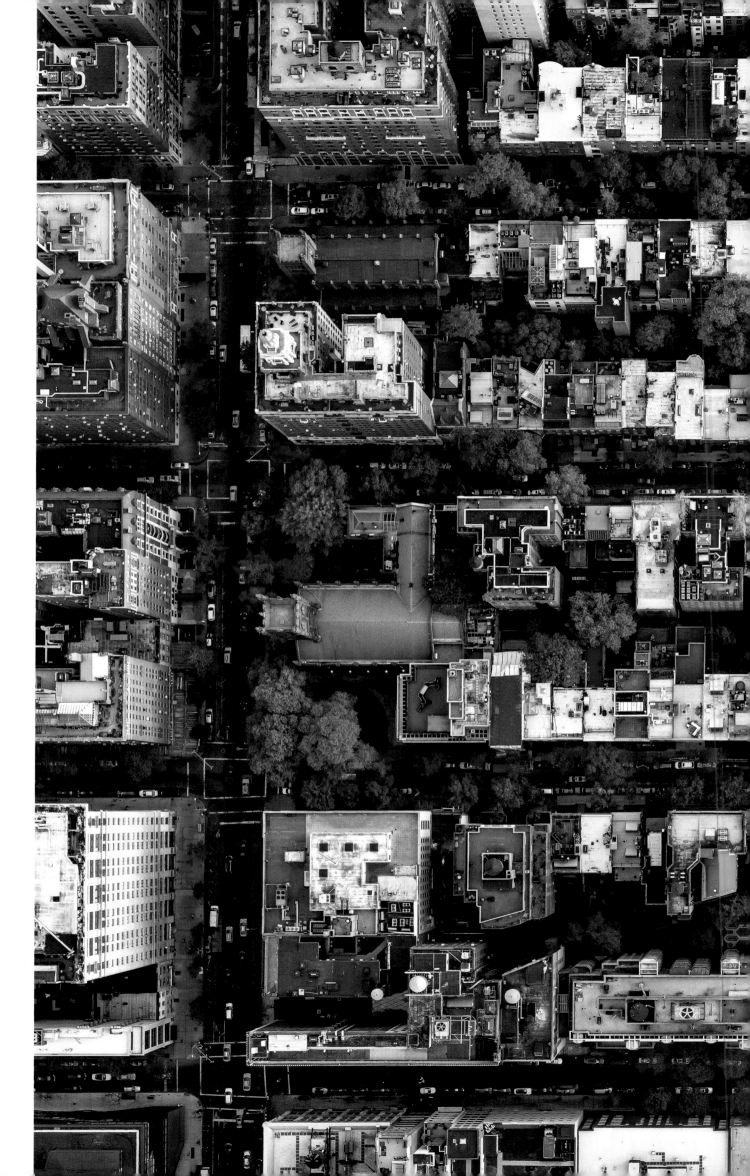

Greenwich Village, NY

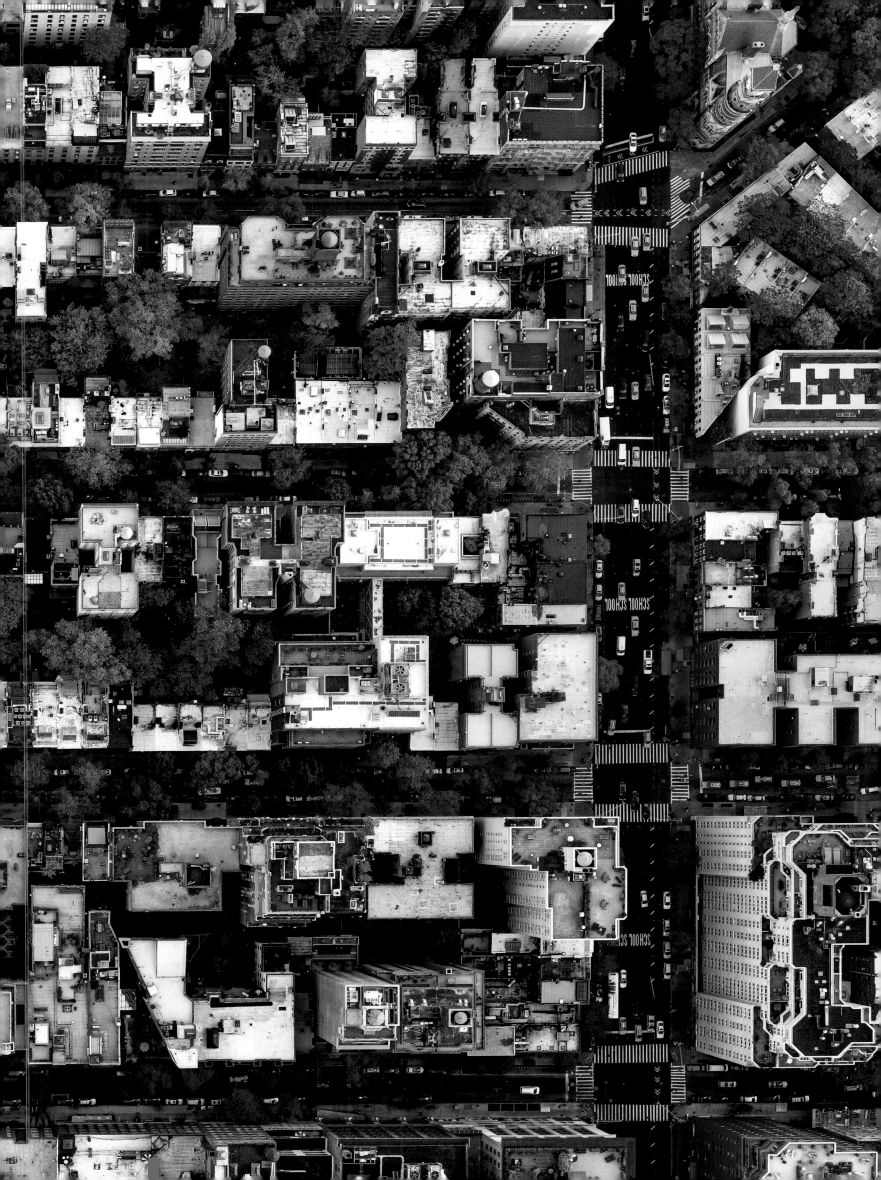

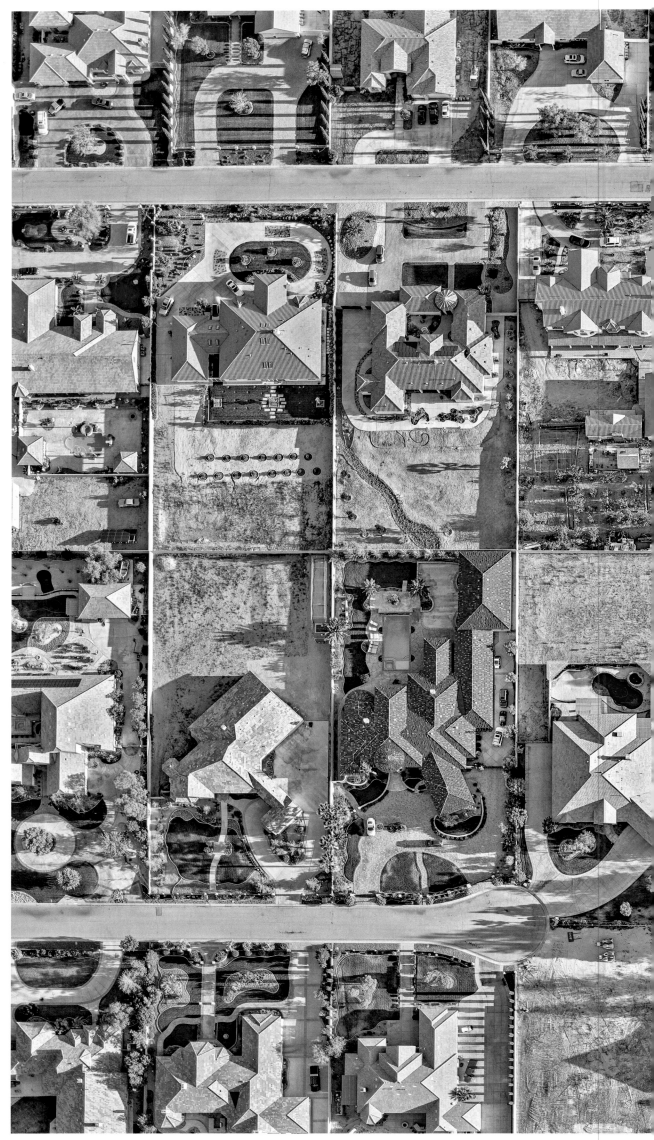

Lancaster, LA

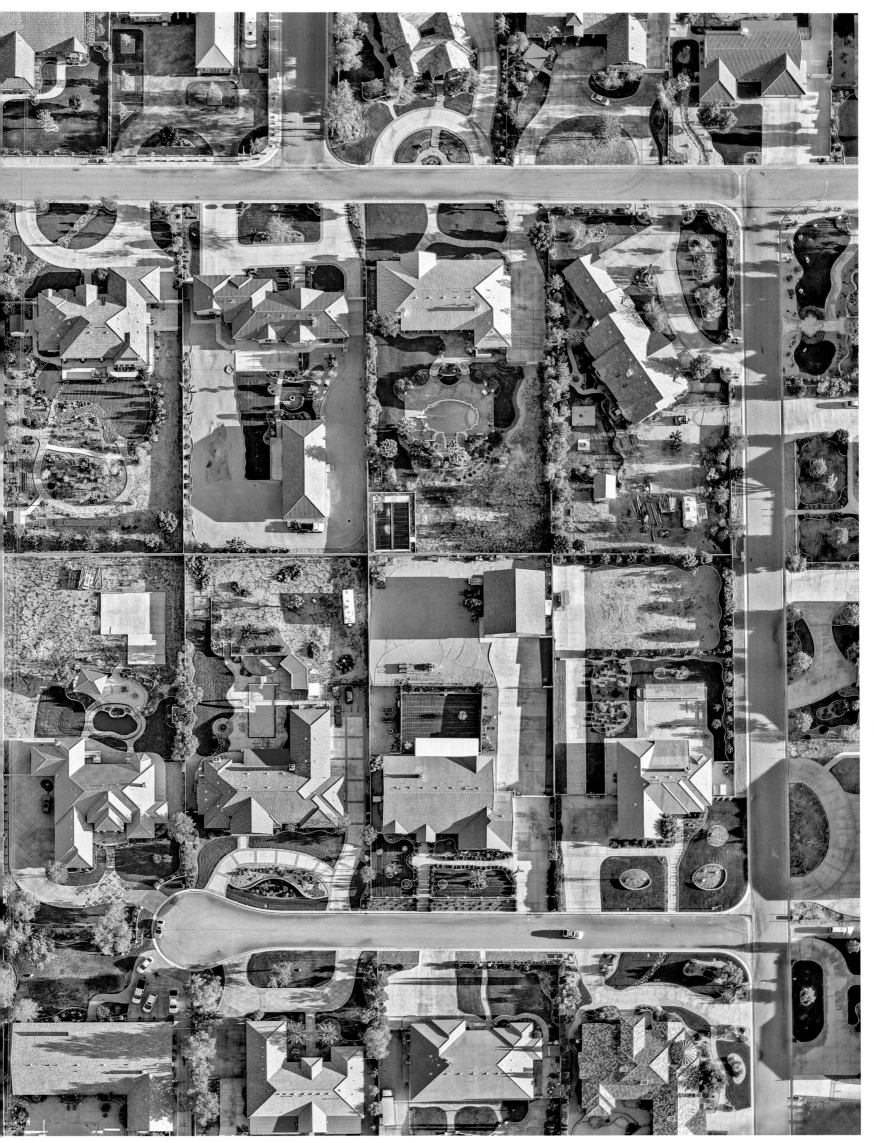

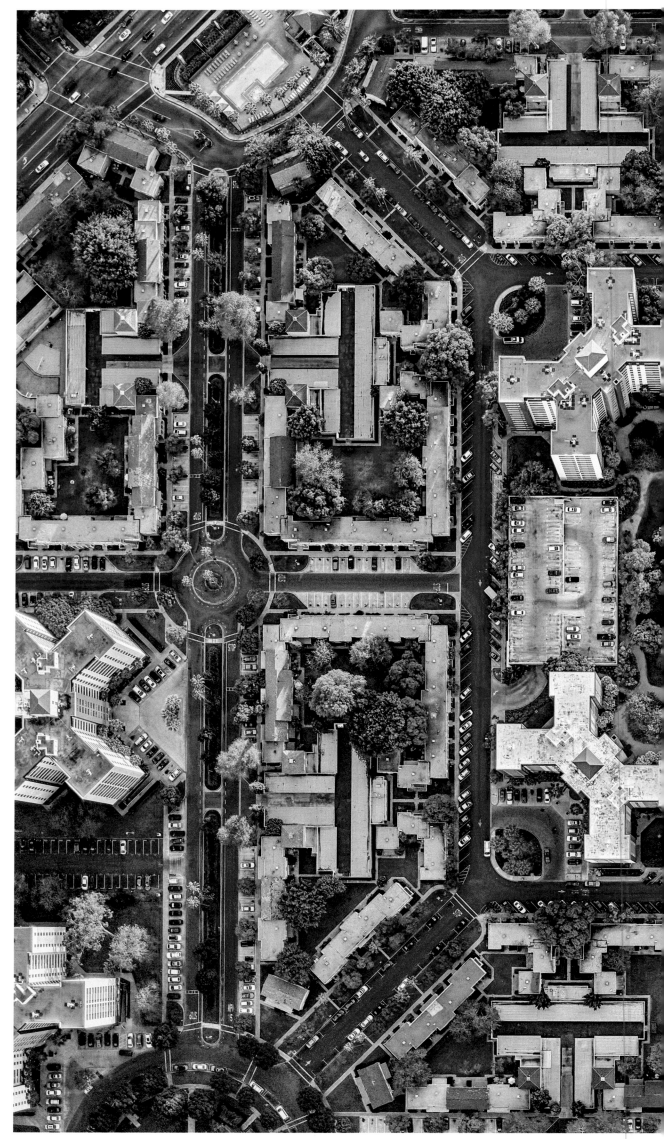

Park La Brea, LA

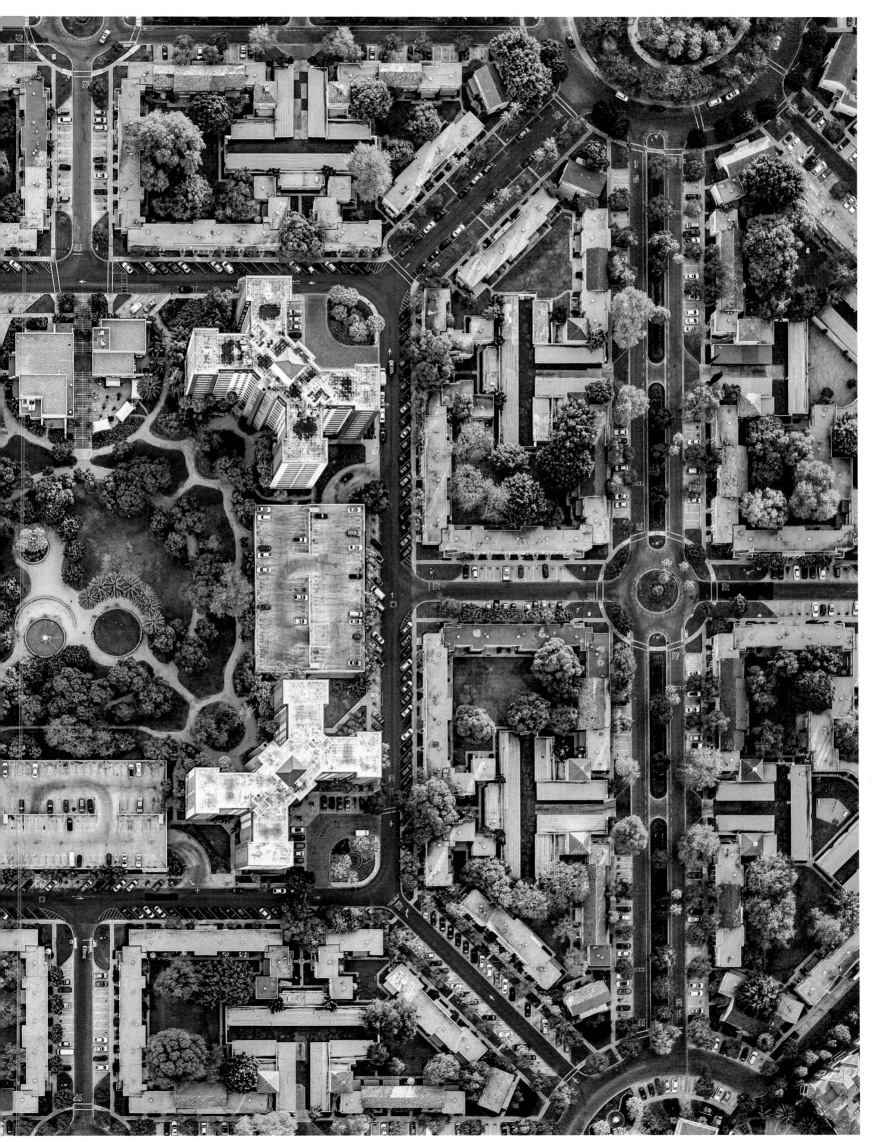

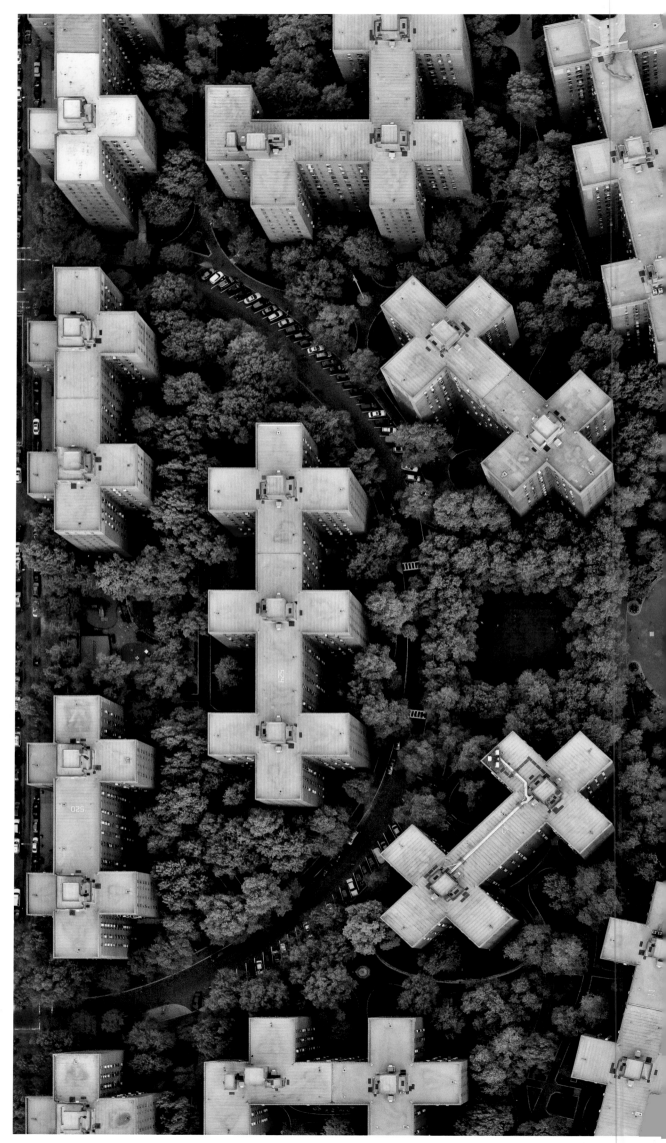

Stuyvesant Town, NY

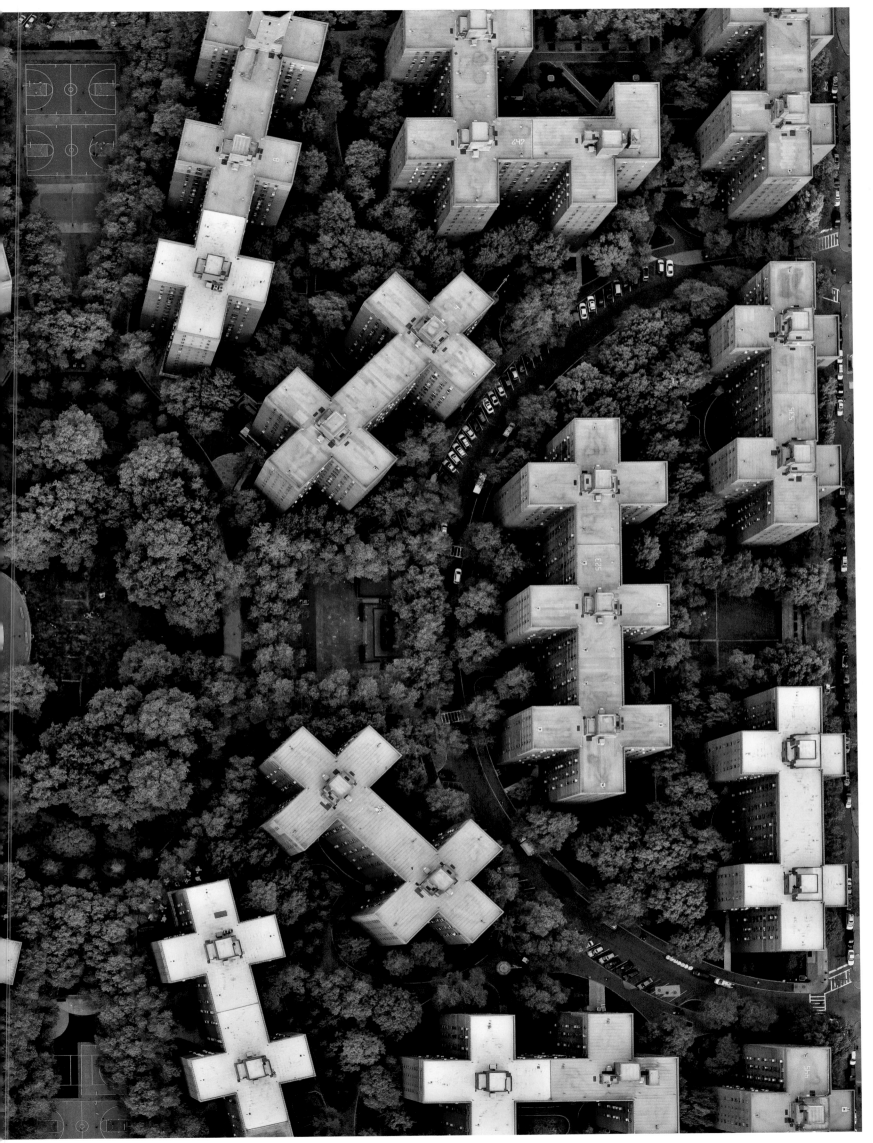

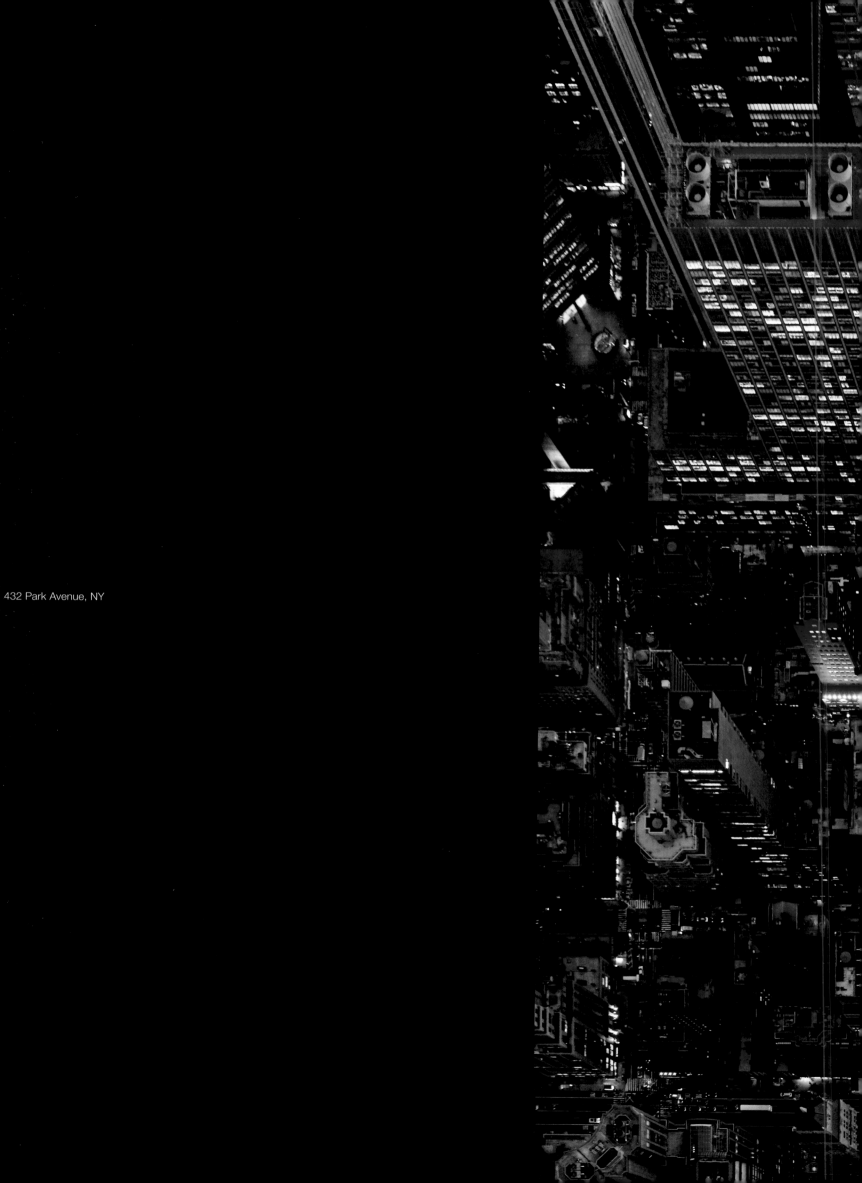

432 Park Avenue, NY

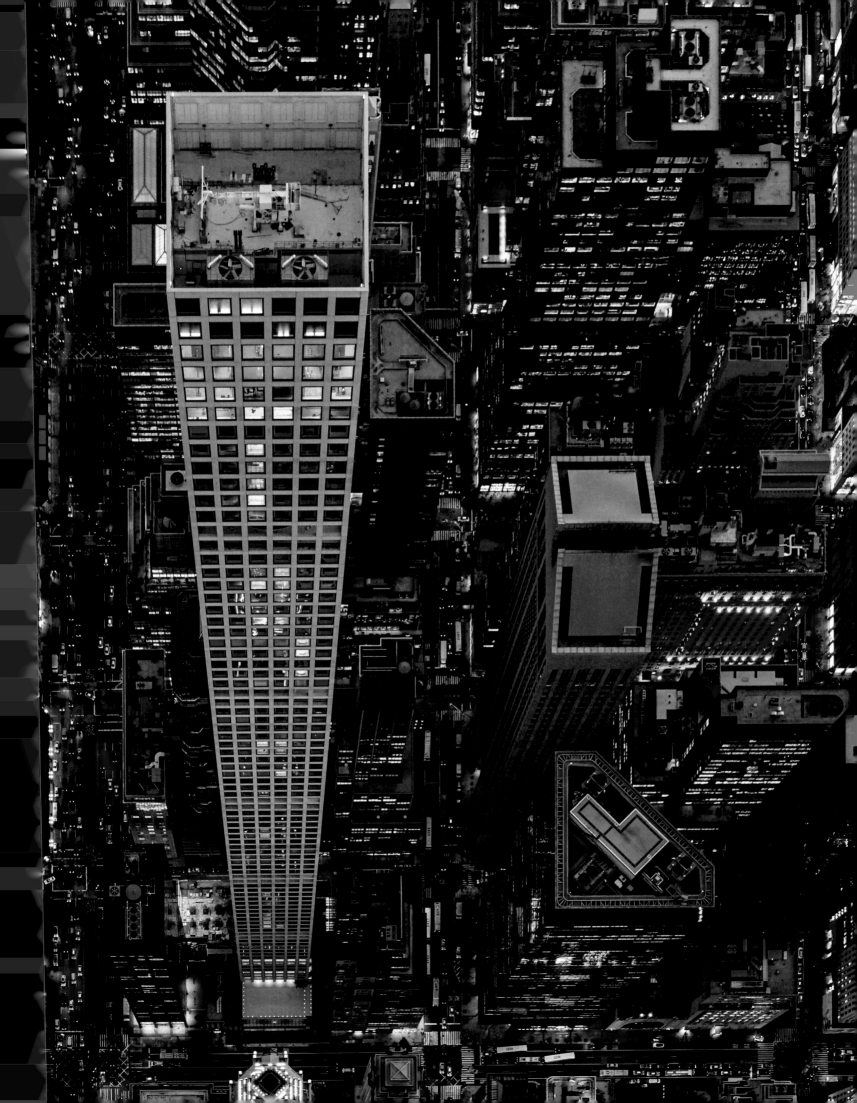

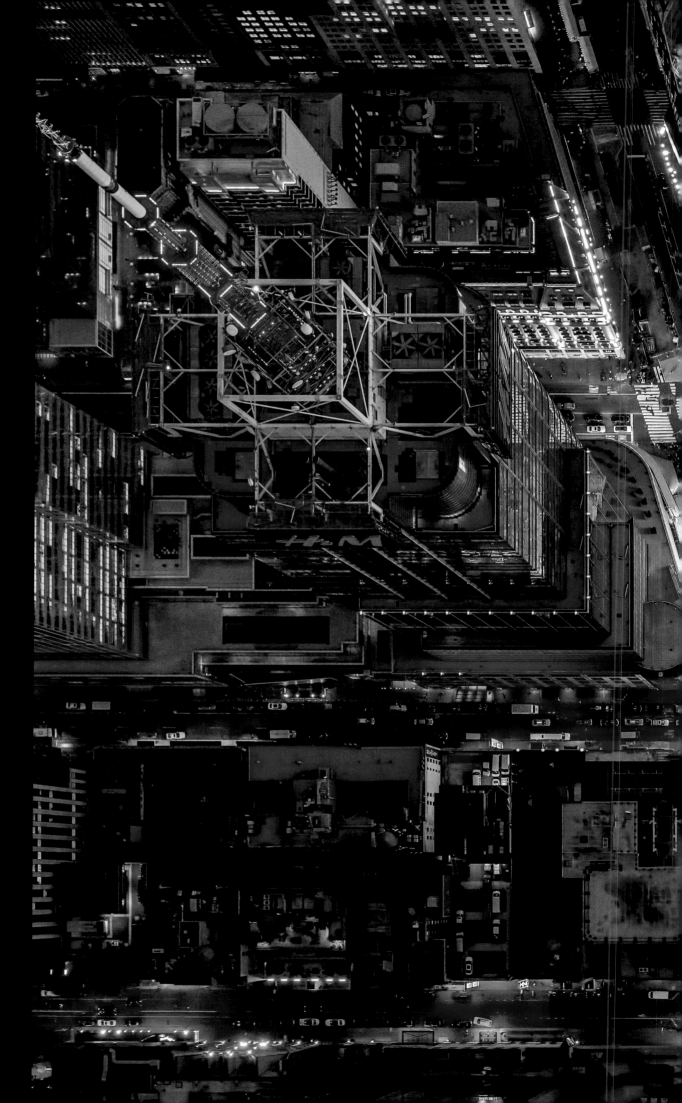

Times Square, NY

Skyscrapers in downtown LA
have mostly flat roofs with large
numbers painted on them, as
opposed to NY's flamboyant,
brightly-lit sculptural rooftop
crowns, which reach to the sky
like church steeples to the god
of commerce. The difference is
due to a 1974 fire ordinance in
LA requiring all new skyscrapers
to have a helipad for fire rescue,
enacted after devastating
skyscraper fires in Brazil. The big
numbers on the roofs, which are
visible in the downtown LA
photos (for instance, overleaf),
refer to the weight limits for
landing helicopters in thousands
of pounds. In 2014 the helipad
requirement was eliminated

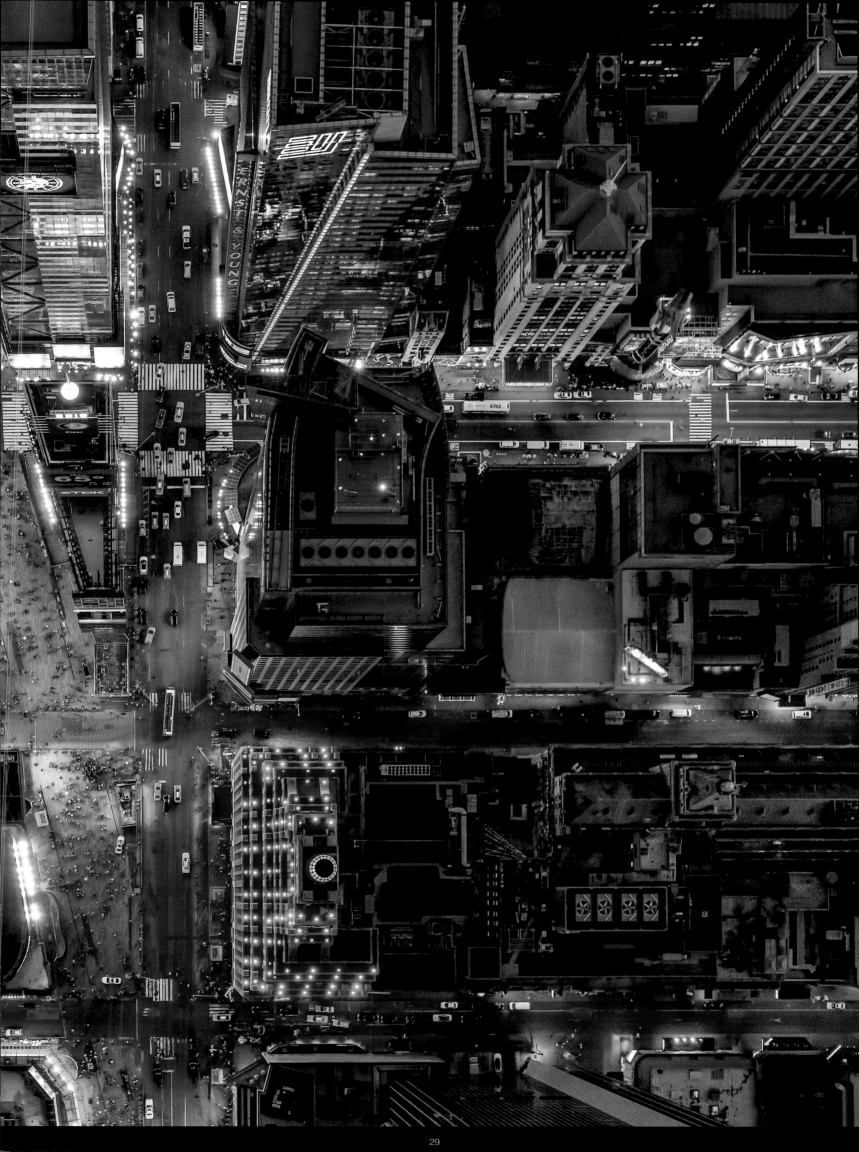

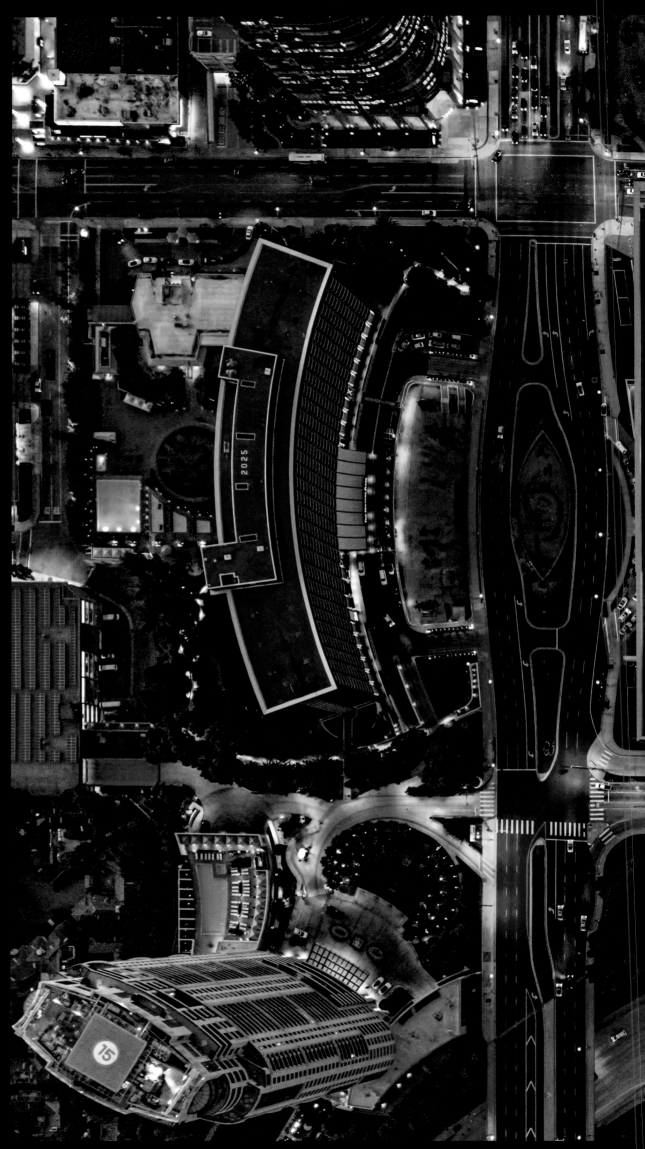

Century City, LA

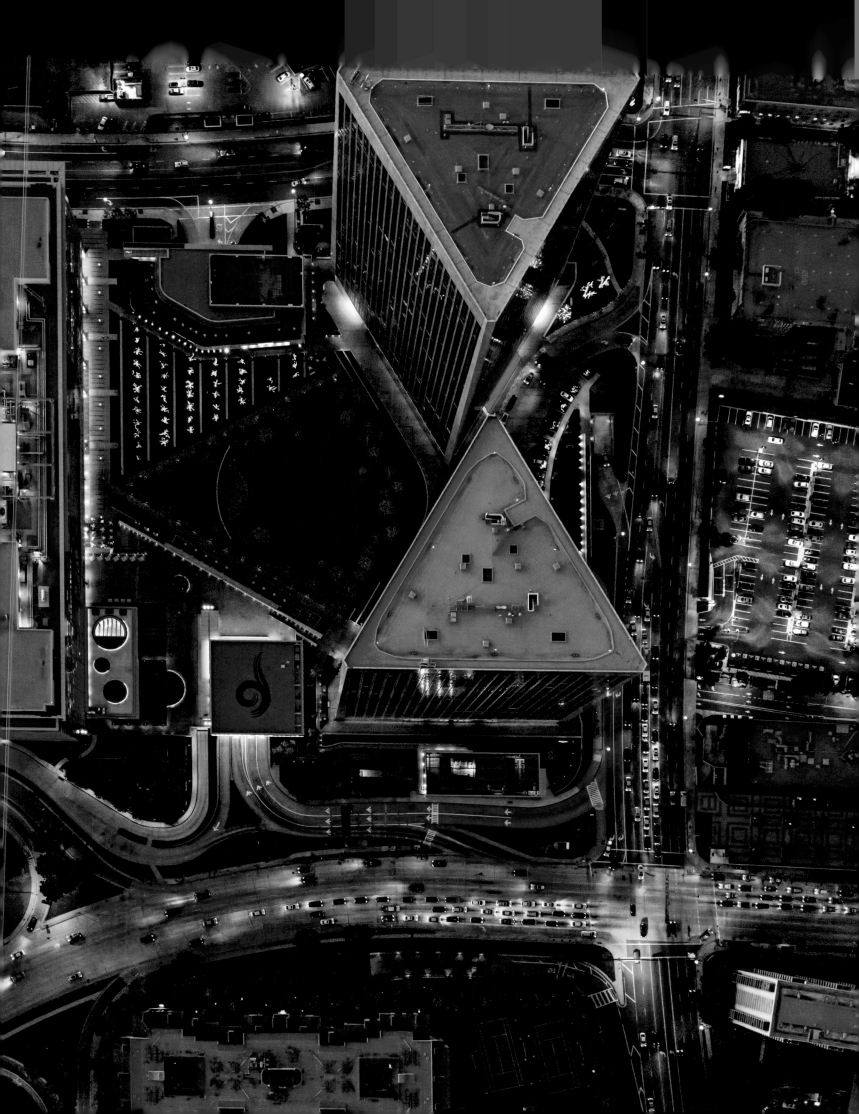

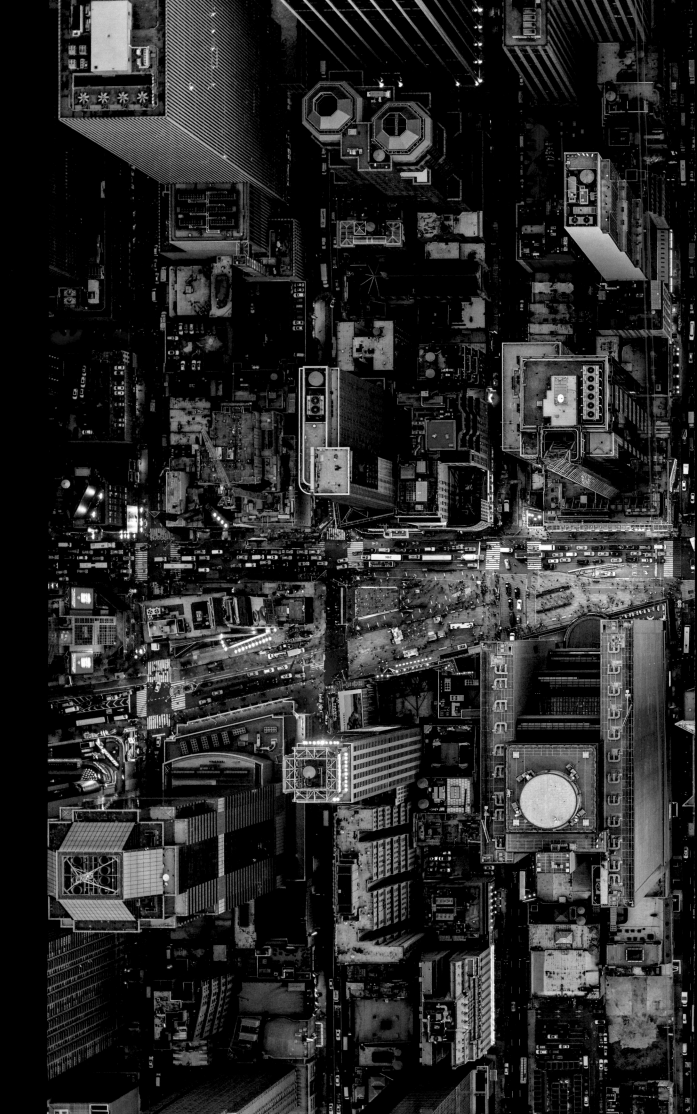

Times Square, NY

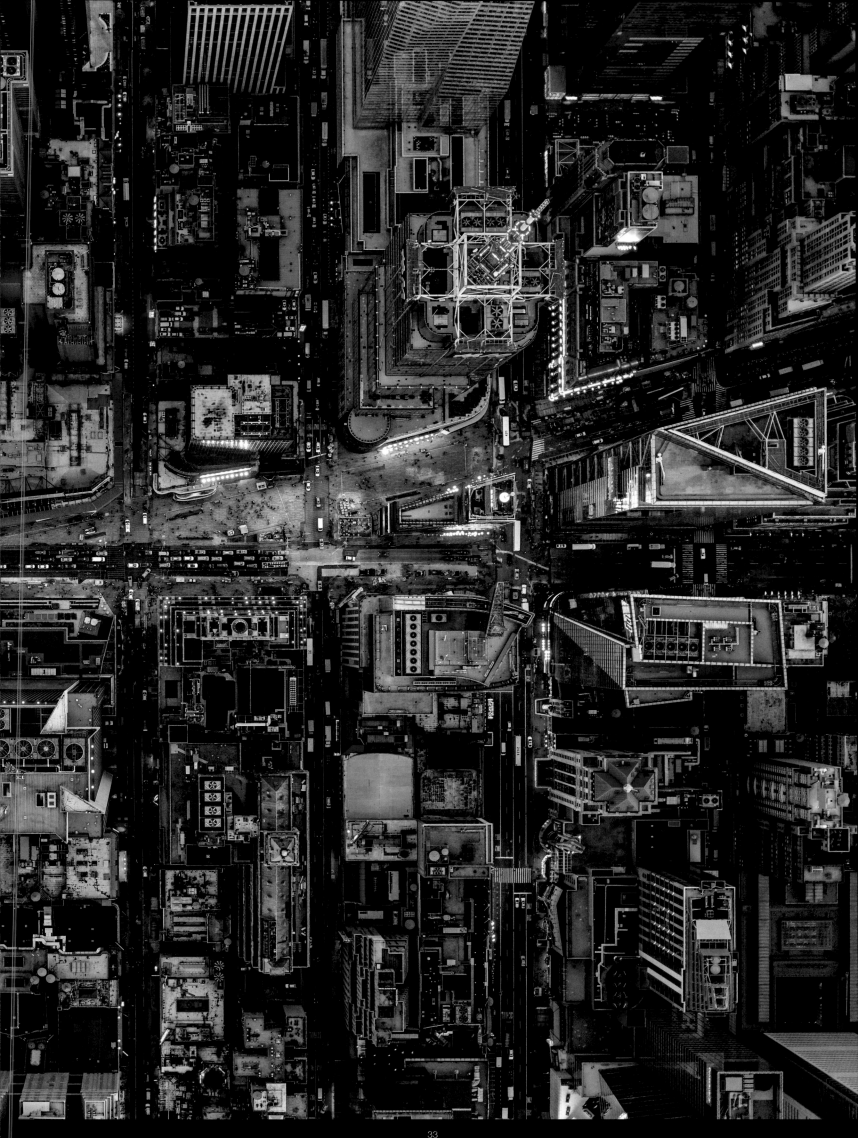

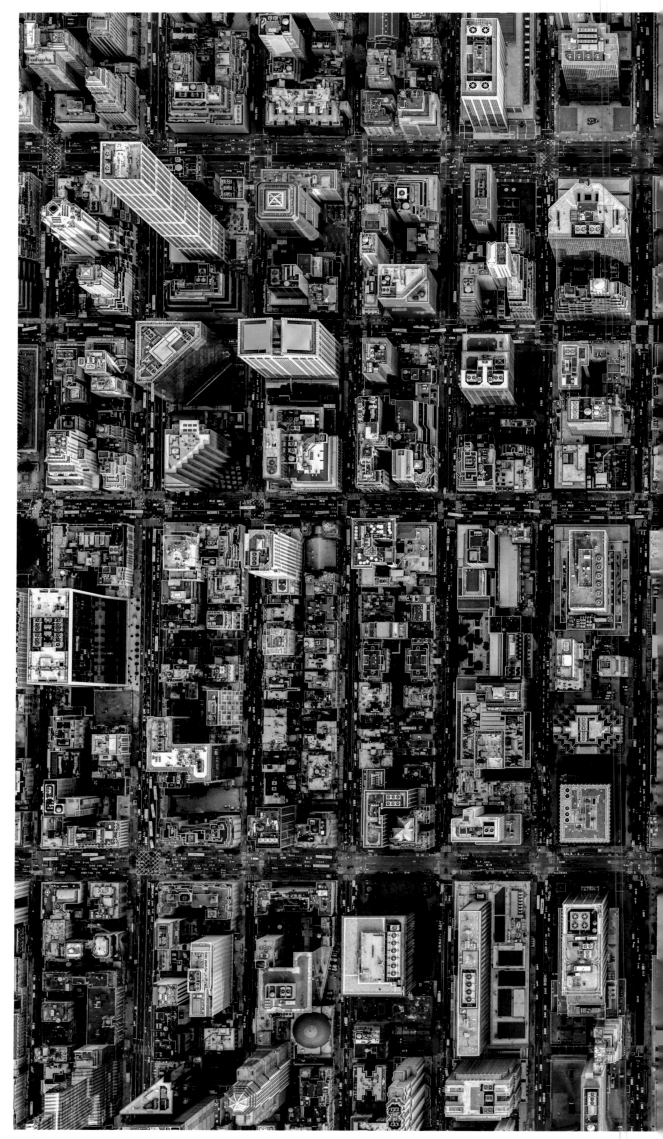

Midtown, Fifth Avenue, NY

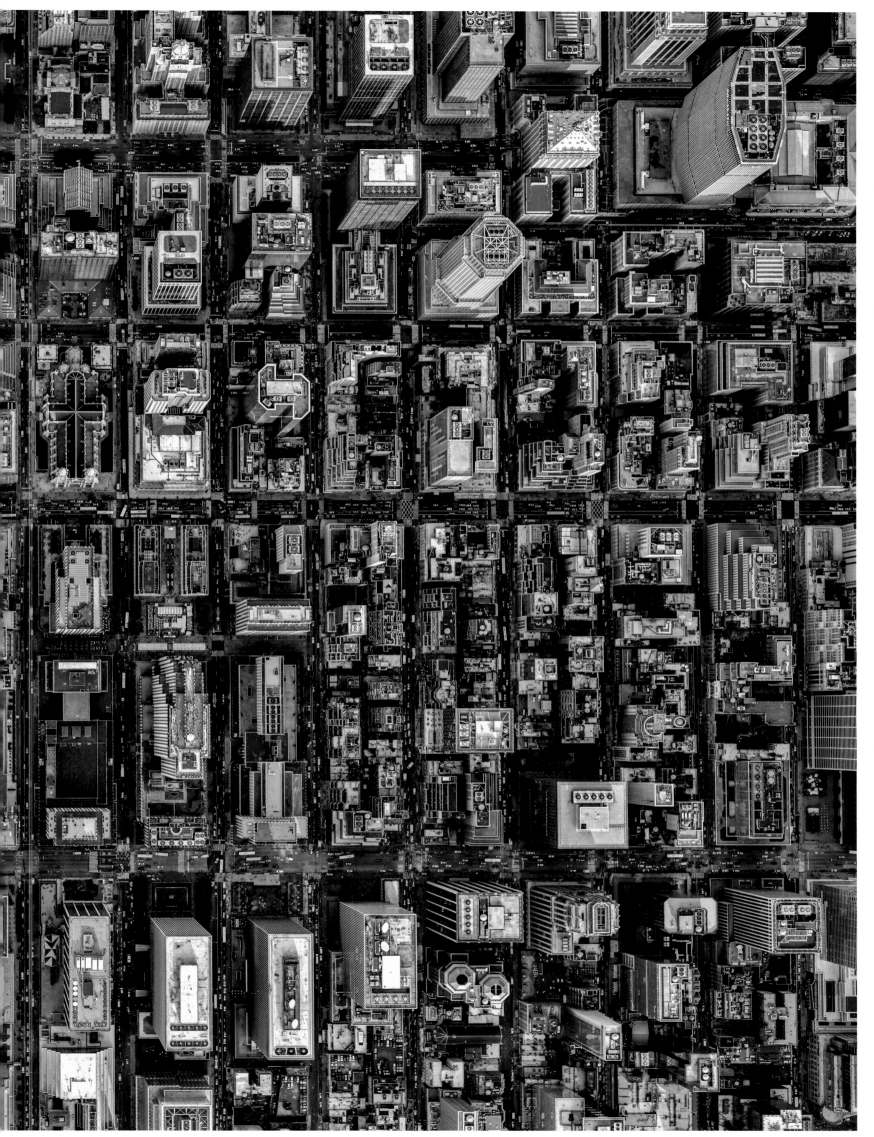

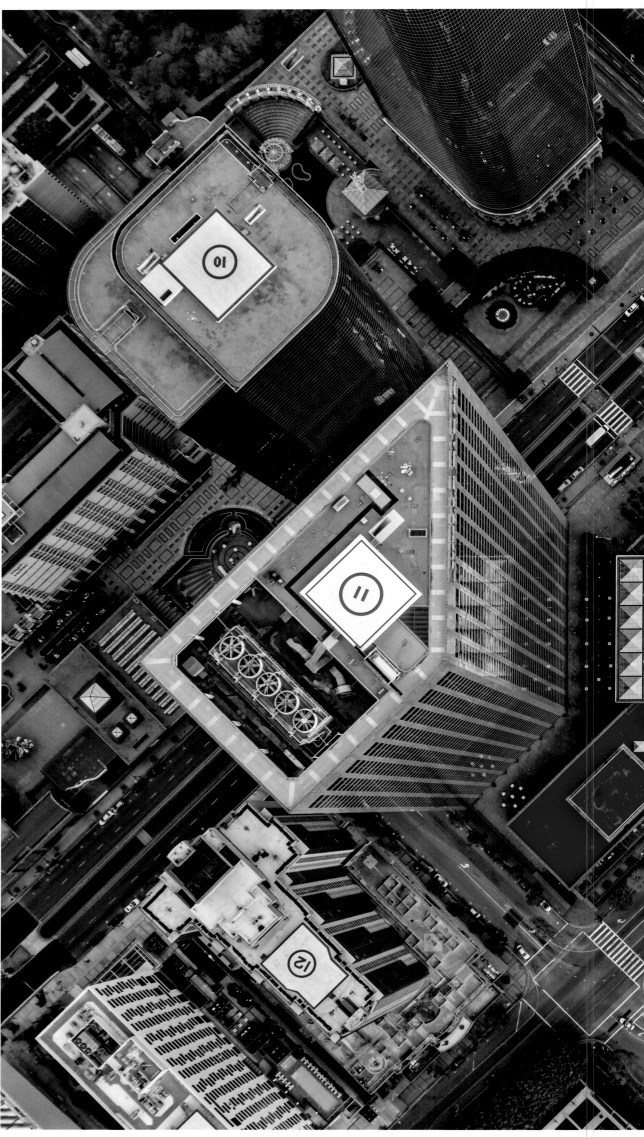

Downtown, LA

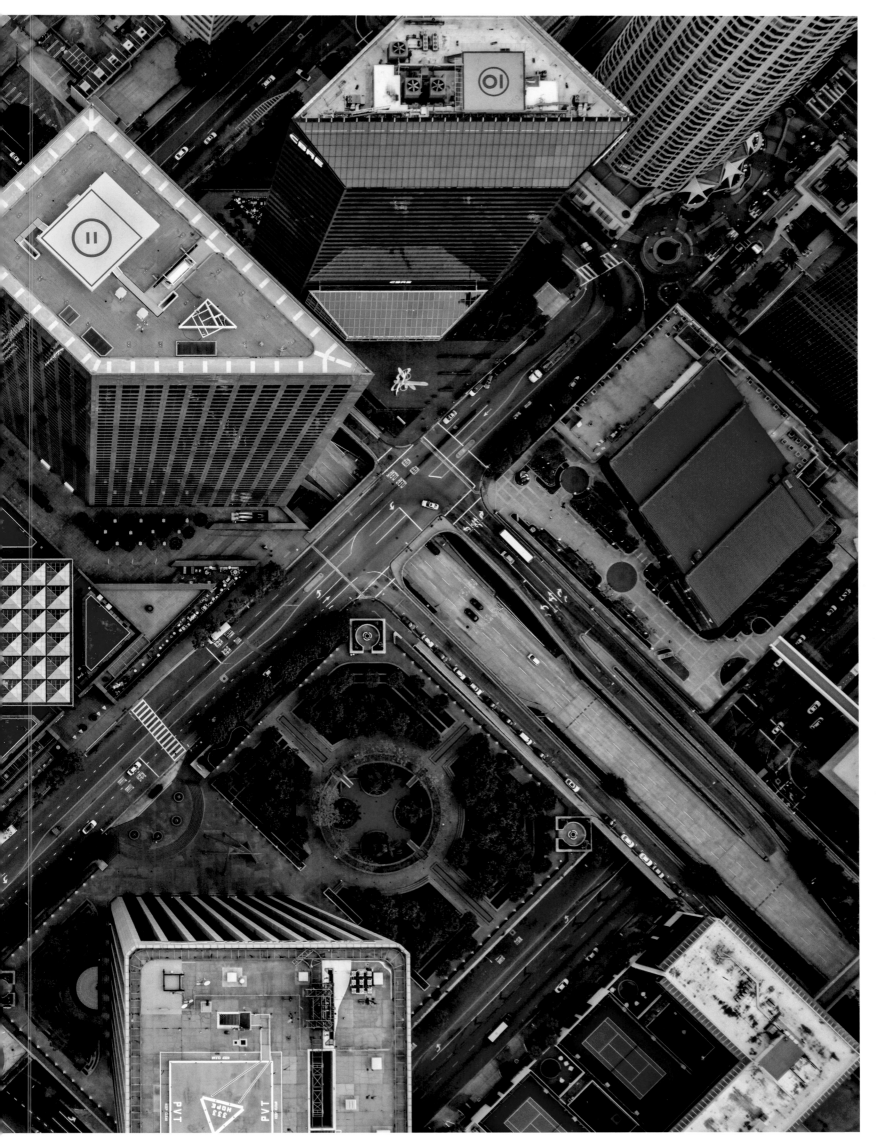

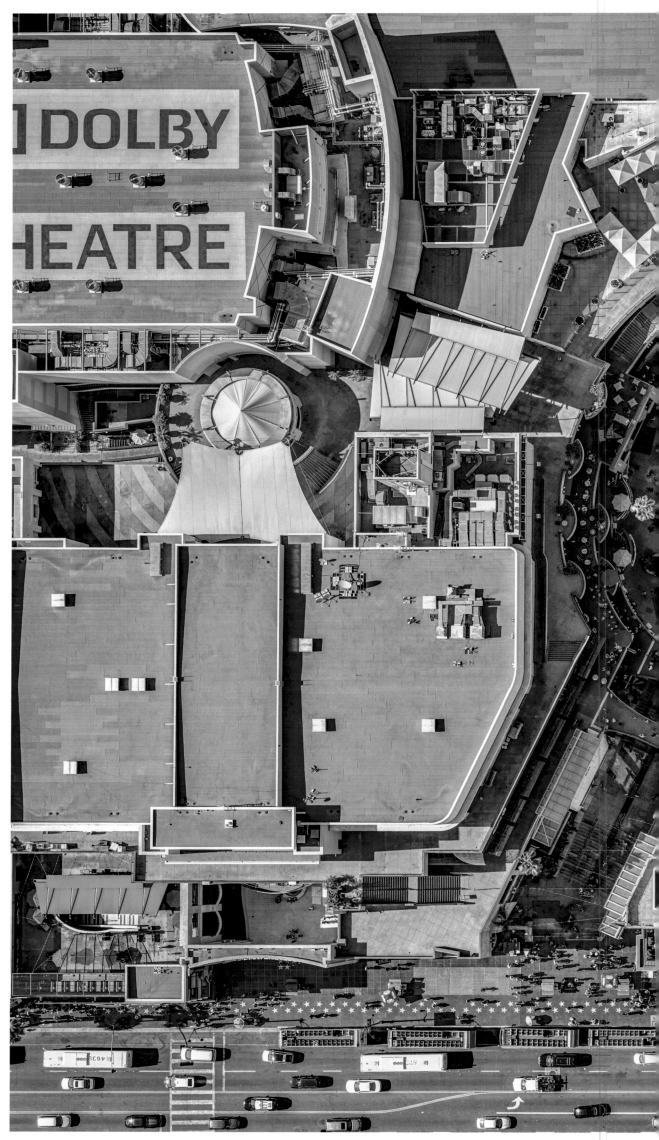

Hollywood Boulevard and Highland
Avenue, LA

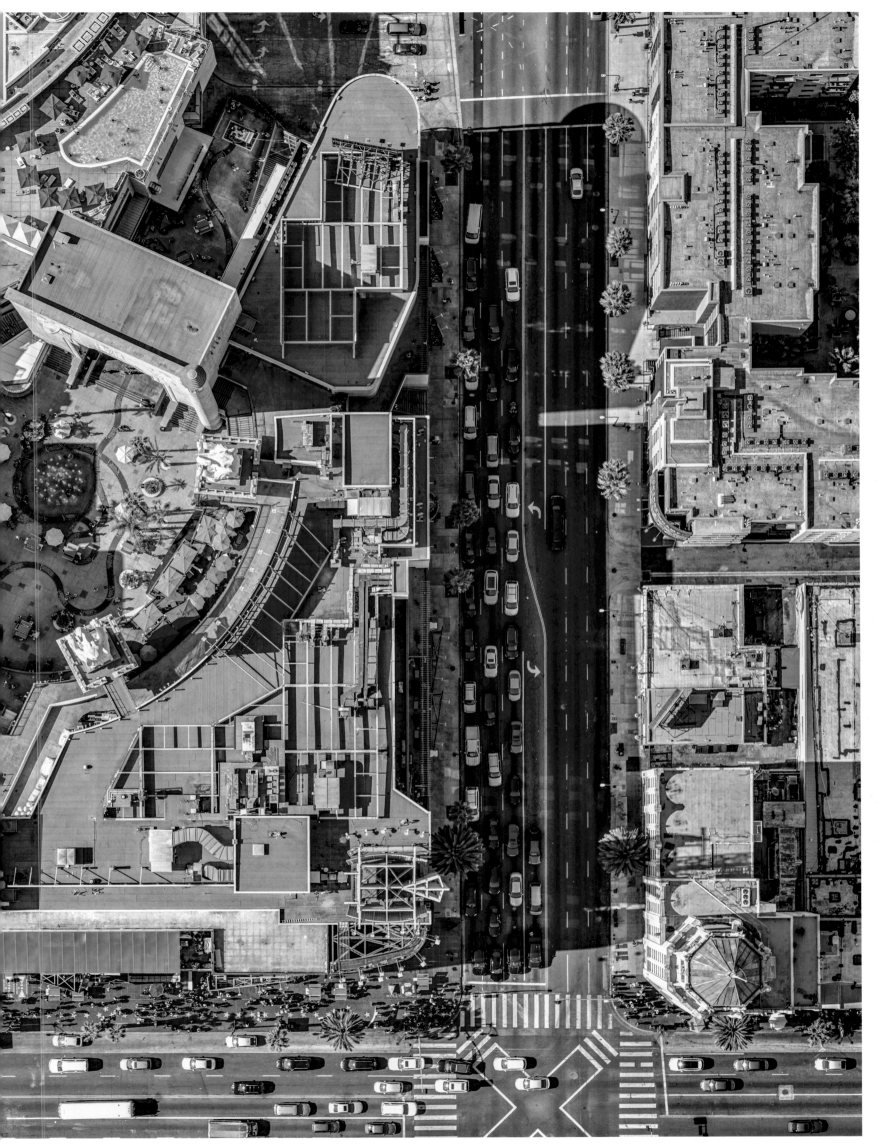

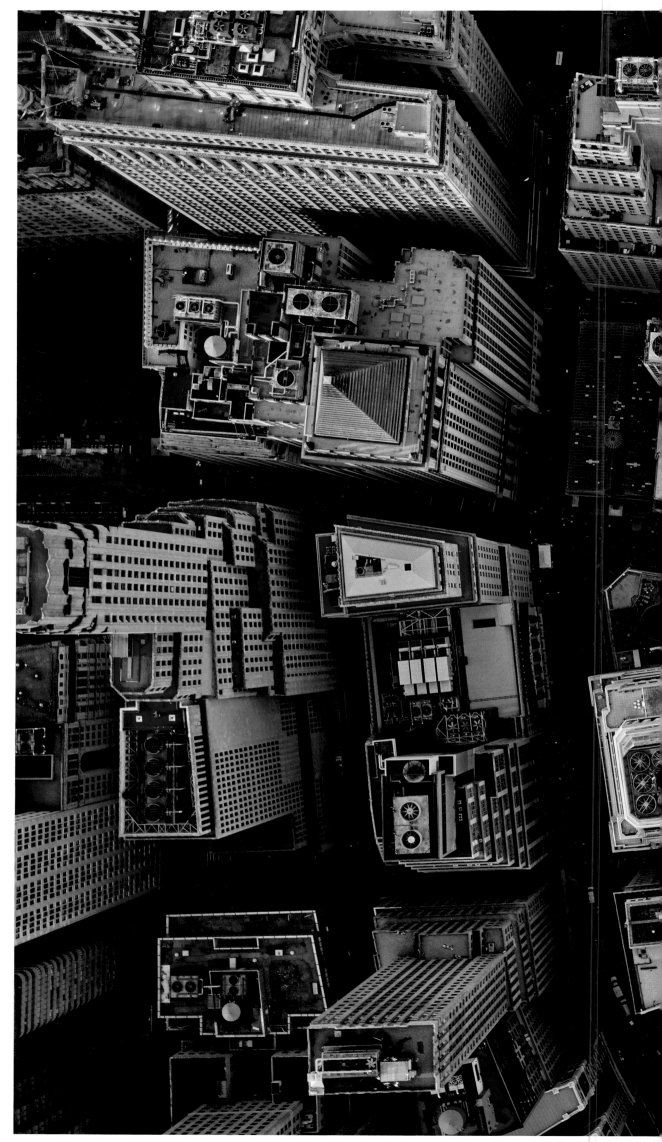

Financial District, NY

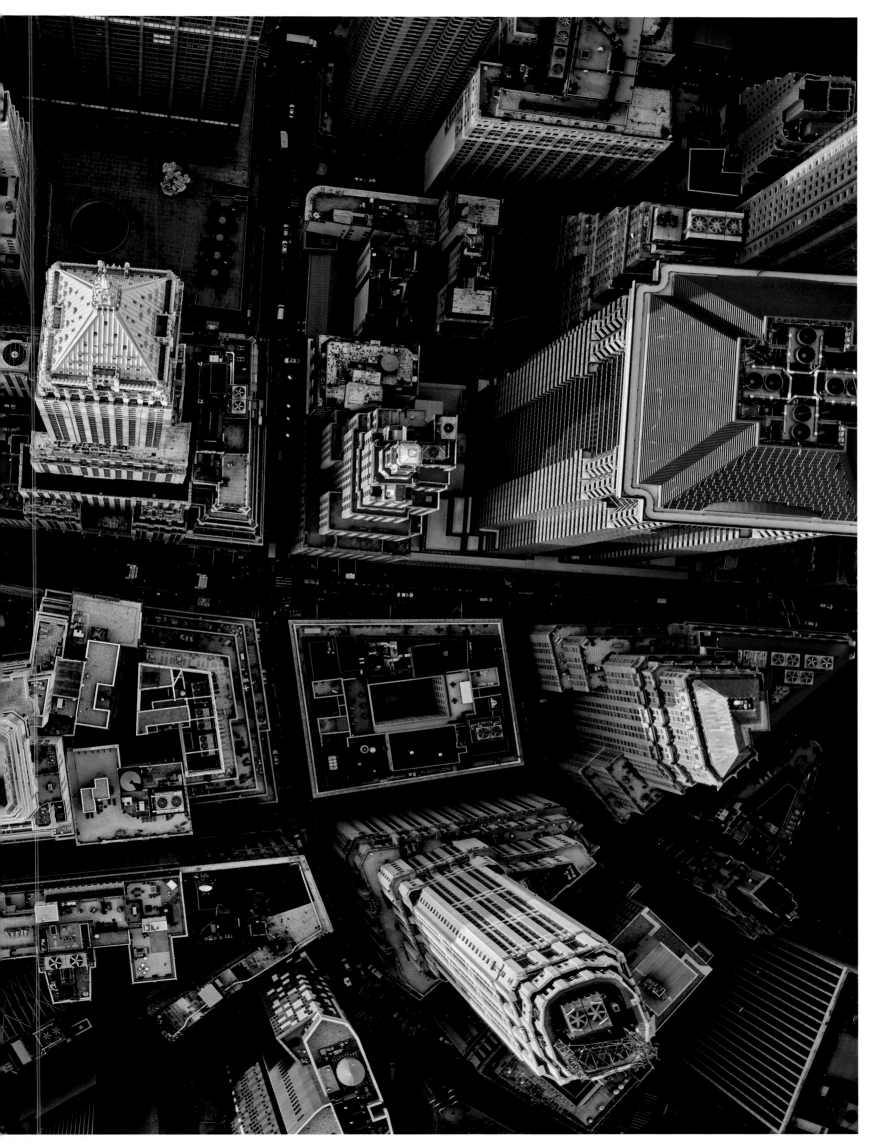

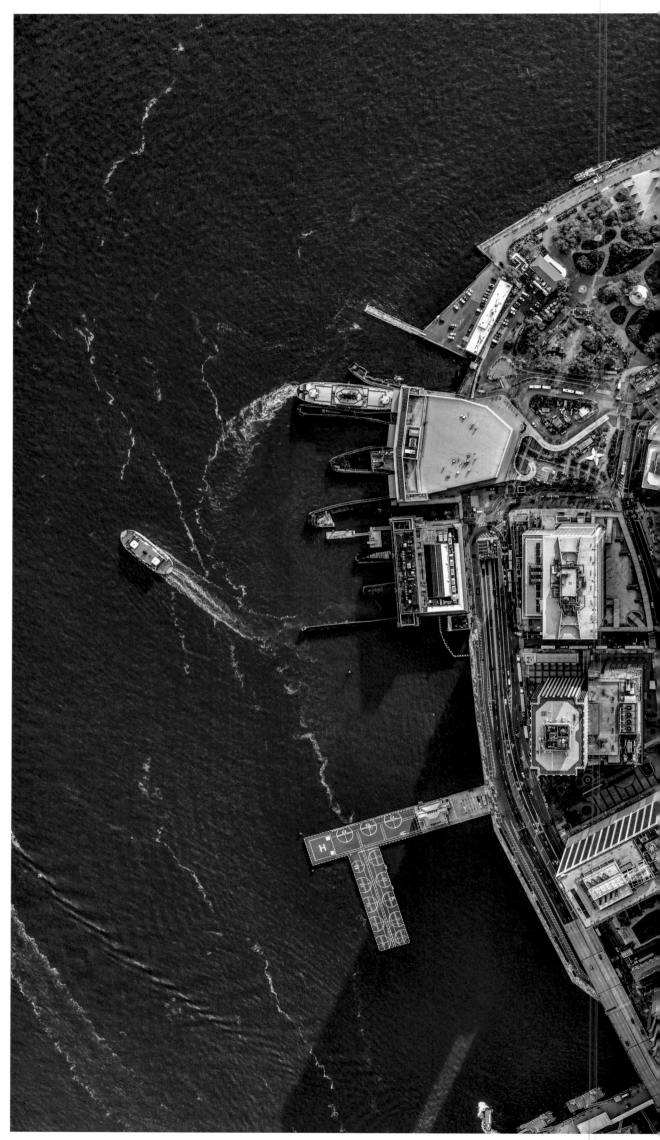

Battery Park, Financial District, NY

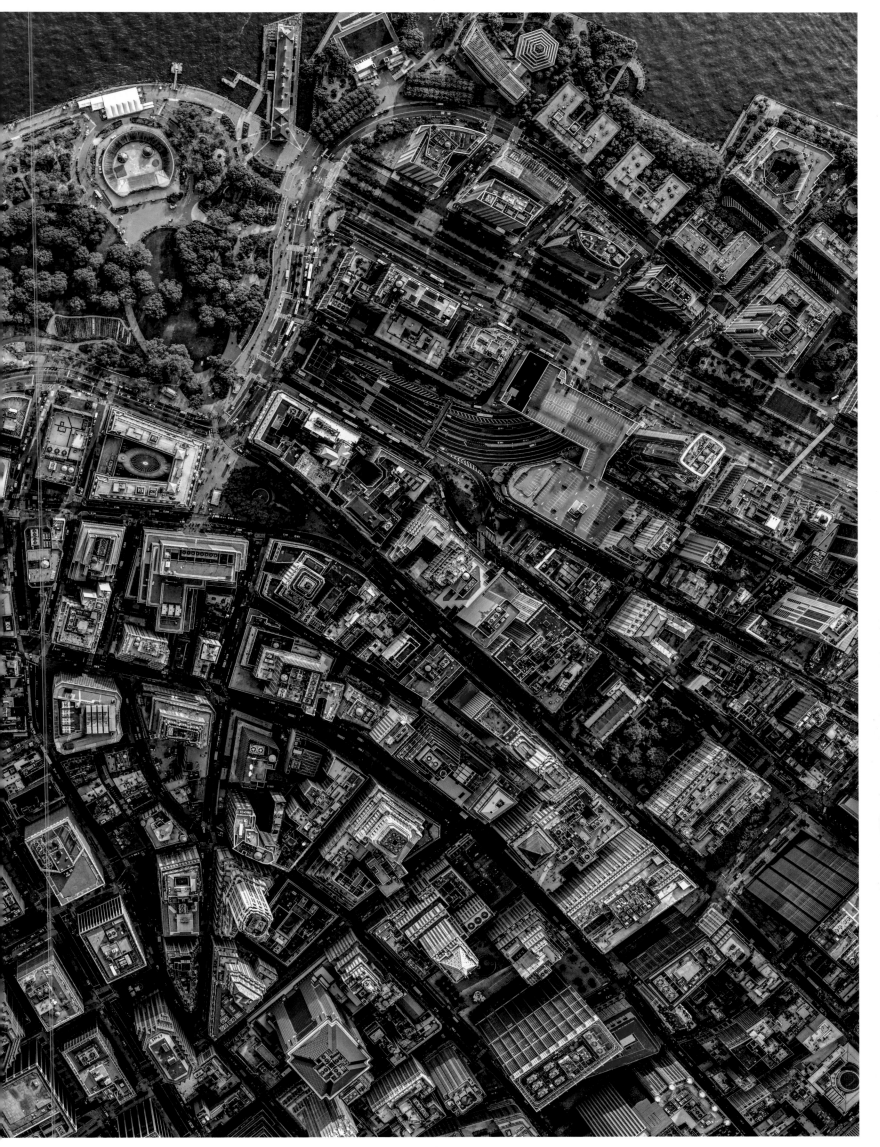

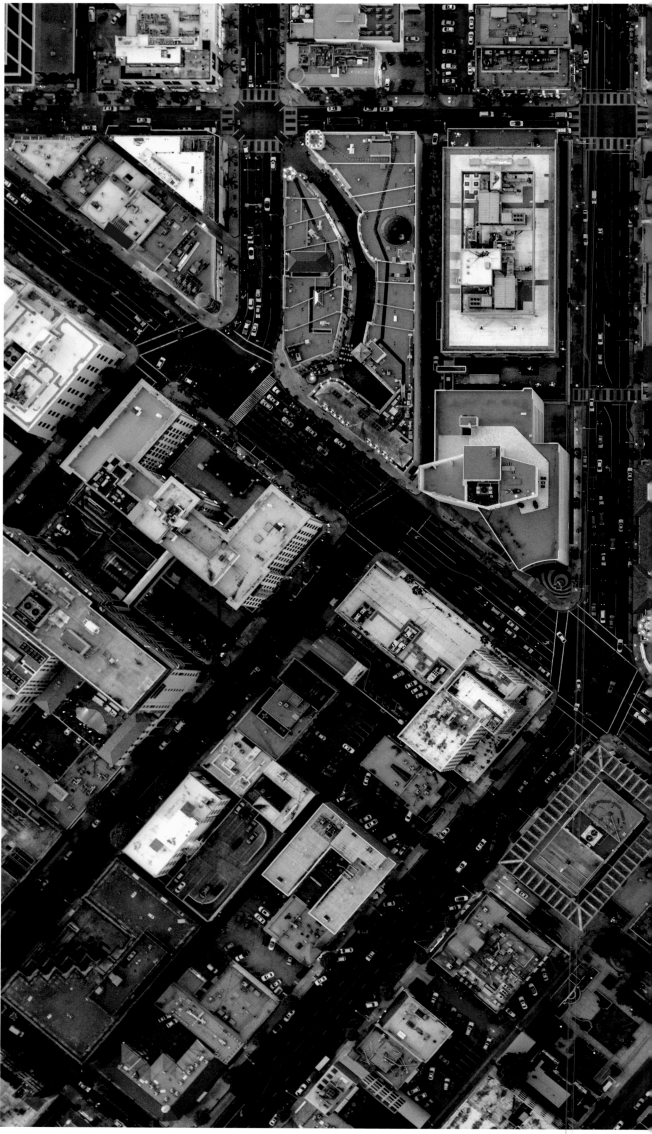

Wilshire Boulevard and Beverly
Drive, Beverly Hills, LA

PAGES 46–47
Columbus Circle, NY

Midtown East, NY

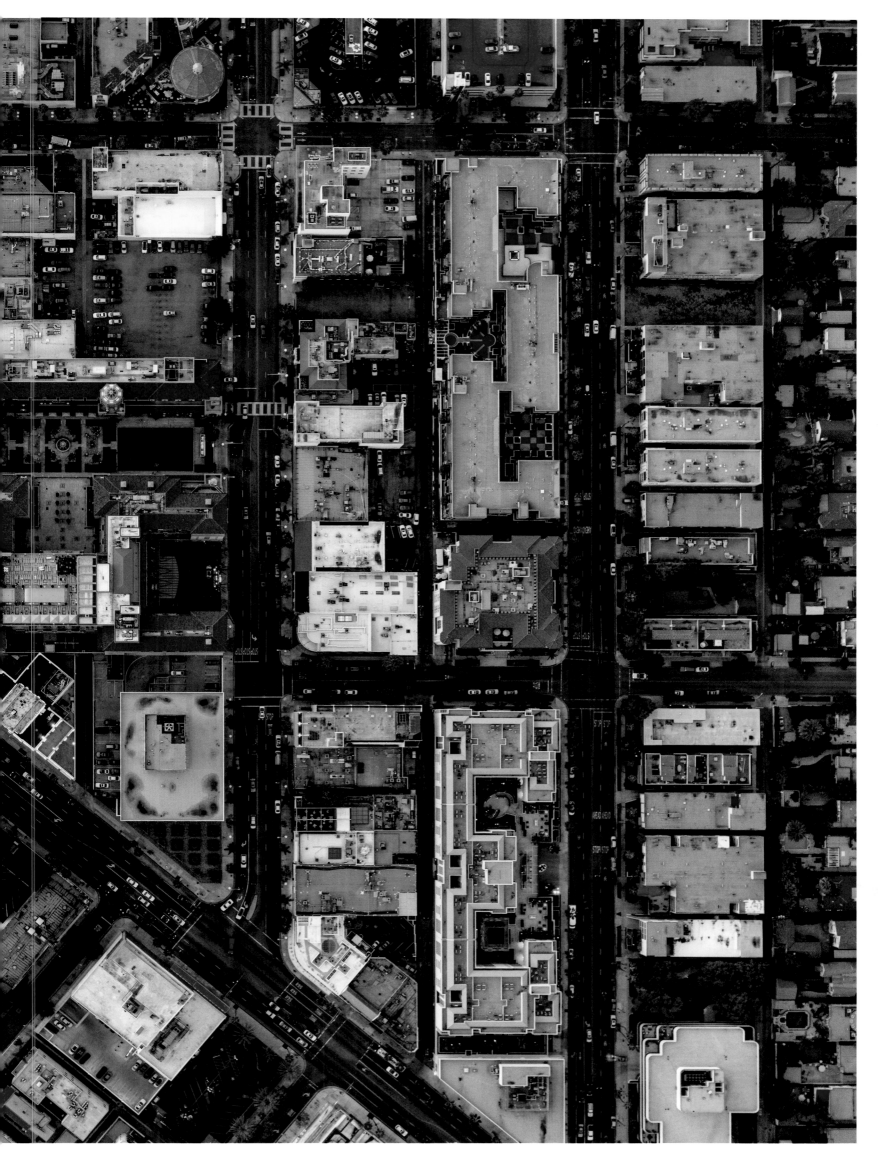

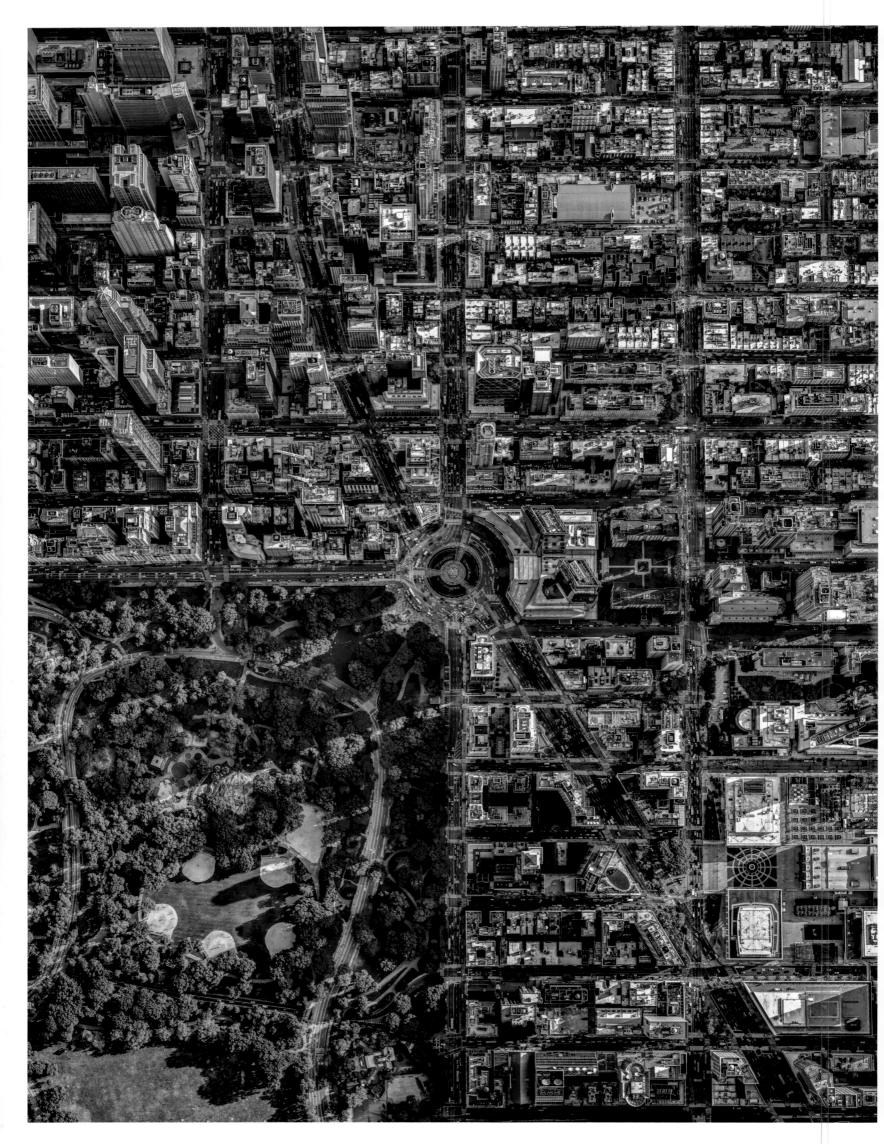

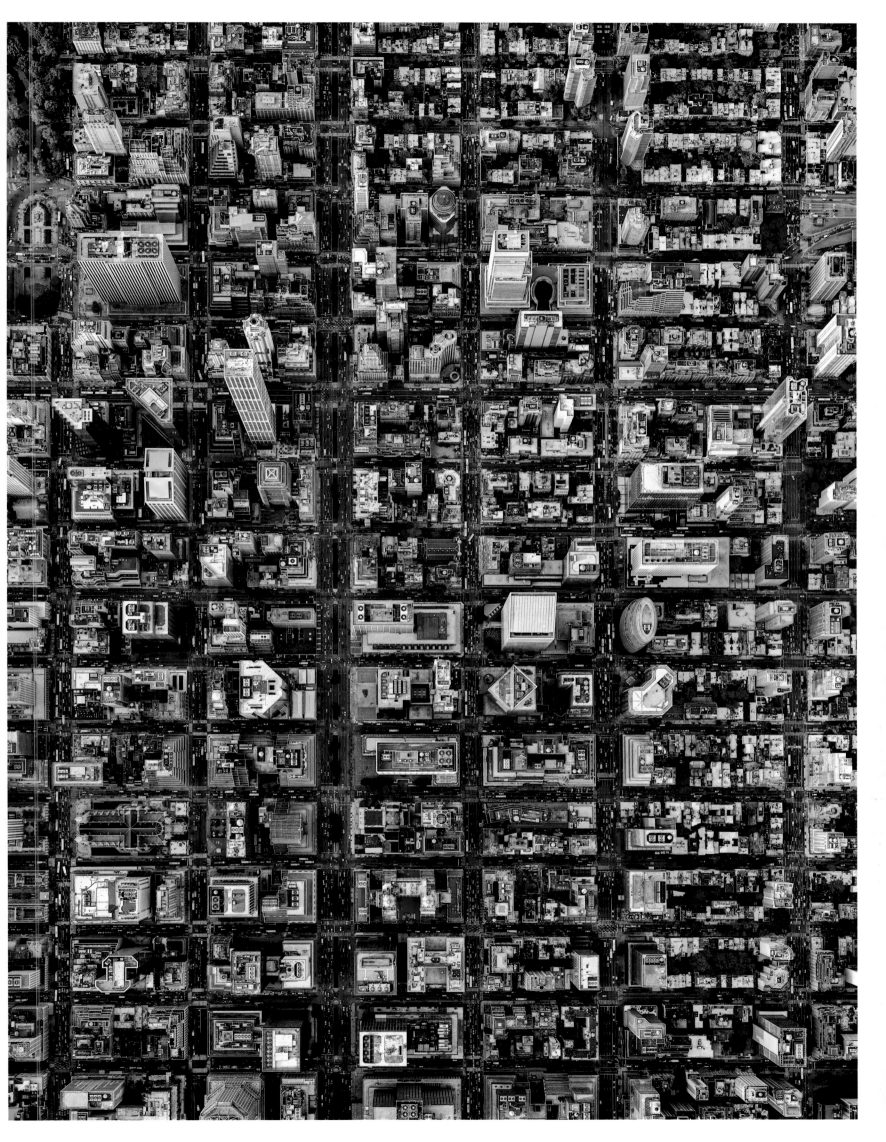

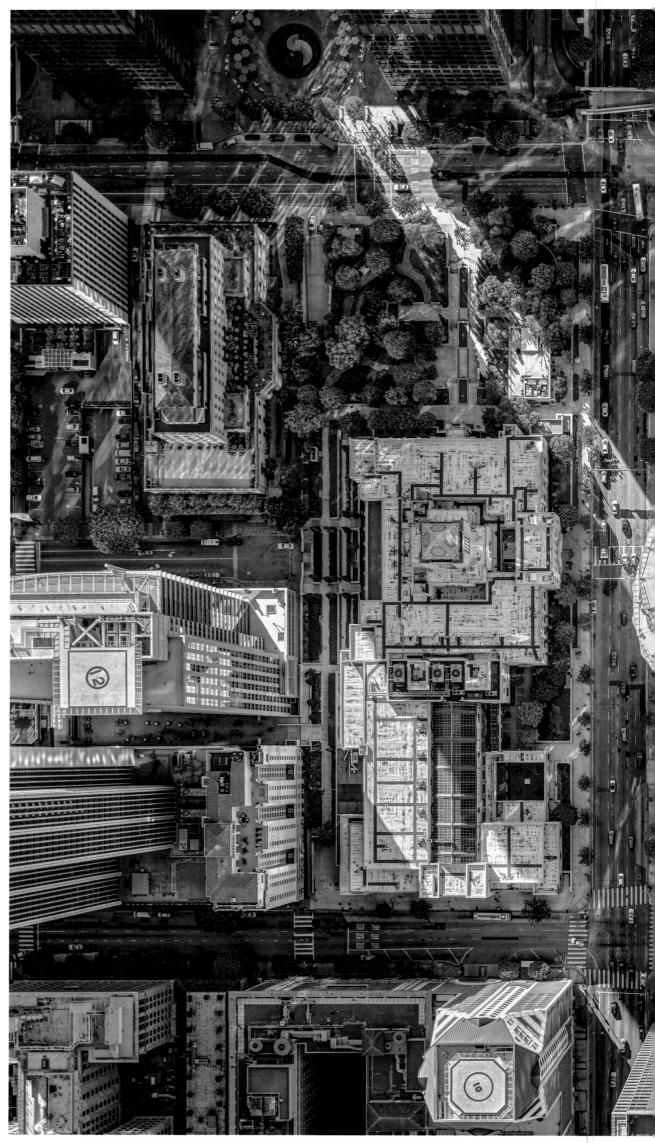

Downtown, LA

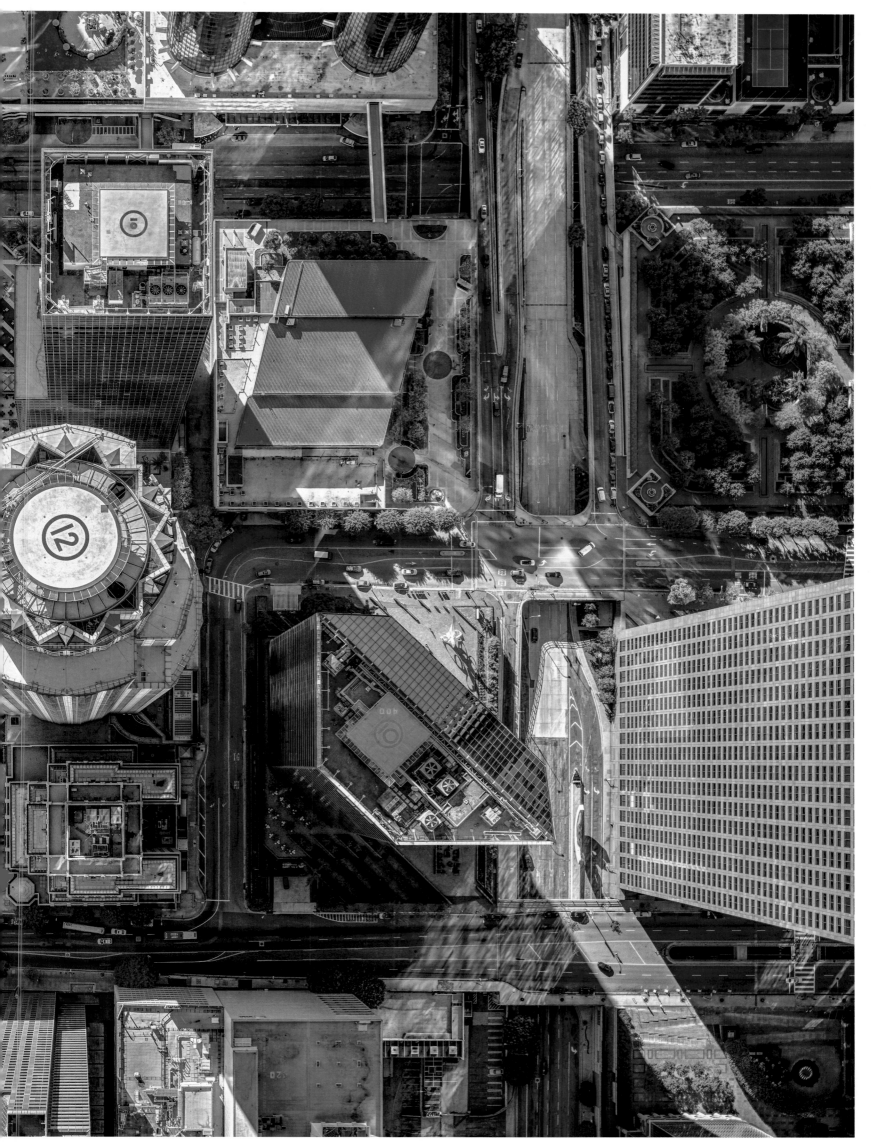

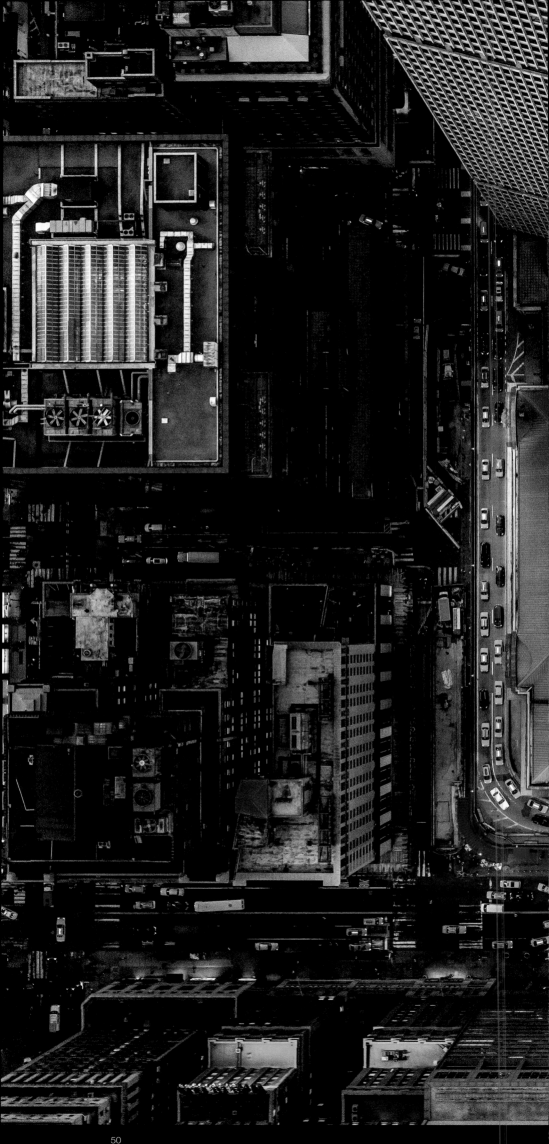

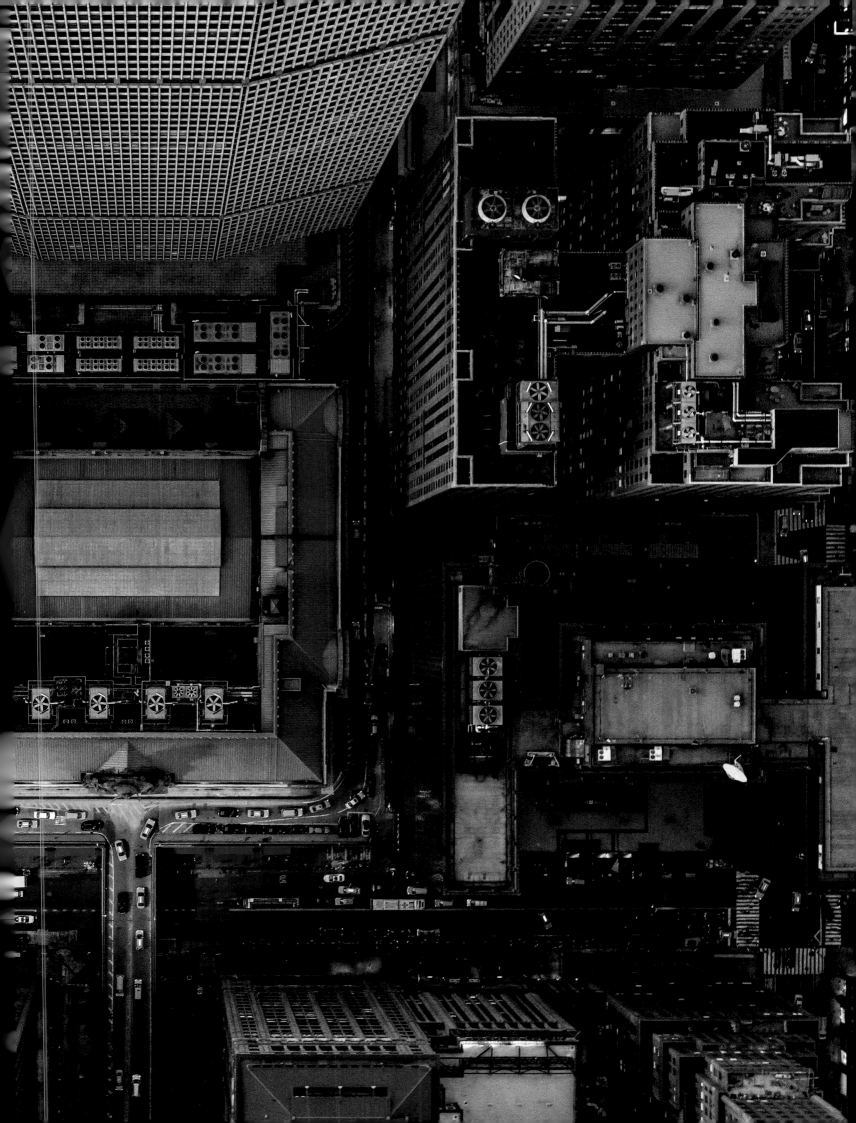

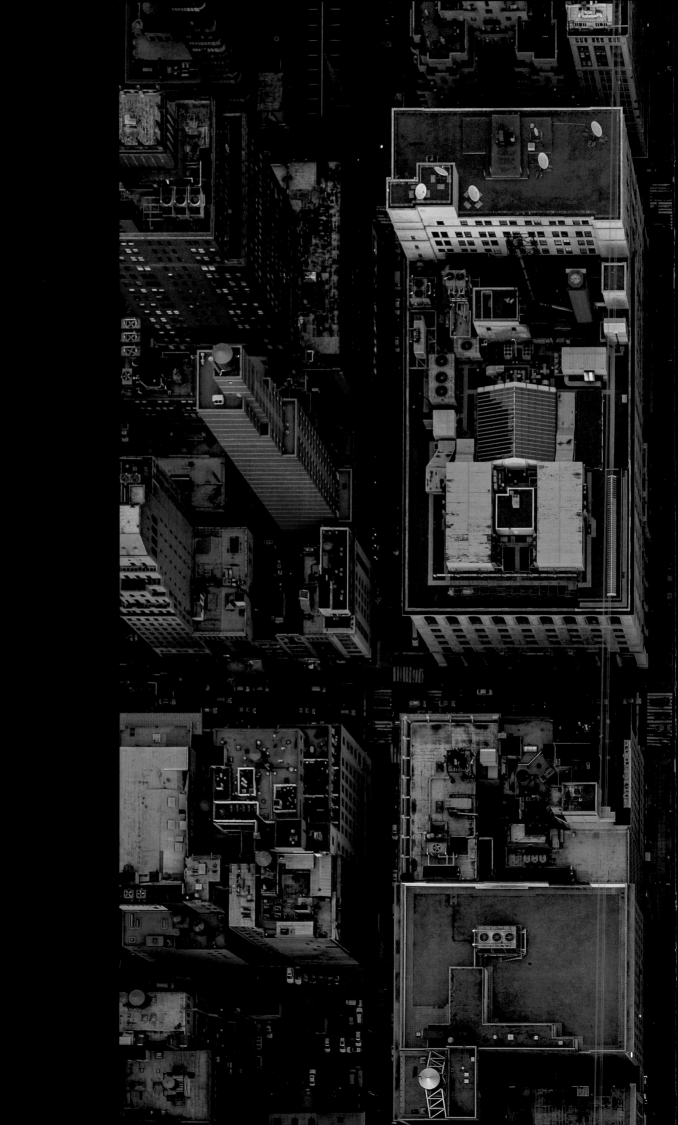

Empire State Building, NY

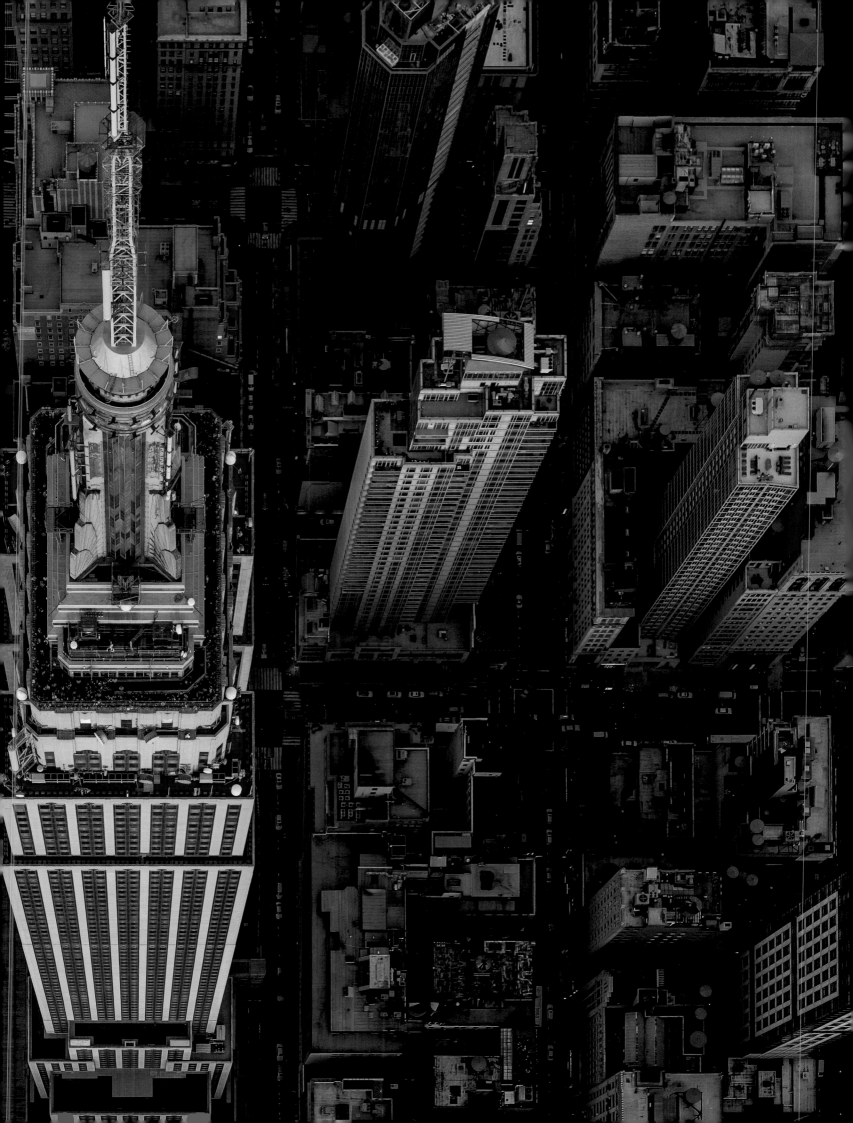

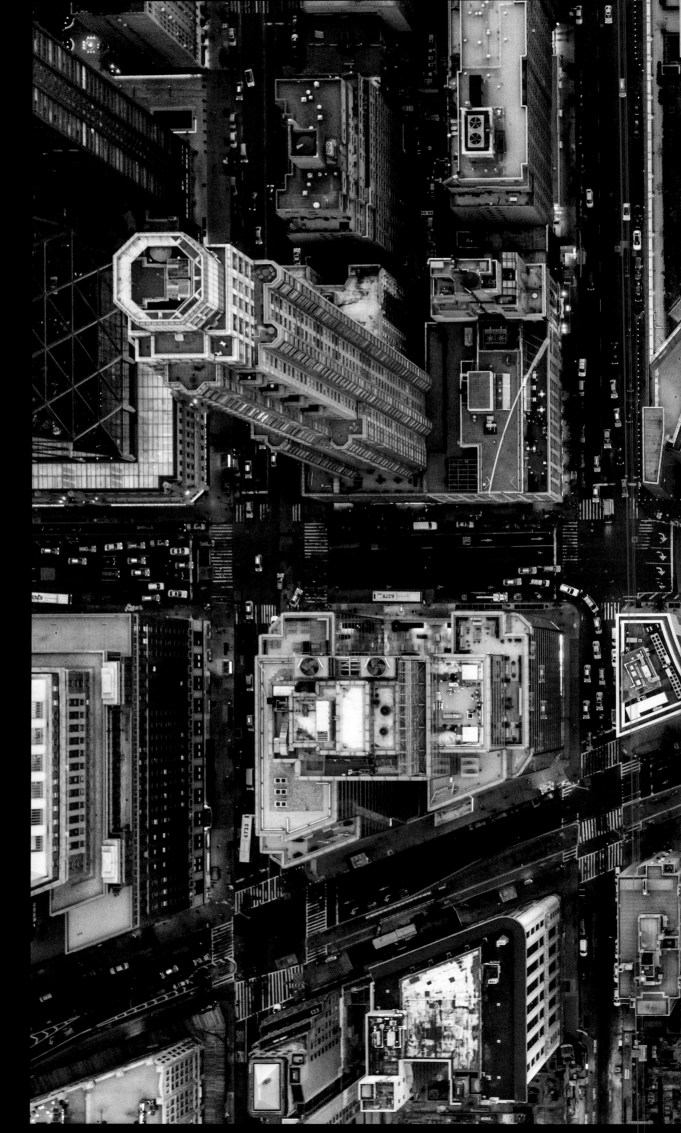

Columbus Circle, NY

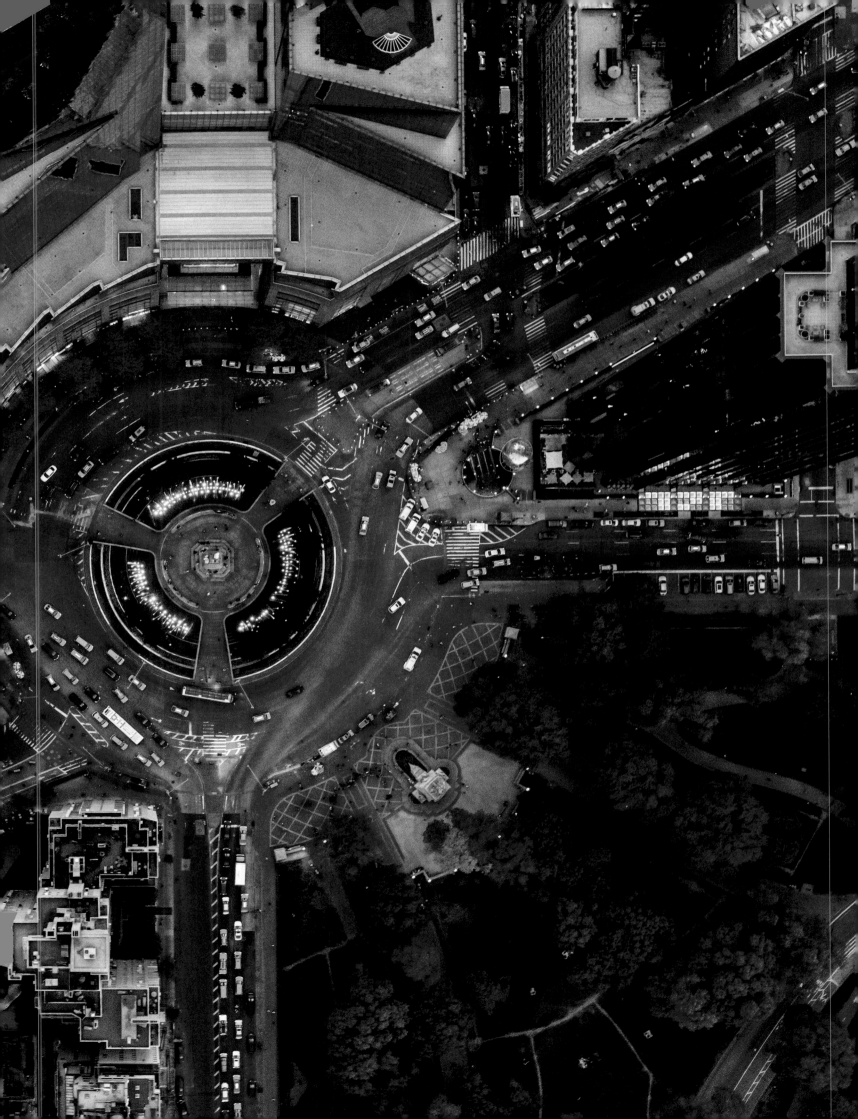

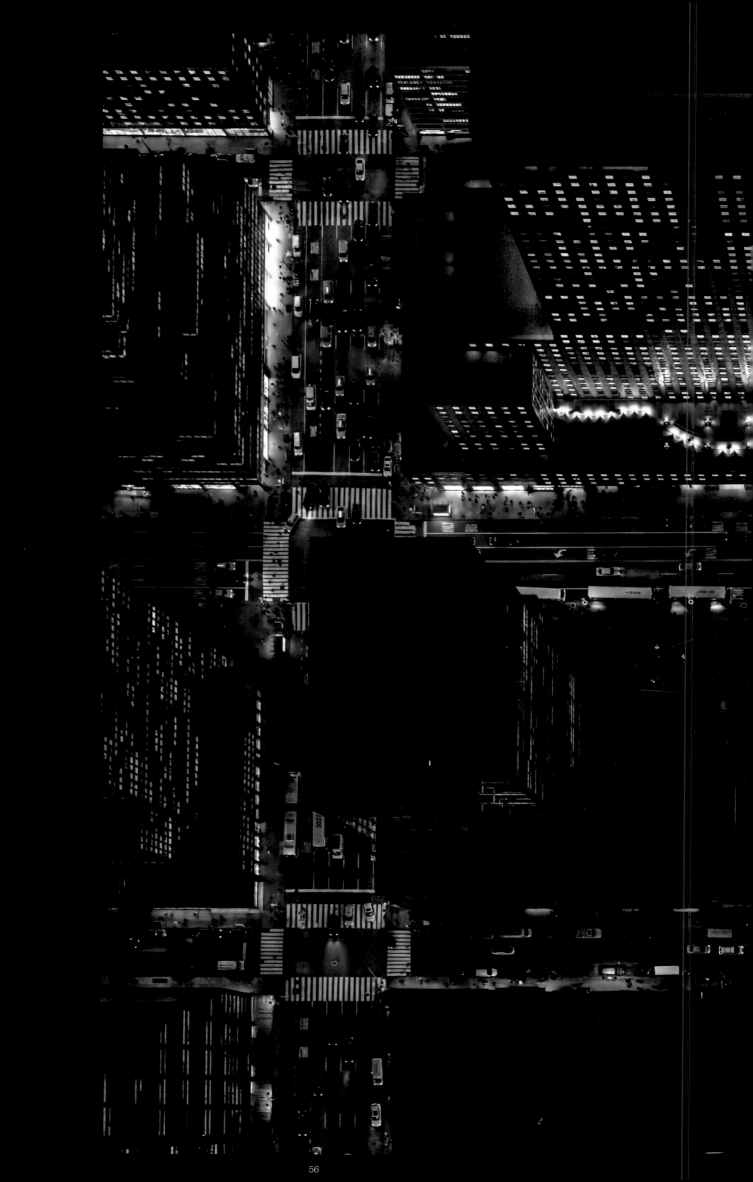

Chrysler Building, NY

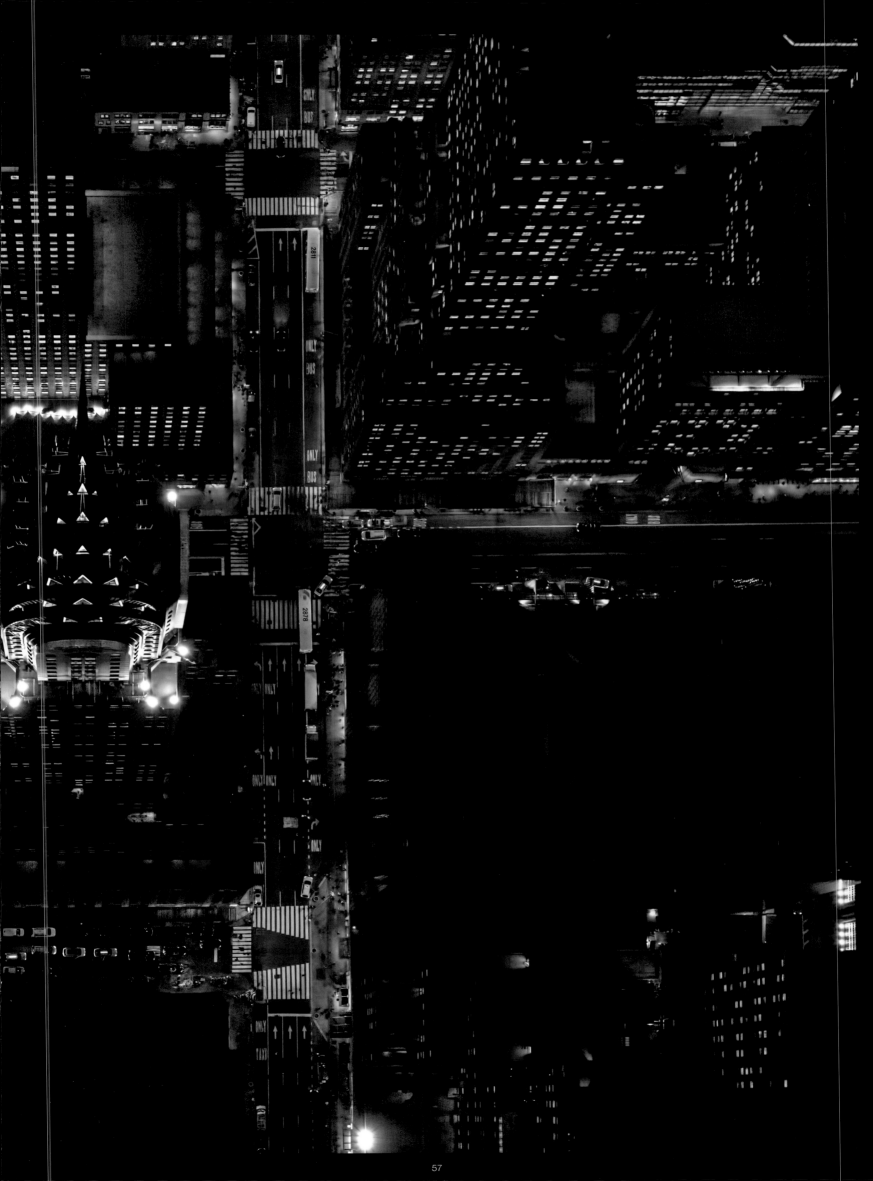

PARKS AND RECREATION

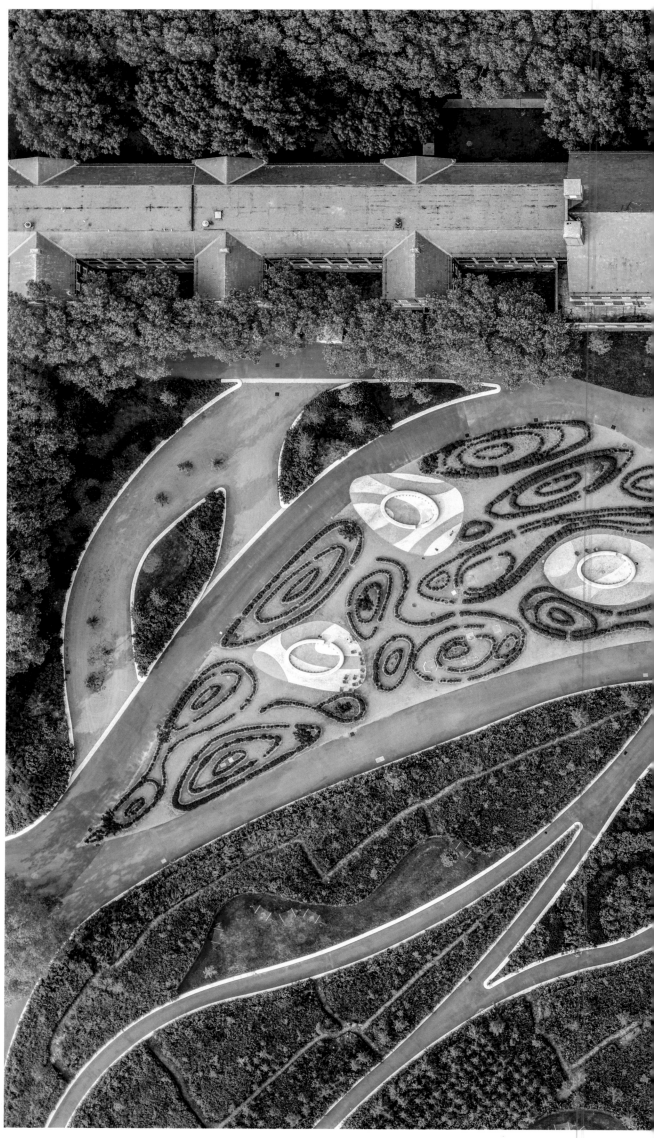

Governors Island, NY

PAGES 60–61
The Enid A. Haupt Conservatory,
New York Botanical Garden, Bronx, NY

PAGES 62–63
Grand Army Plaza, NY

Bryant Park and the New York Public
Library, NY

Thronged with crowds of people,
Times Square, with its bright lights
and dazzling signage, pulses
with a frenetic energy unique to
midtown. But the urban density of
Manhattan is relieved by the great
rectangular swath of greenery at
its heart. In Central Park the grid
dissolves into meandering paths,
great lawns, and leafy dells. Other
parks and squares throughout
the city also offer respite from the
concrete canyons. The pleasant
LA weather has fostered world-
class amusement parks like
Disneyland and Universal Studios
and museums such as the Getty
Center where landscaping and
gardens and outdoor activities are
essential to the experience. The
laid-back Angelenos also enjoy
miles of beautiful golden beaches.

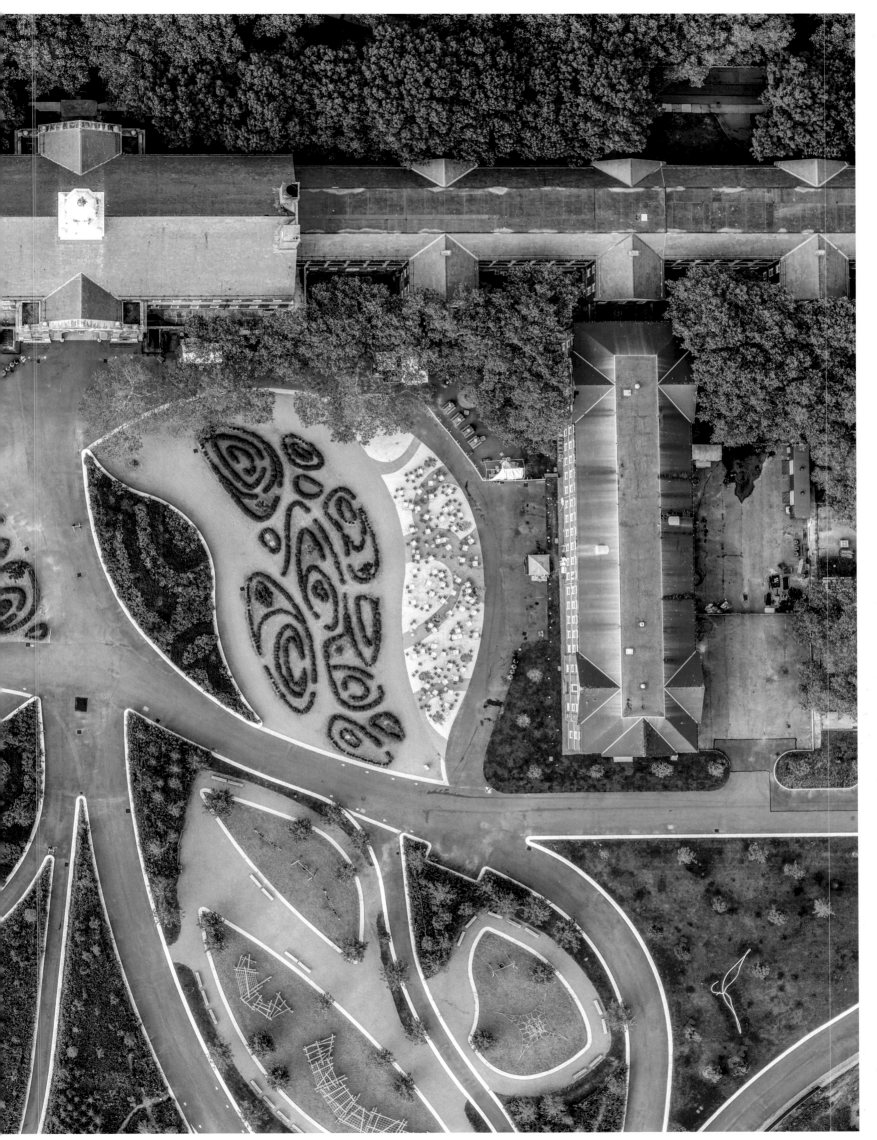

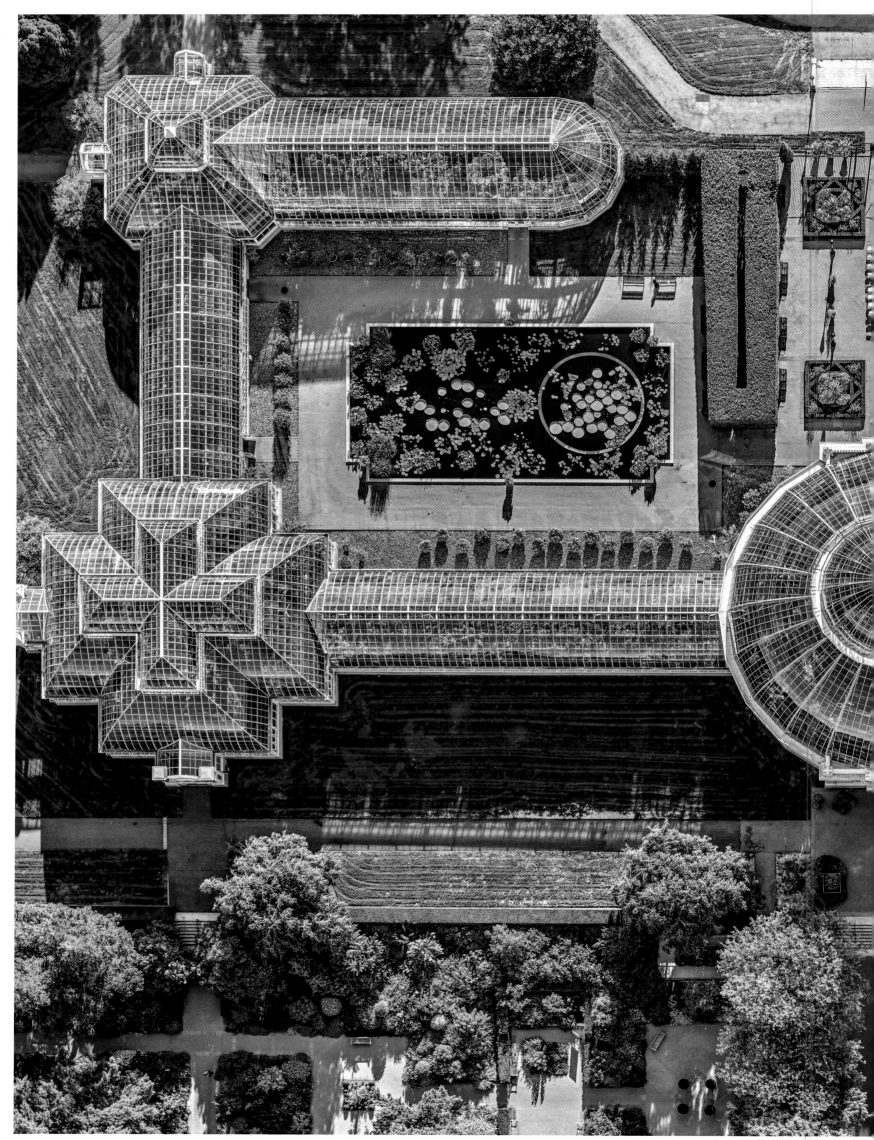

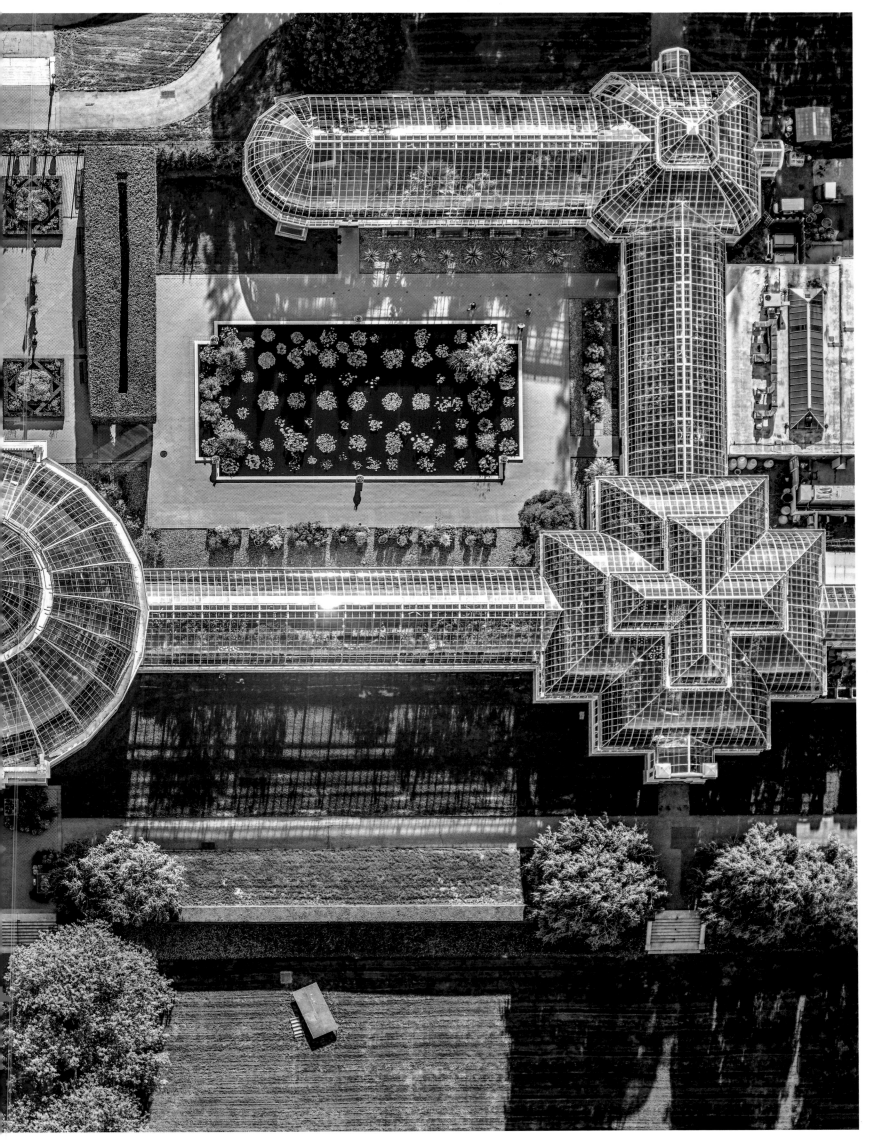

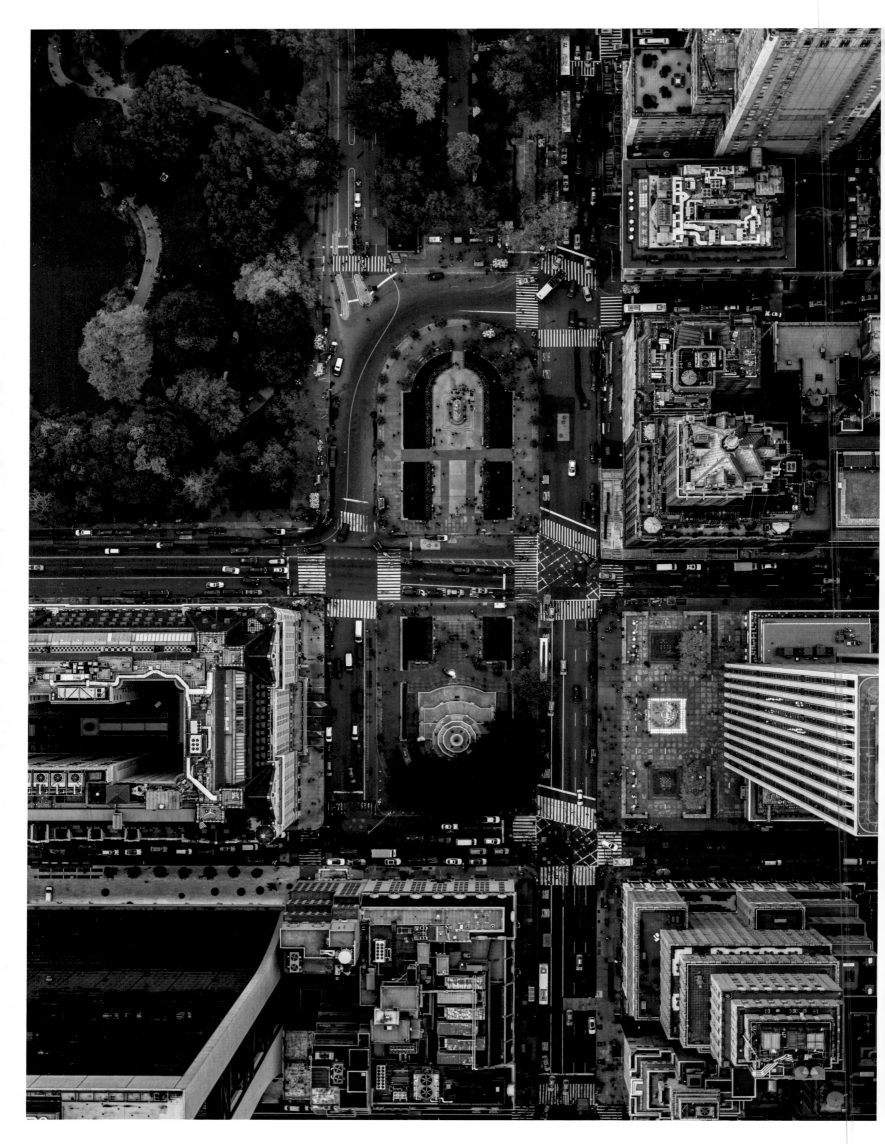

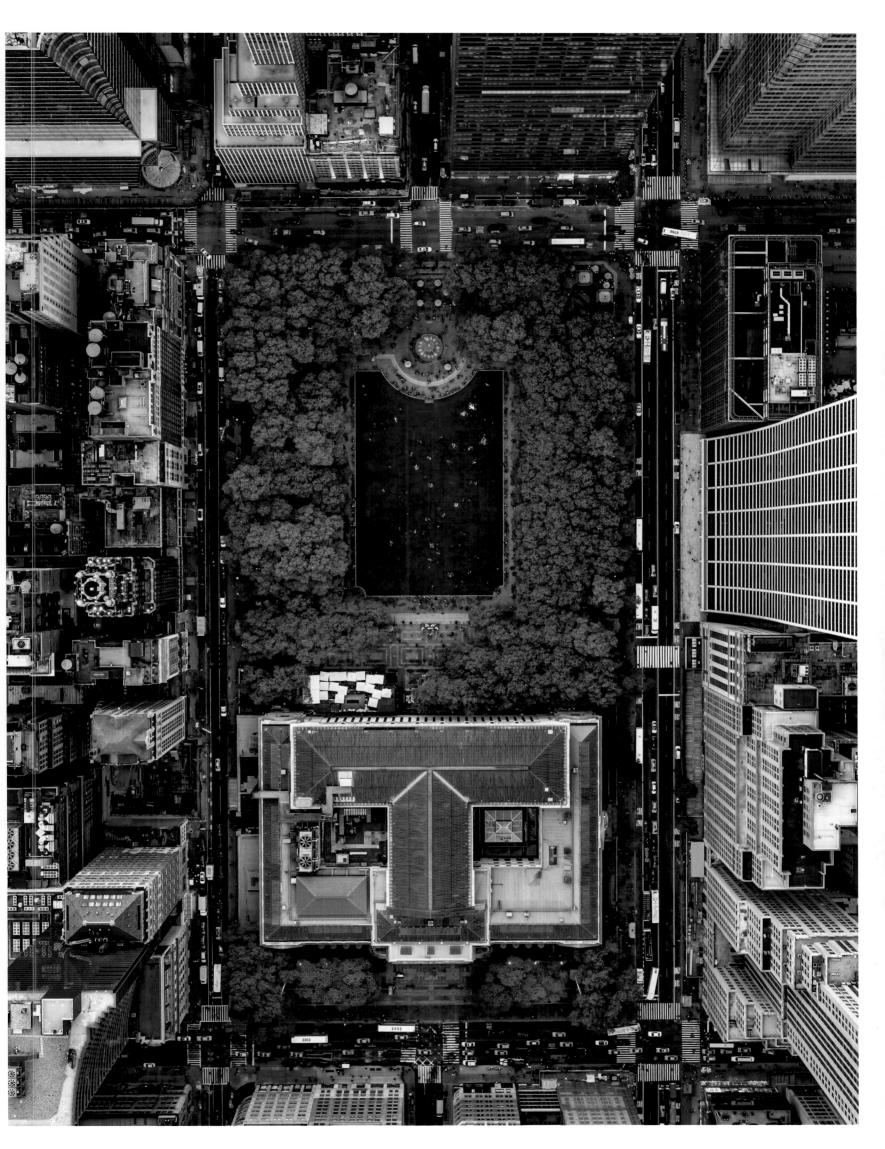

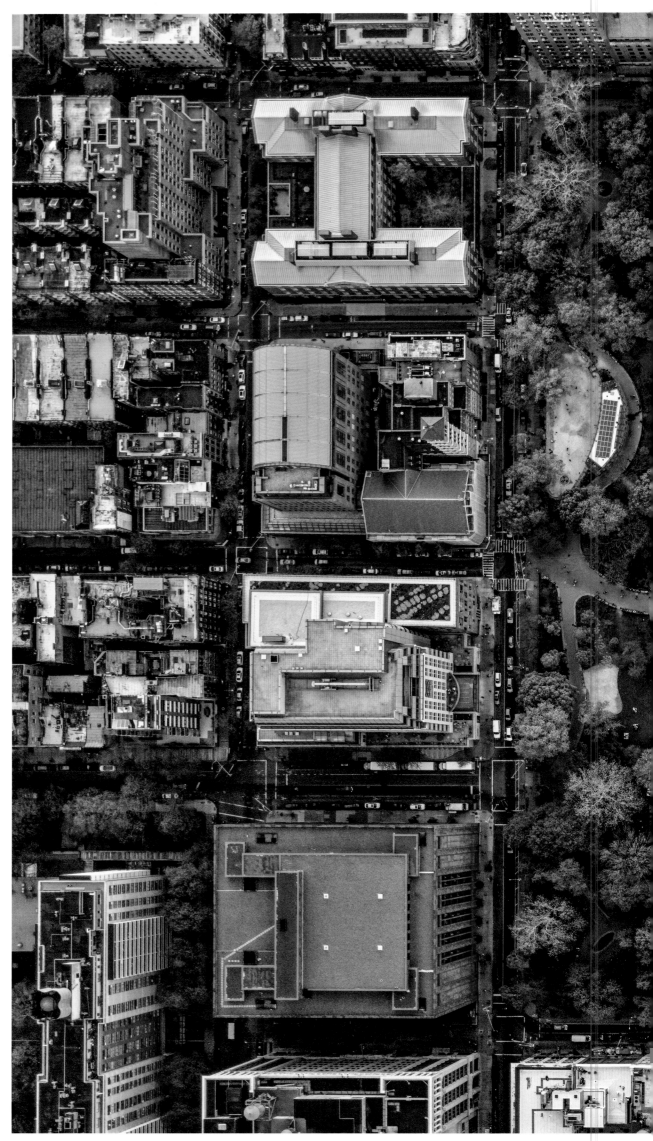

Washington Square Park, NY

PAGES 66–67
Columbia University, NY

PAGES 68–69
Central Park, NY

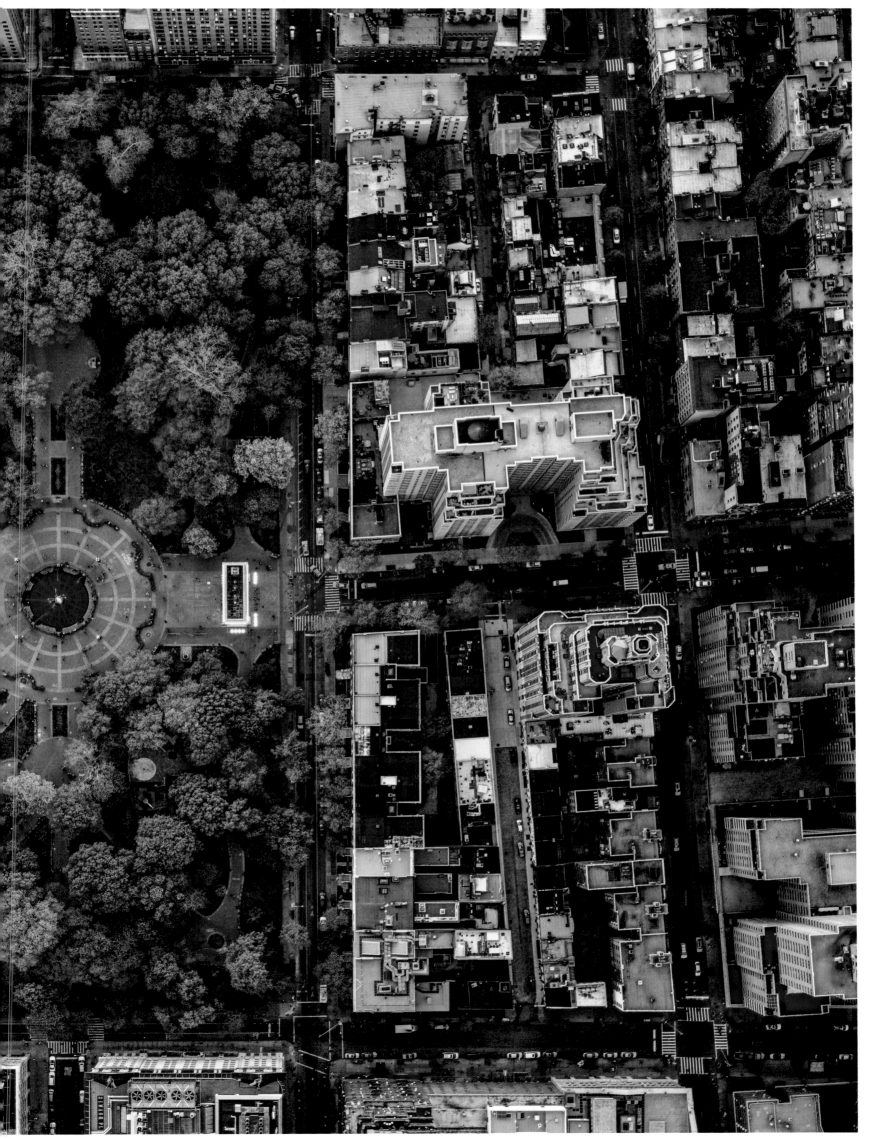

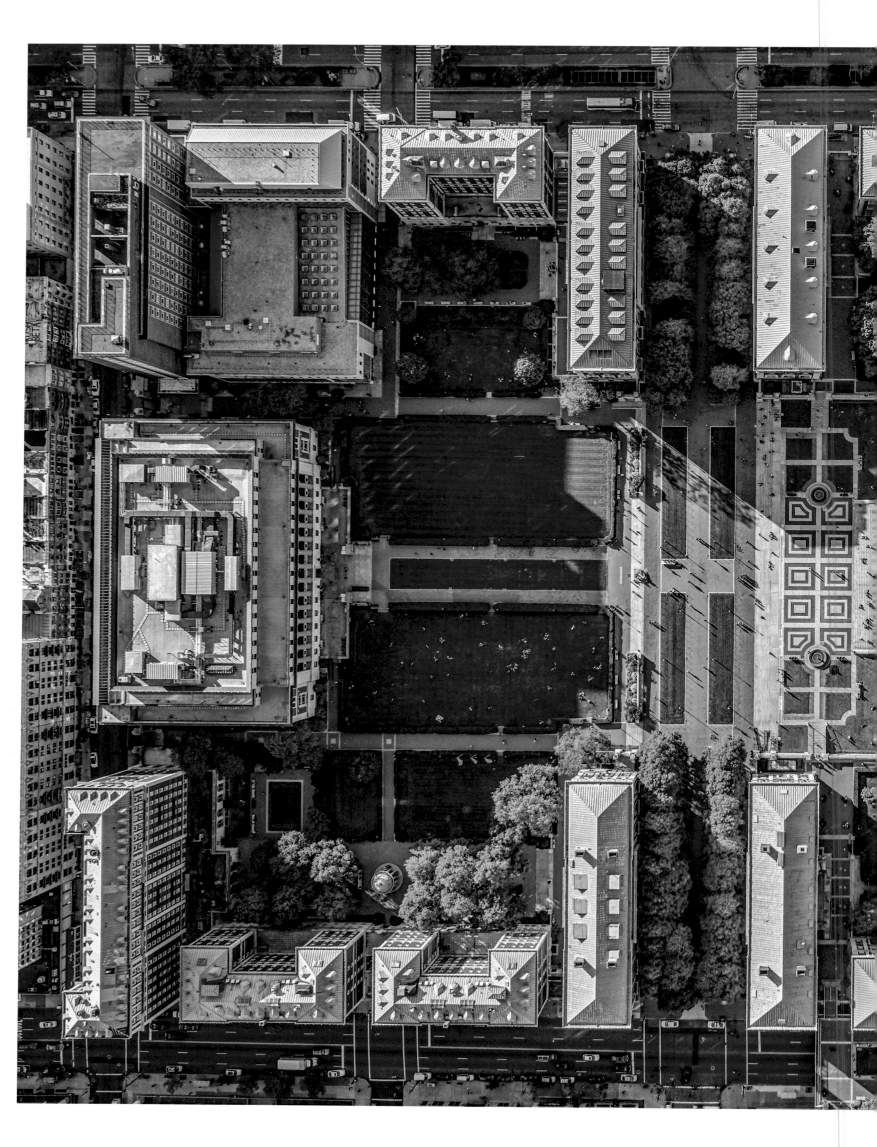

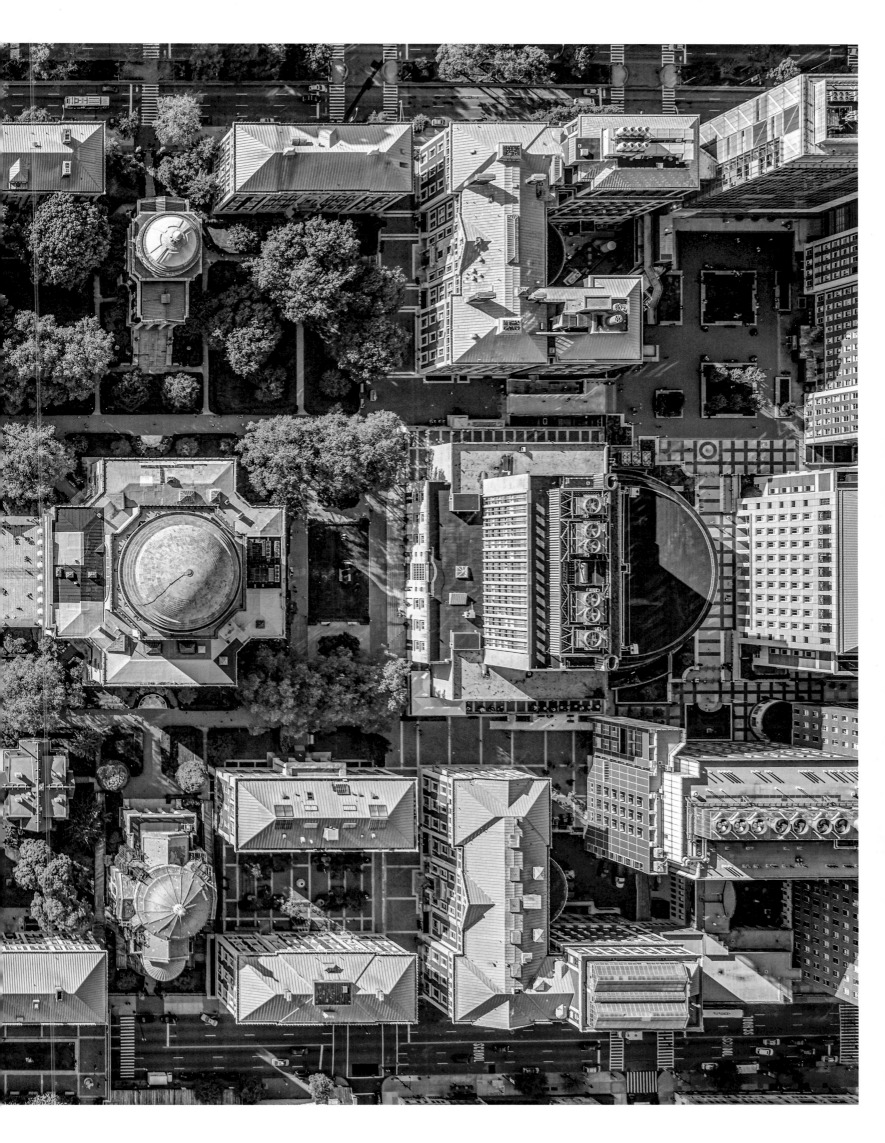

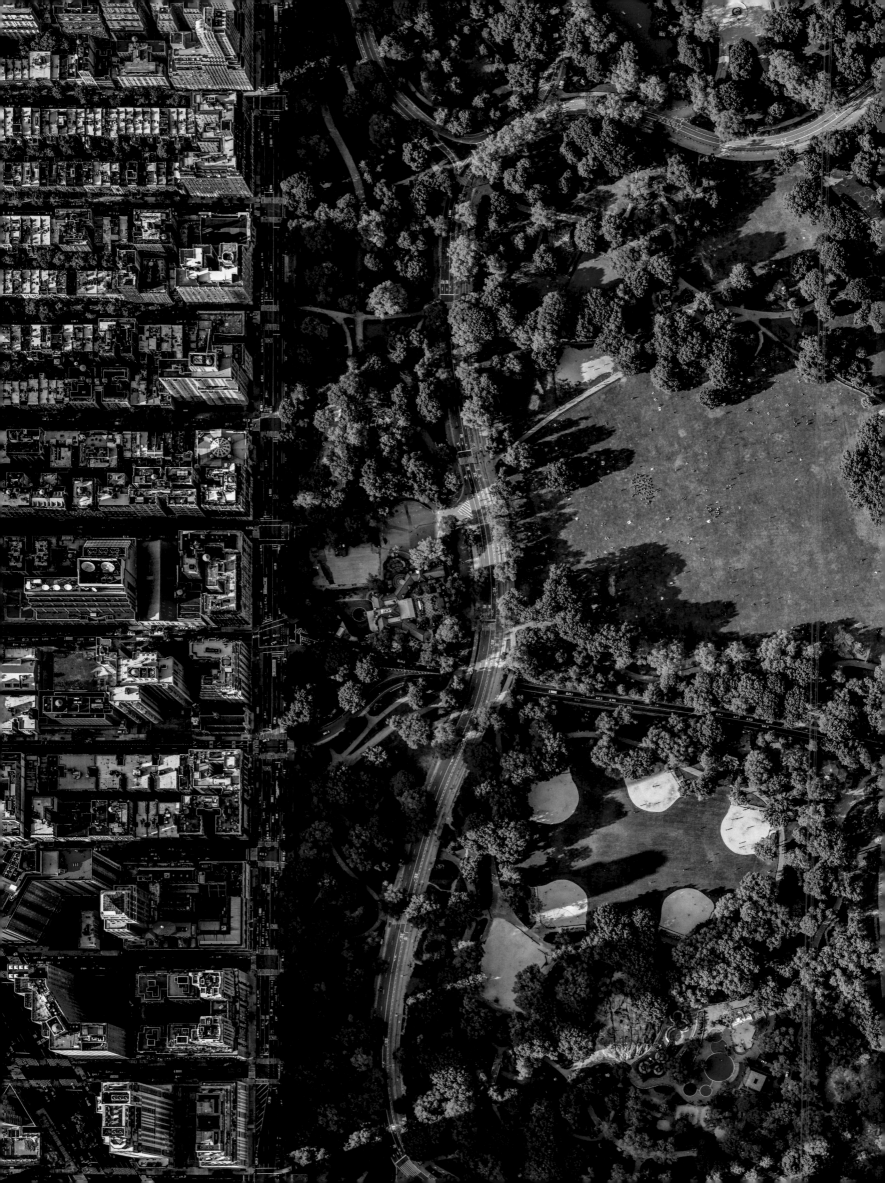

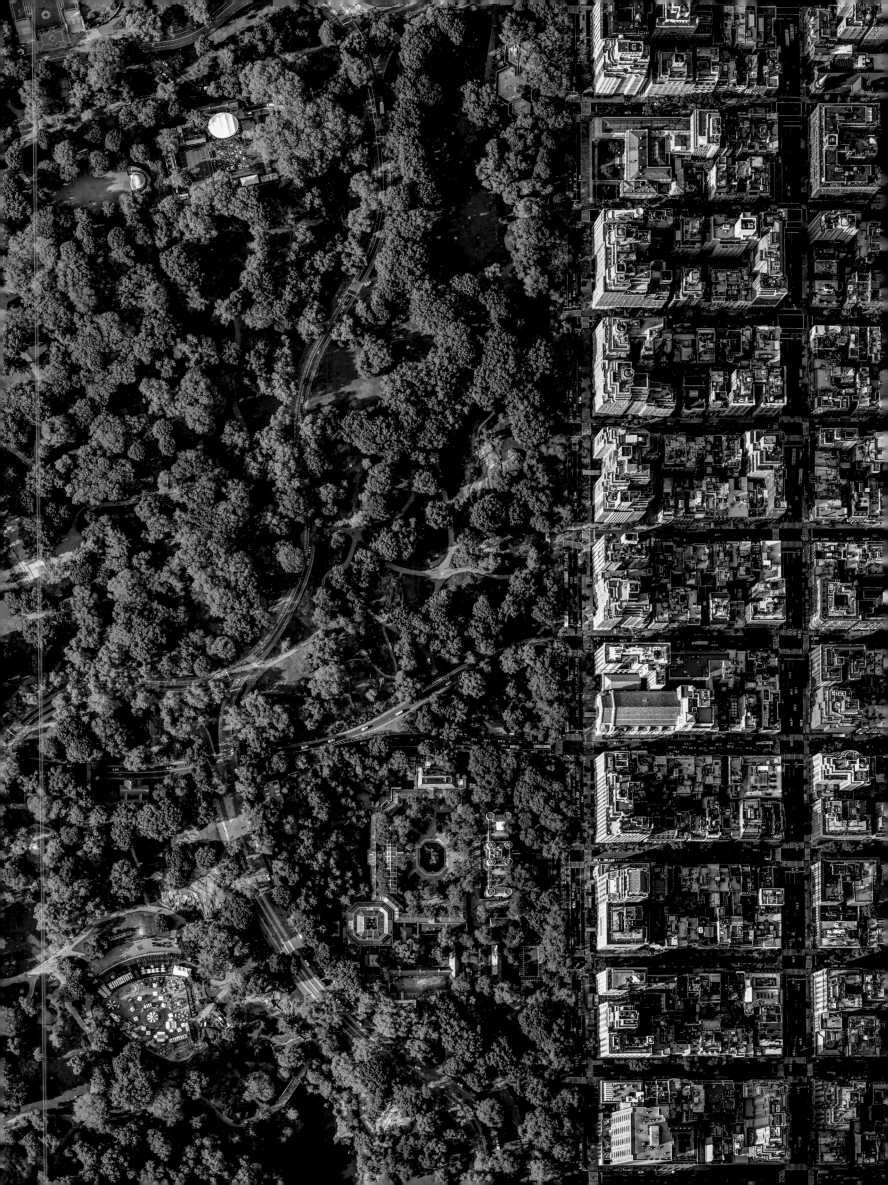

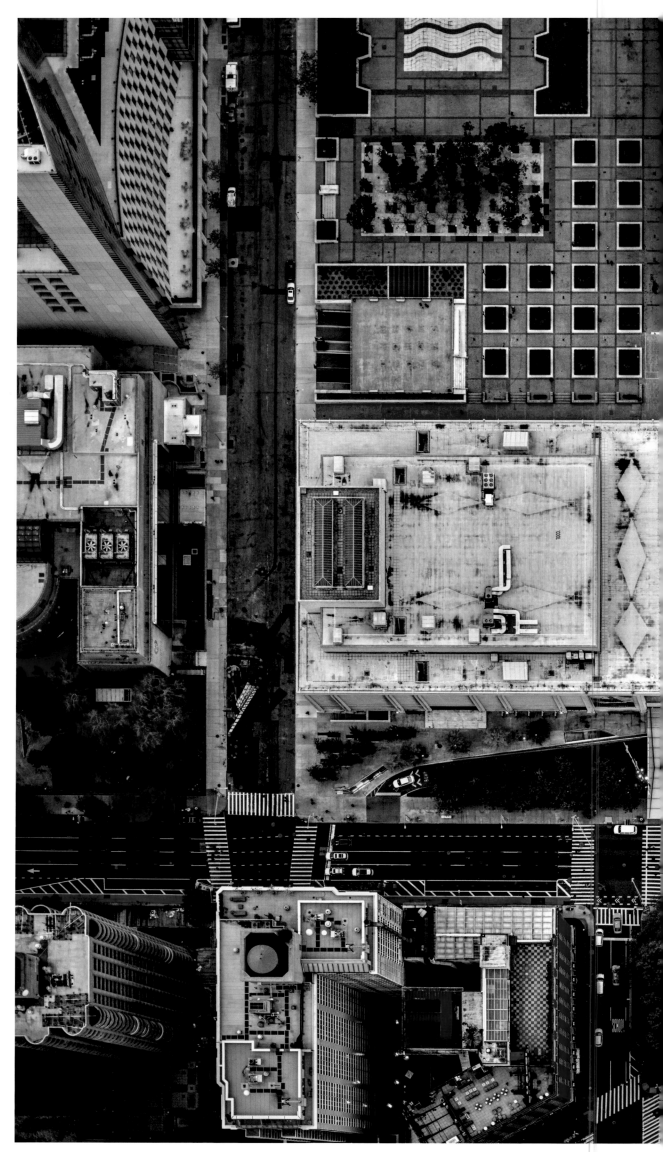

Lincoln Center for the Performing Arts,
NY

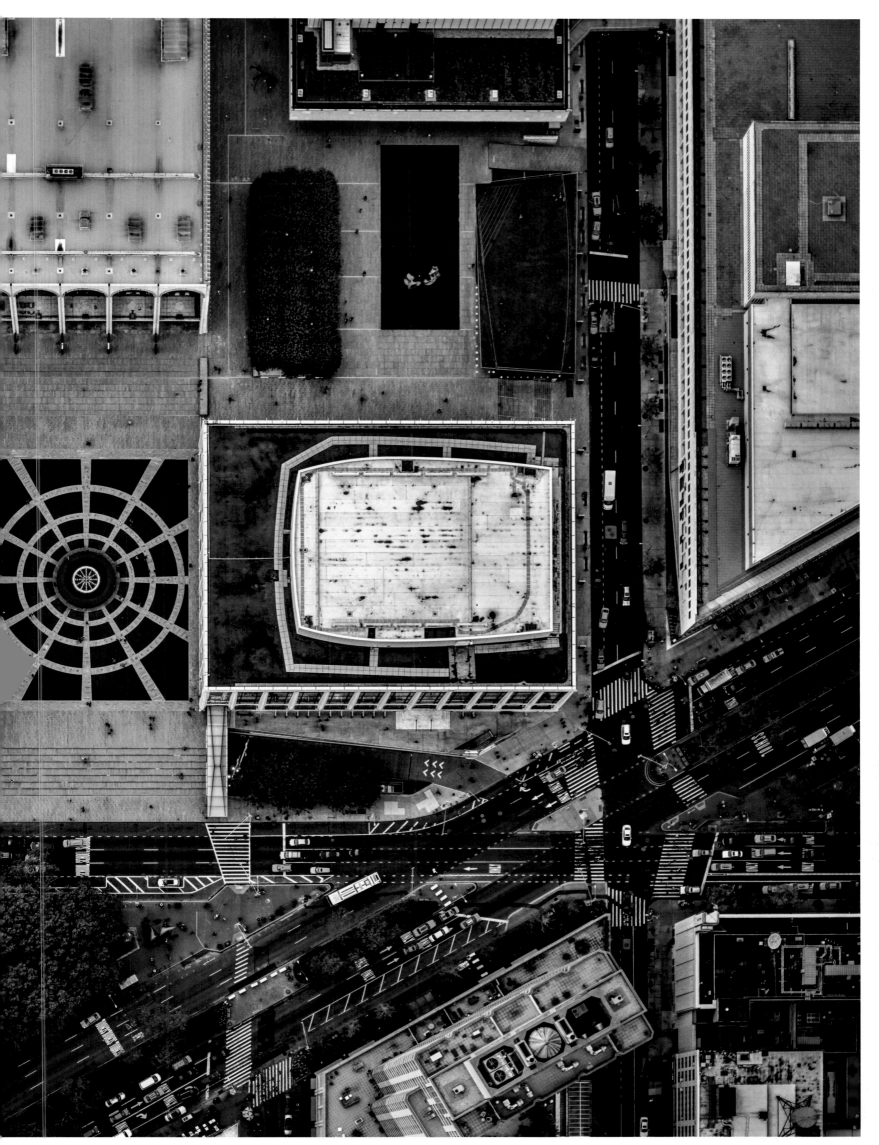

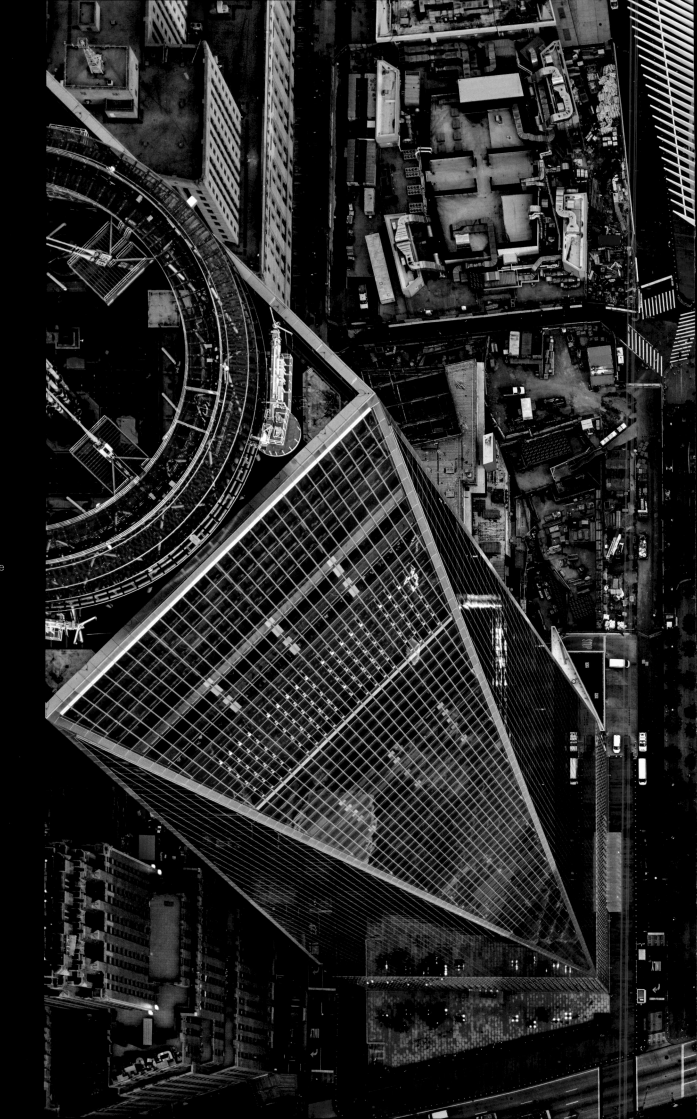

9/11 Memorial and One World Trade
Center, NY

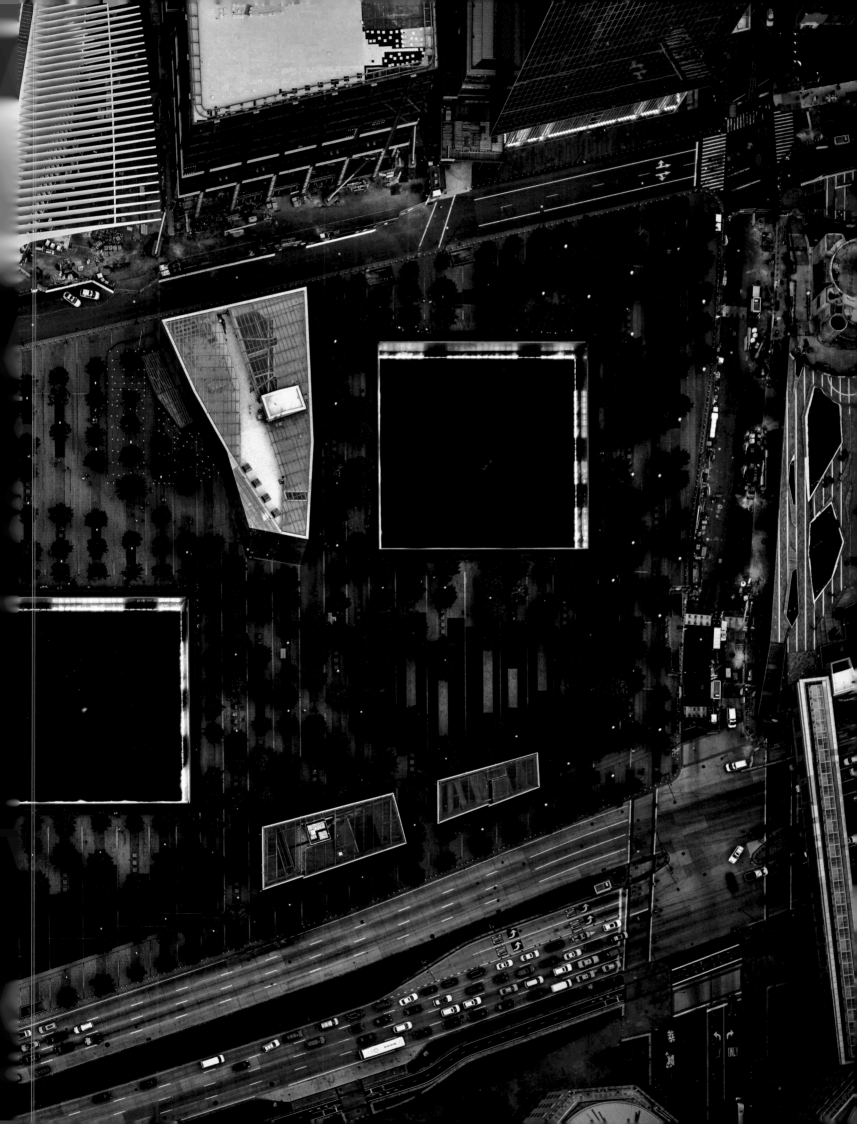

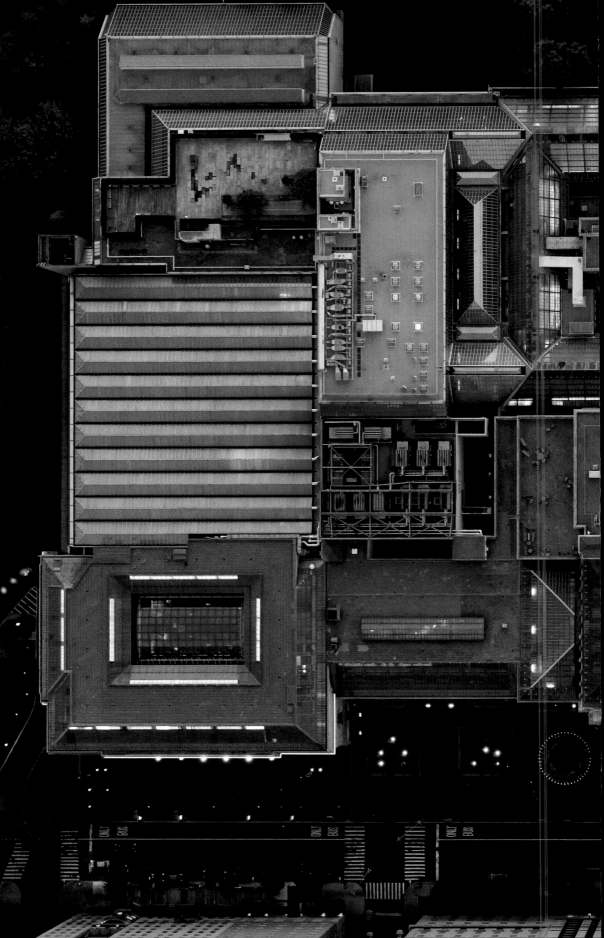

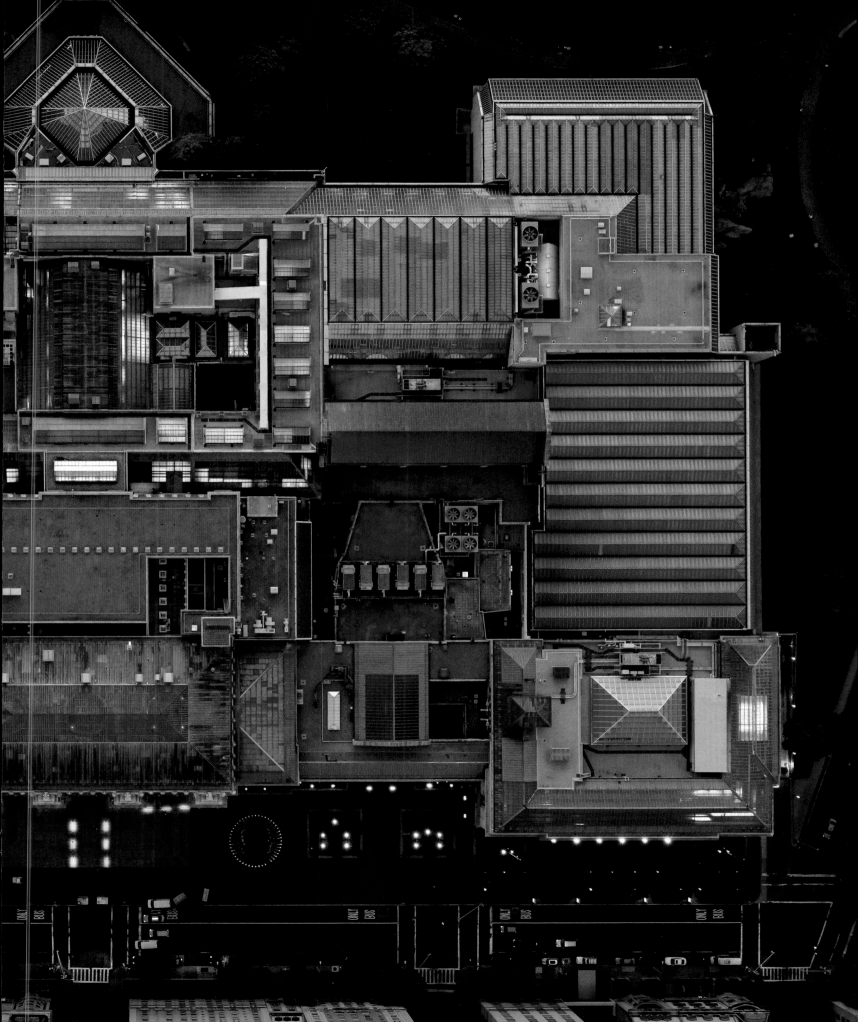

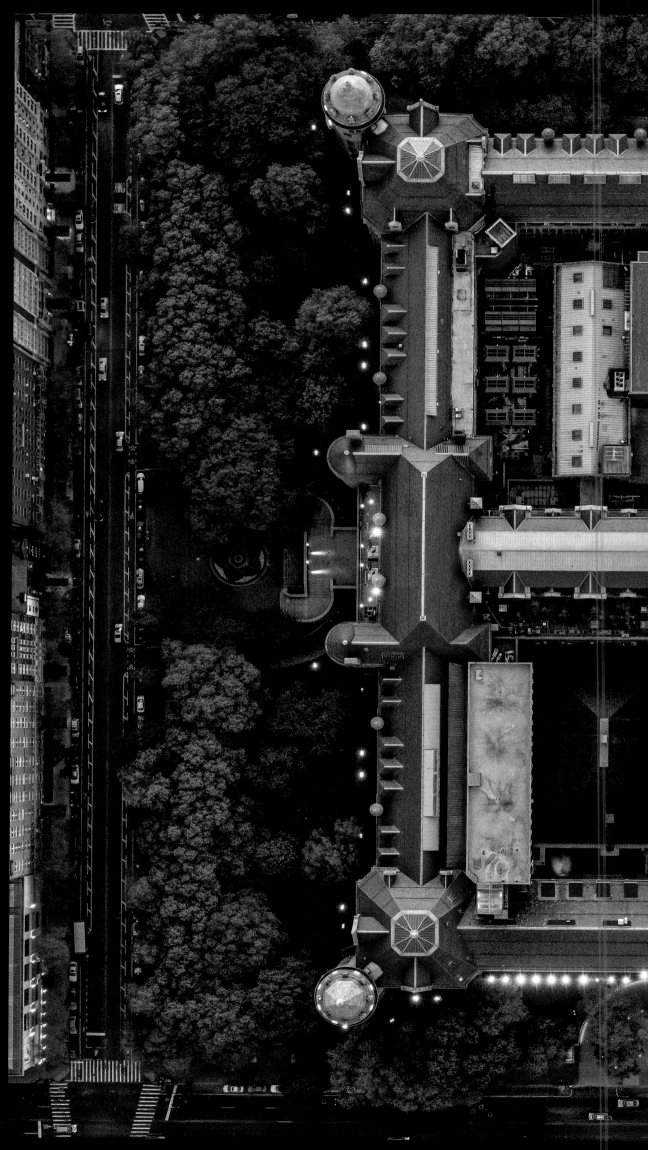

American Museum of Natural History, NY

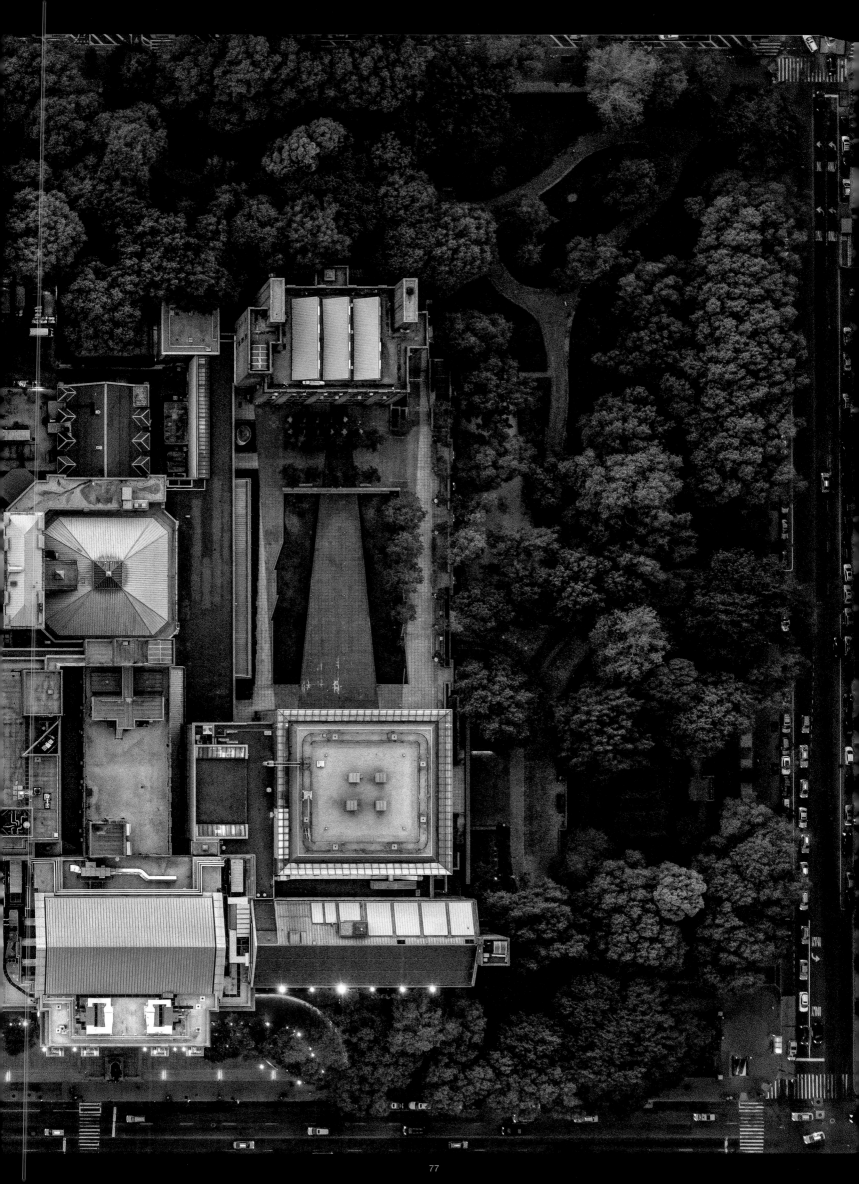

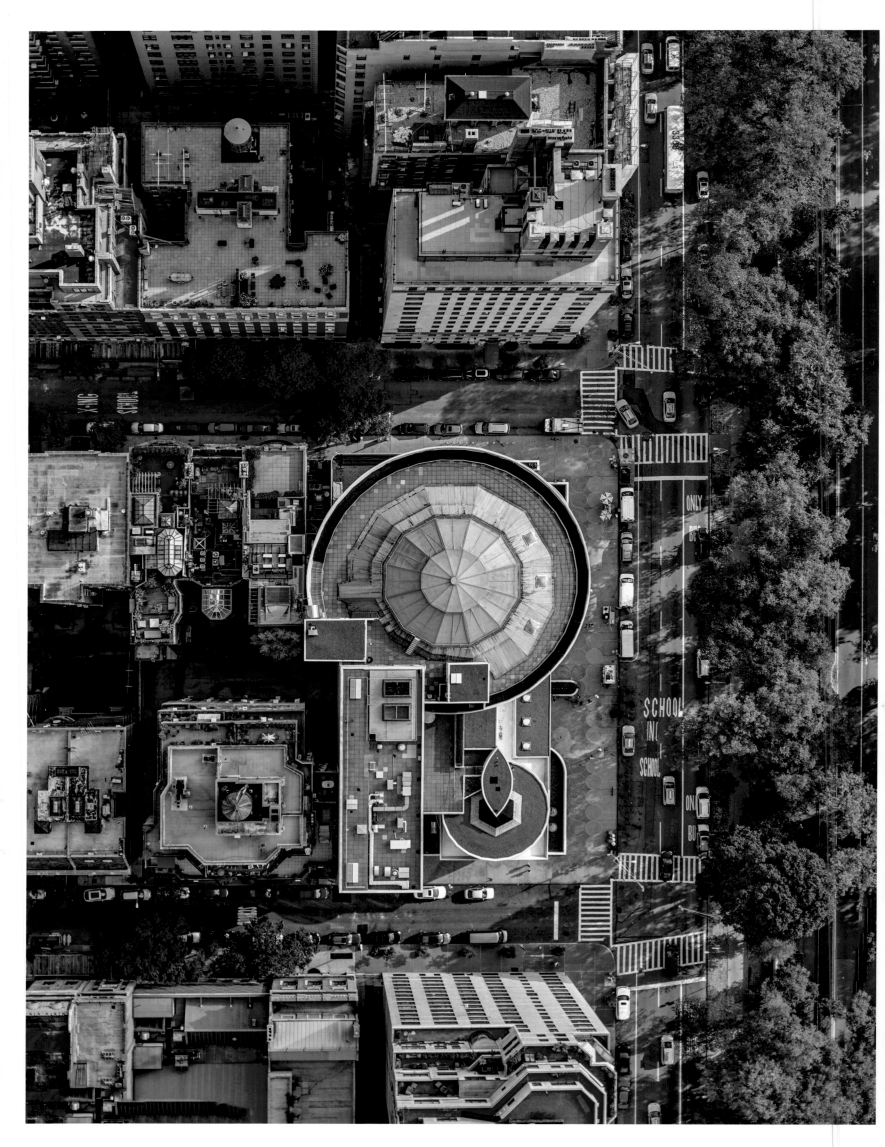

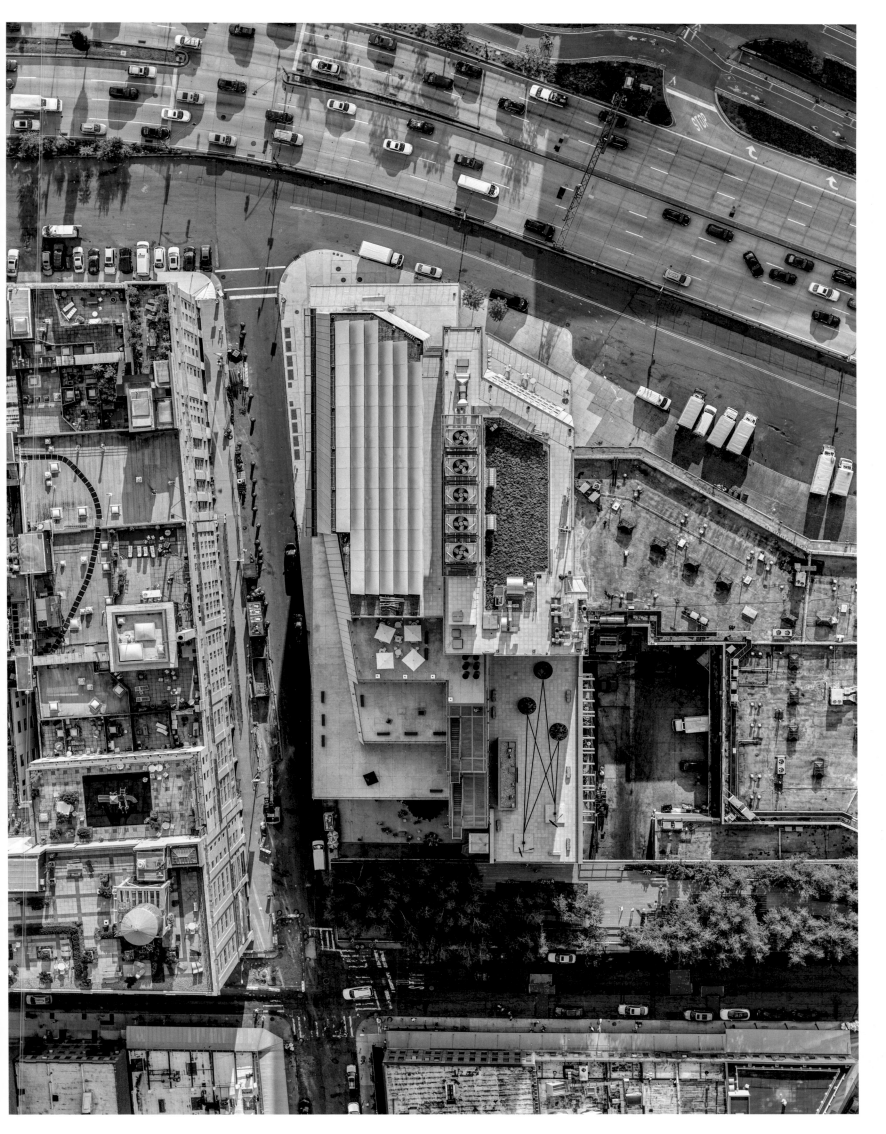

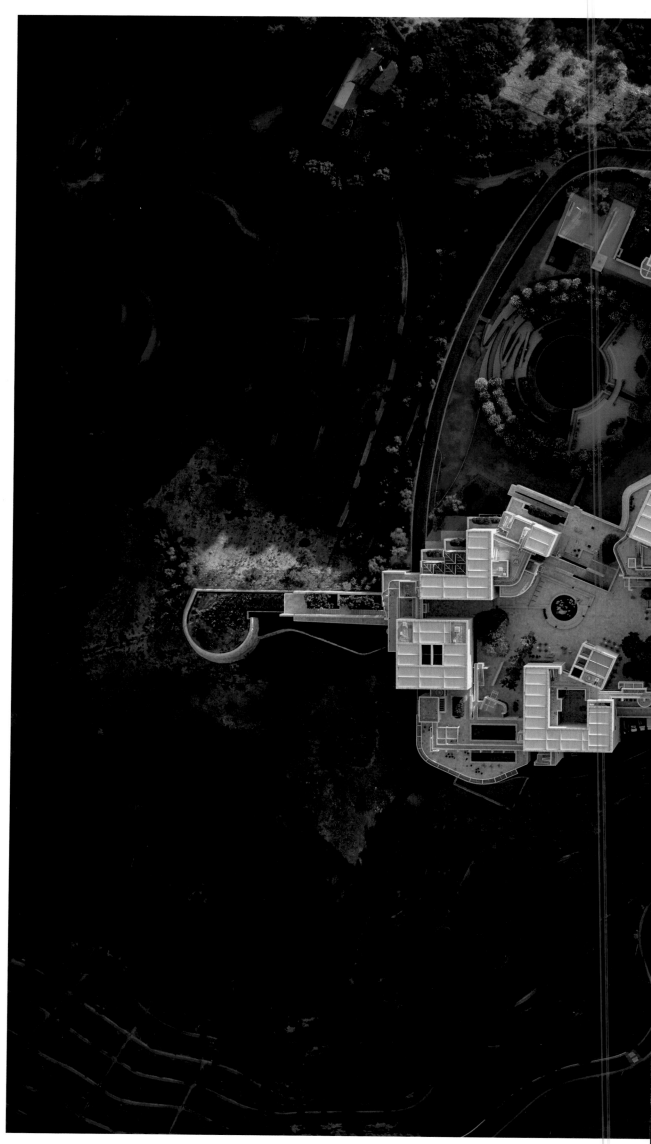

The Getty Center, LA

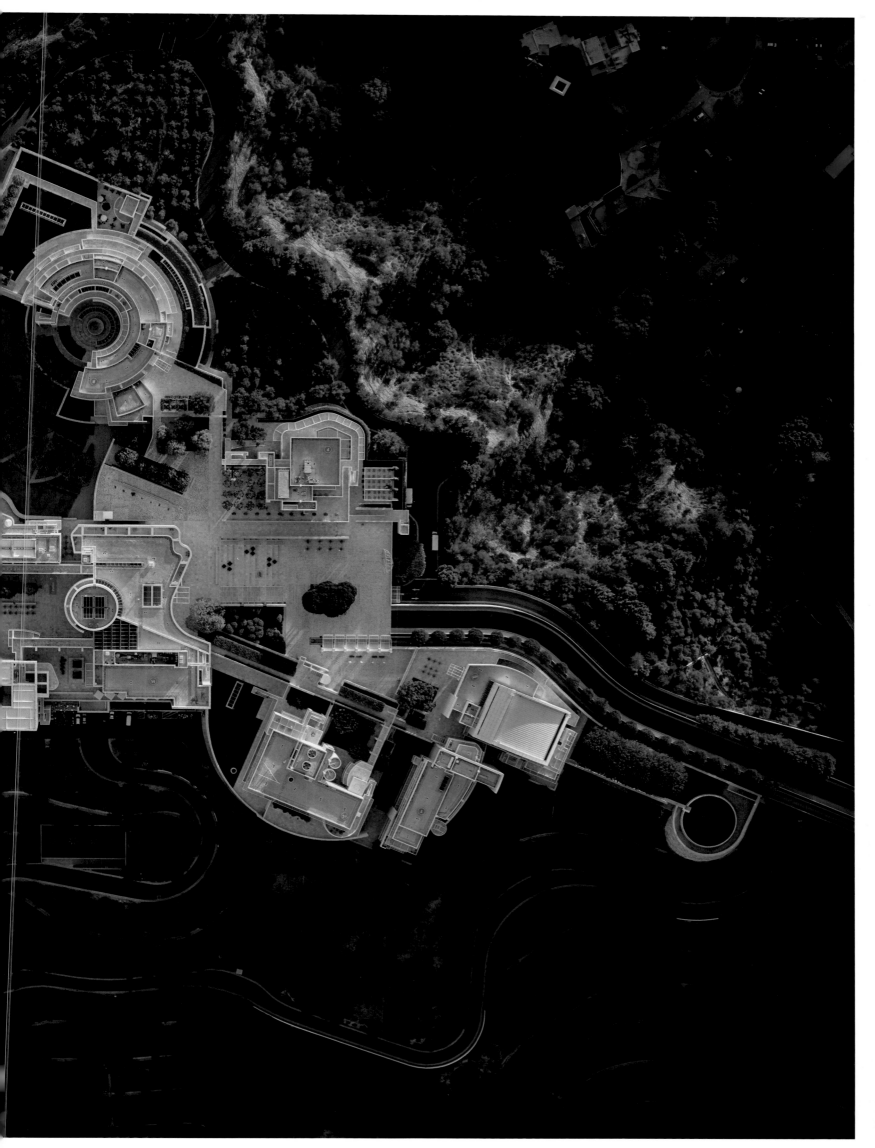

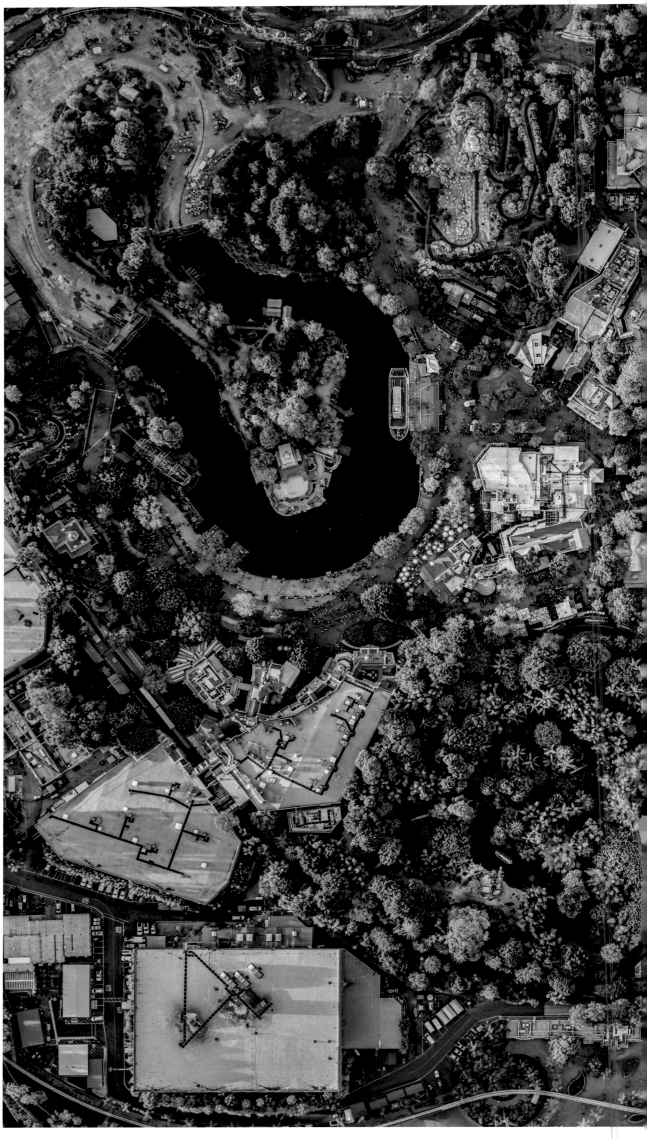

Disneyland, Anaheim, CA

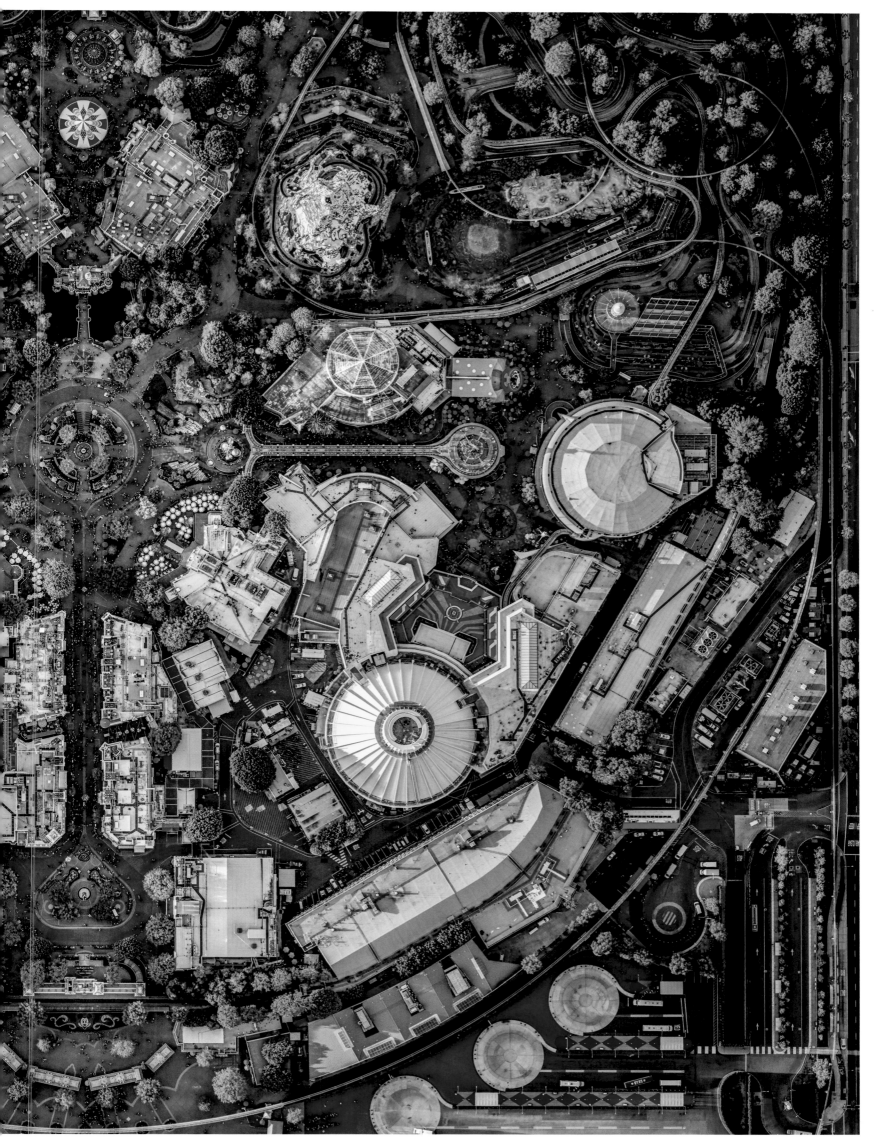

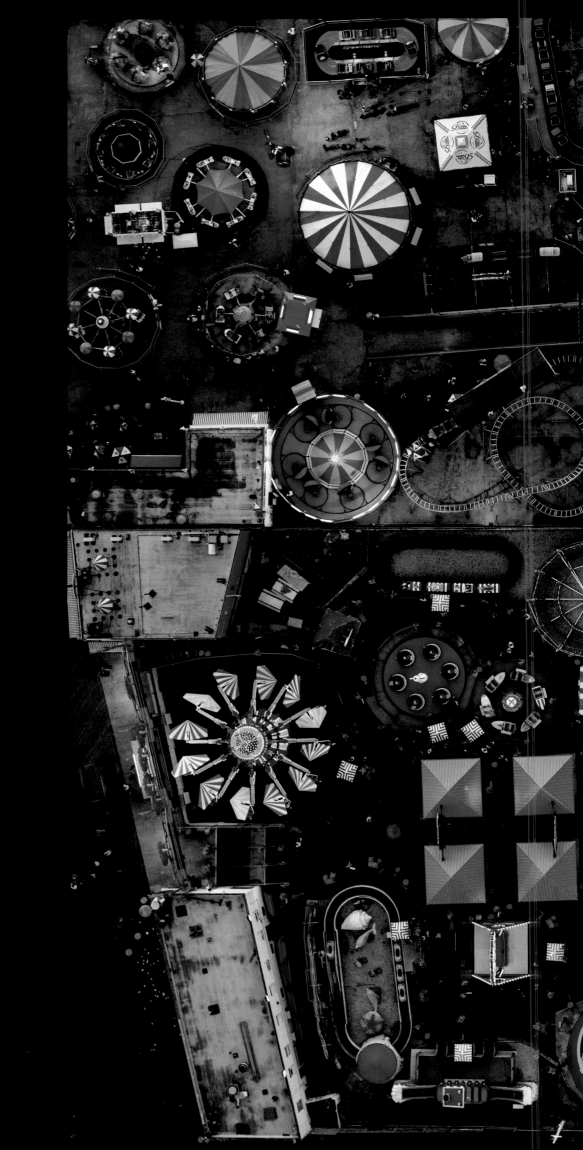

Coney Island, Brooklyn, NY

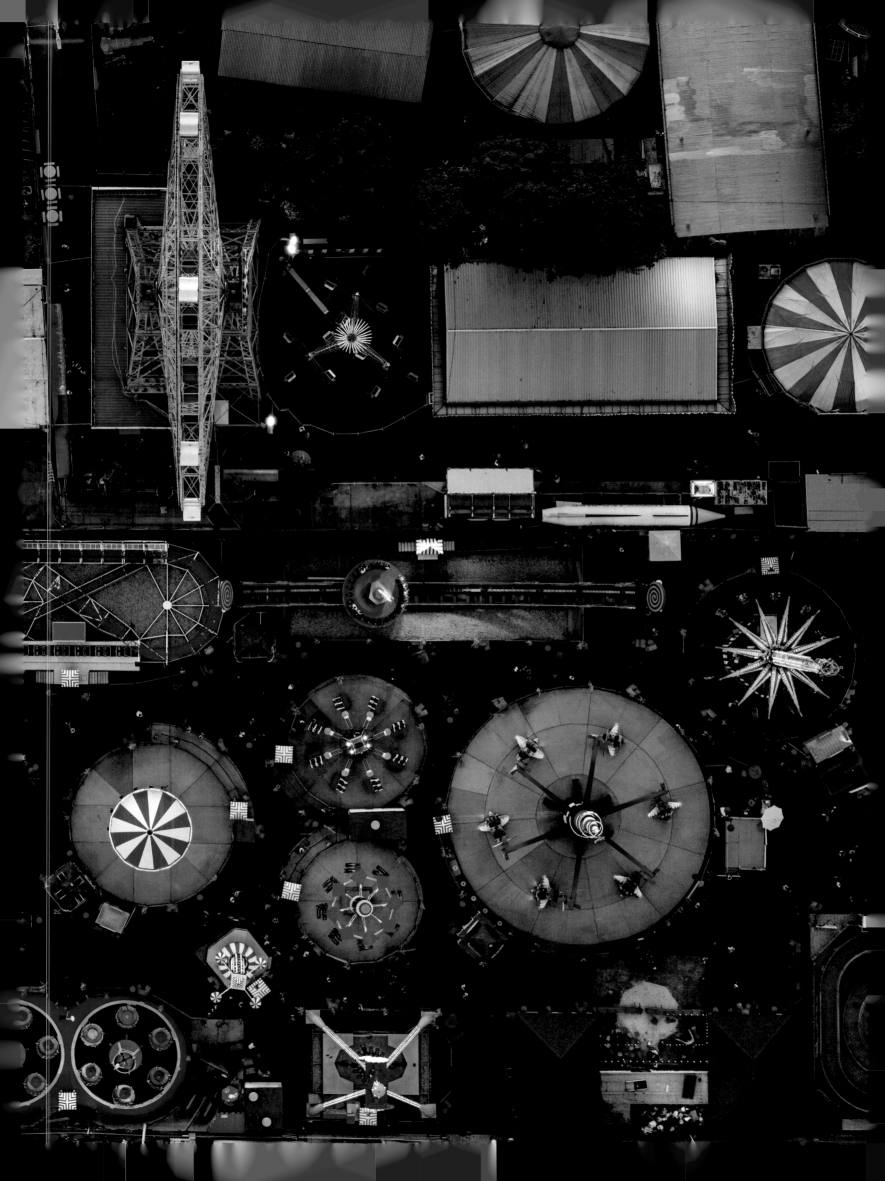

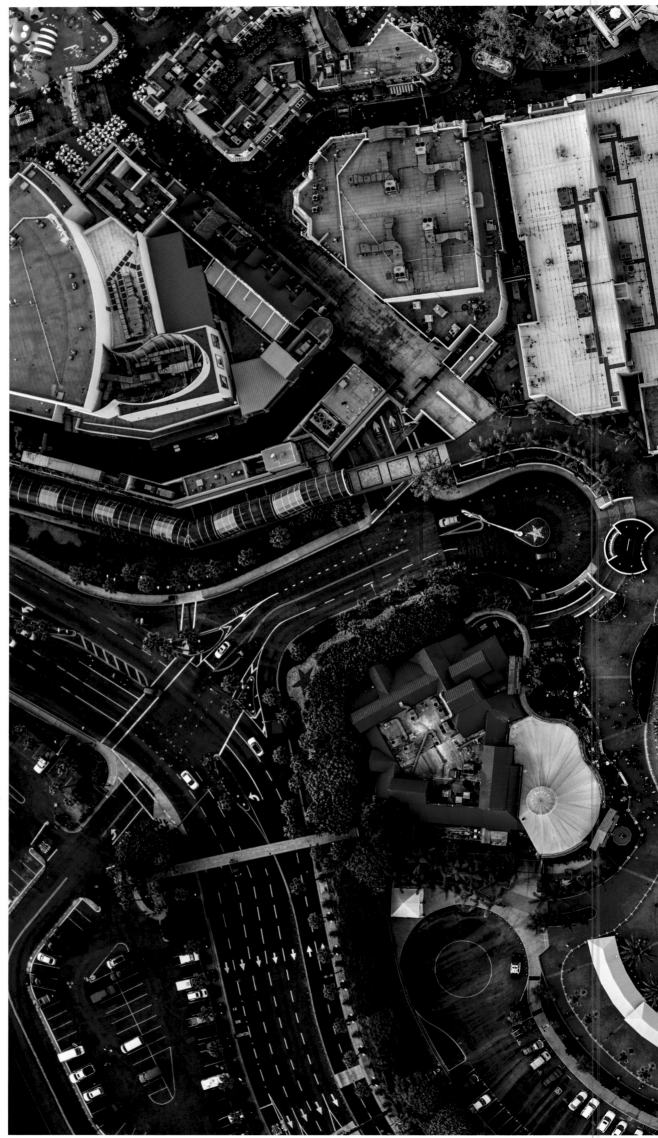

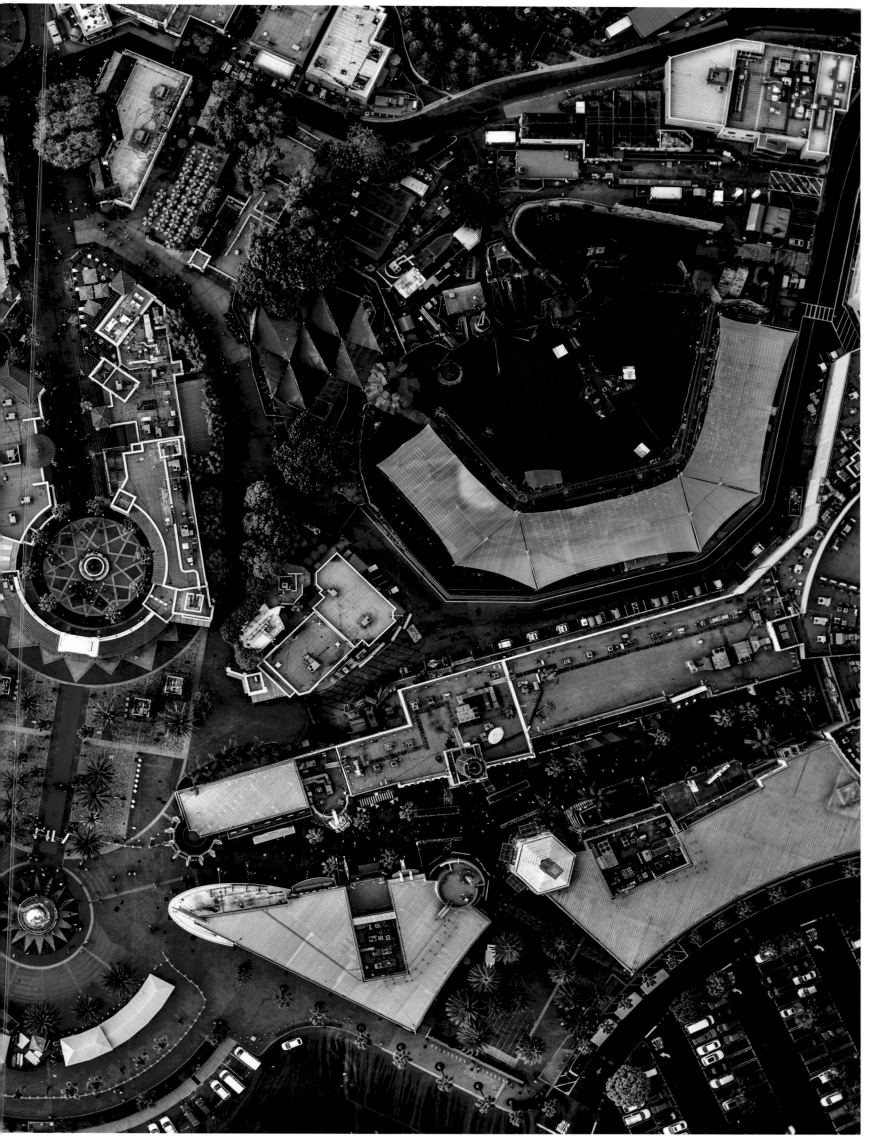

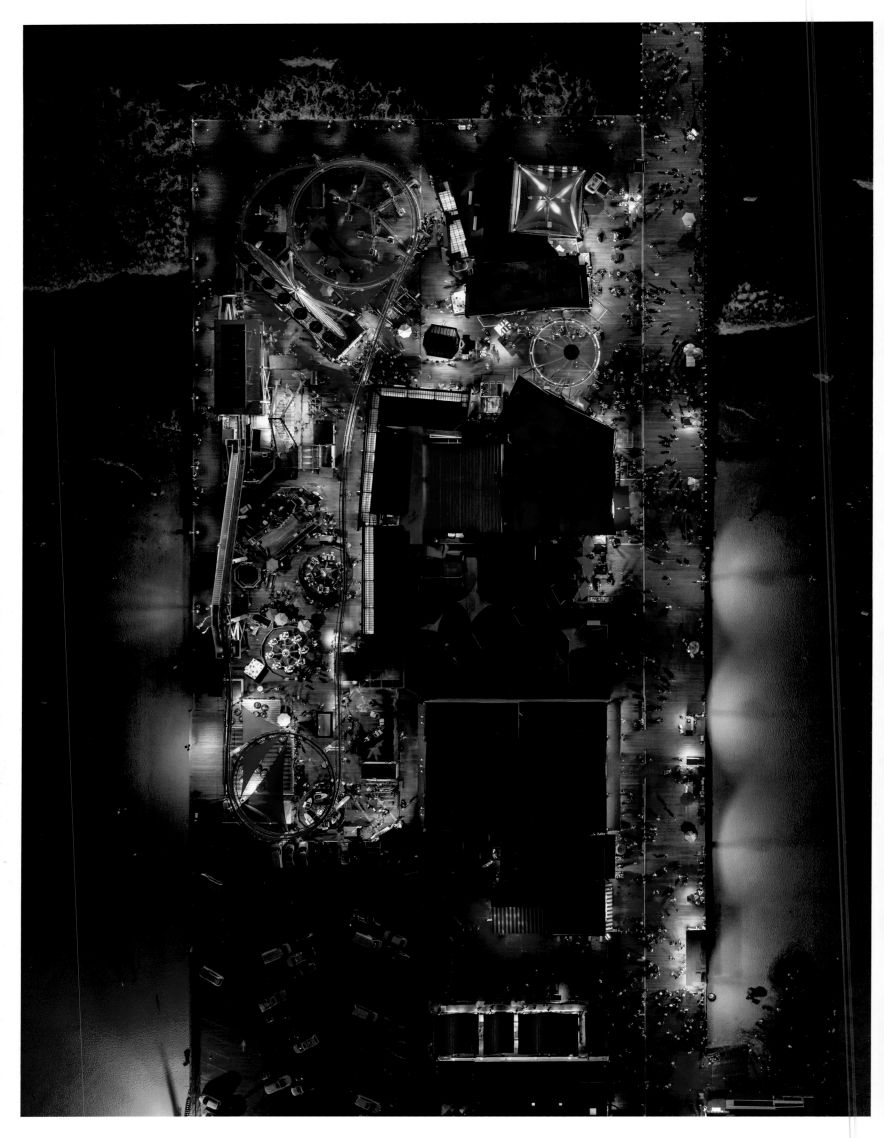

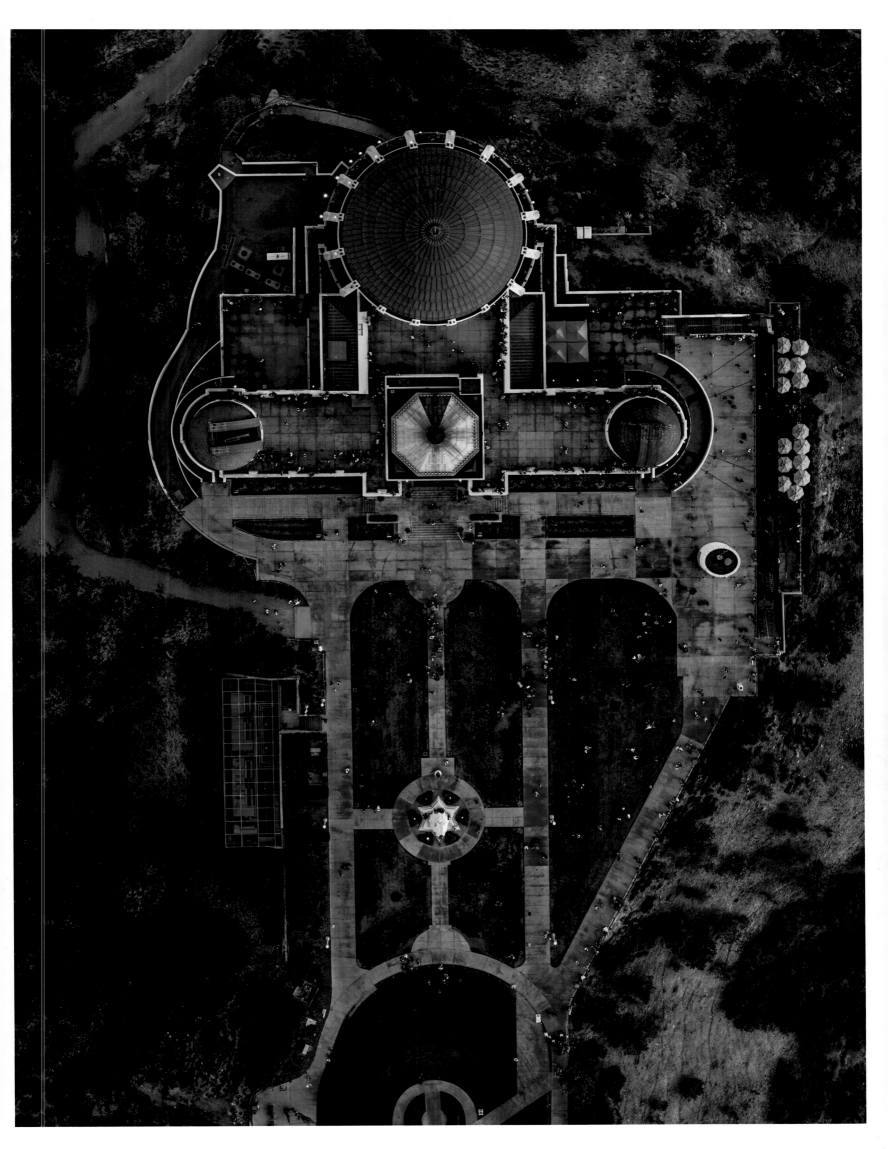

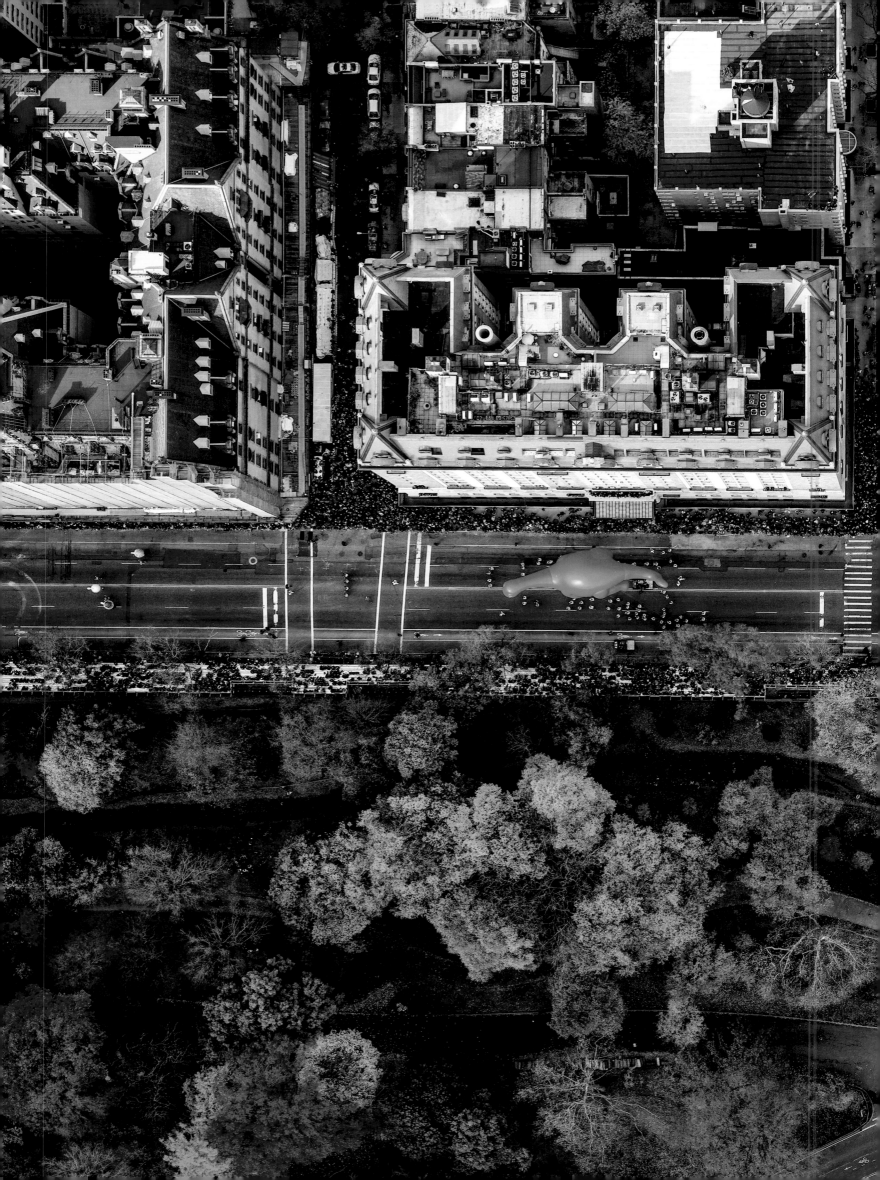

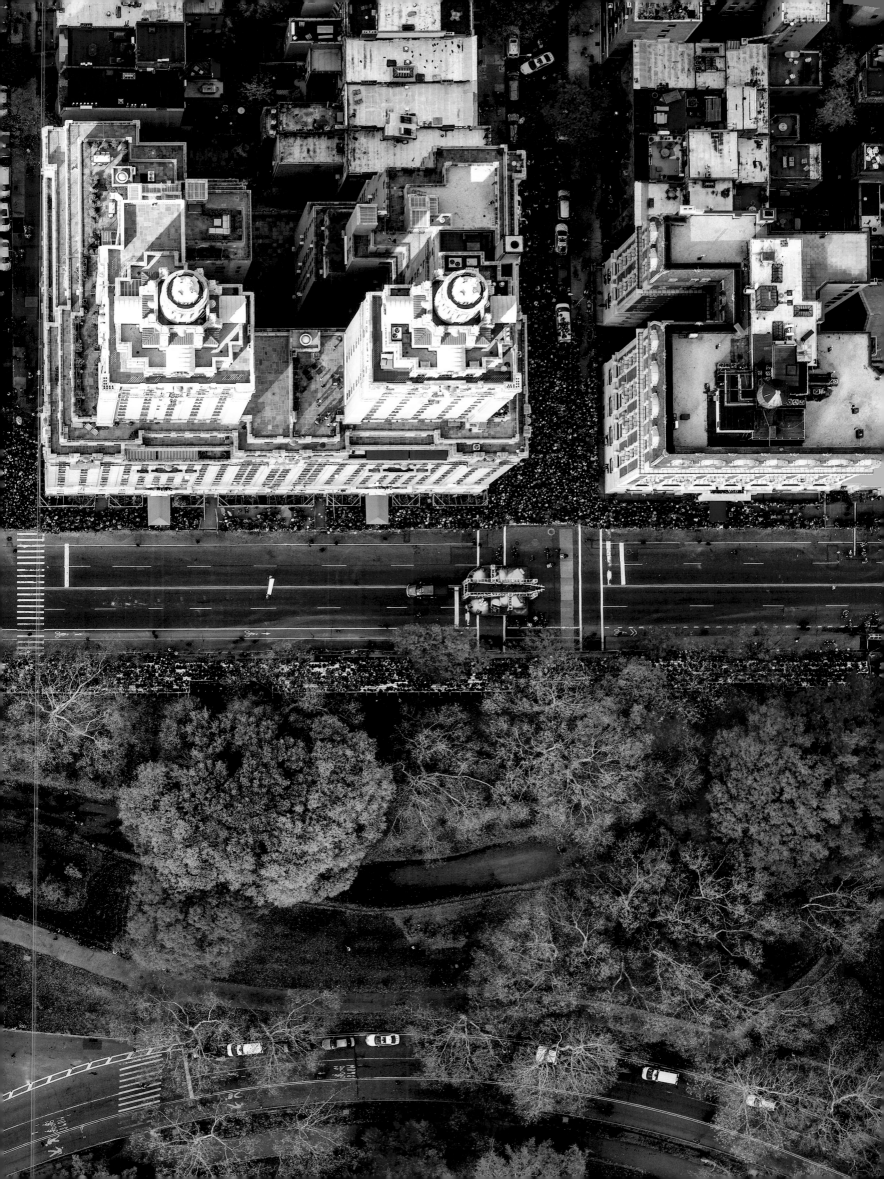

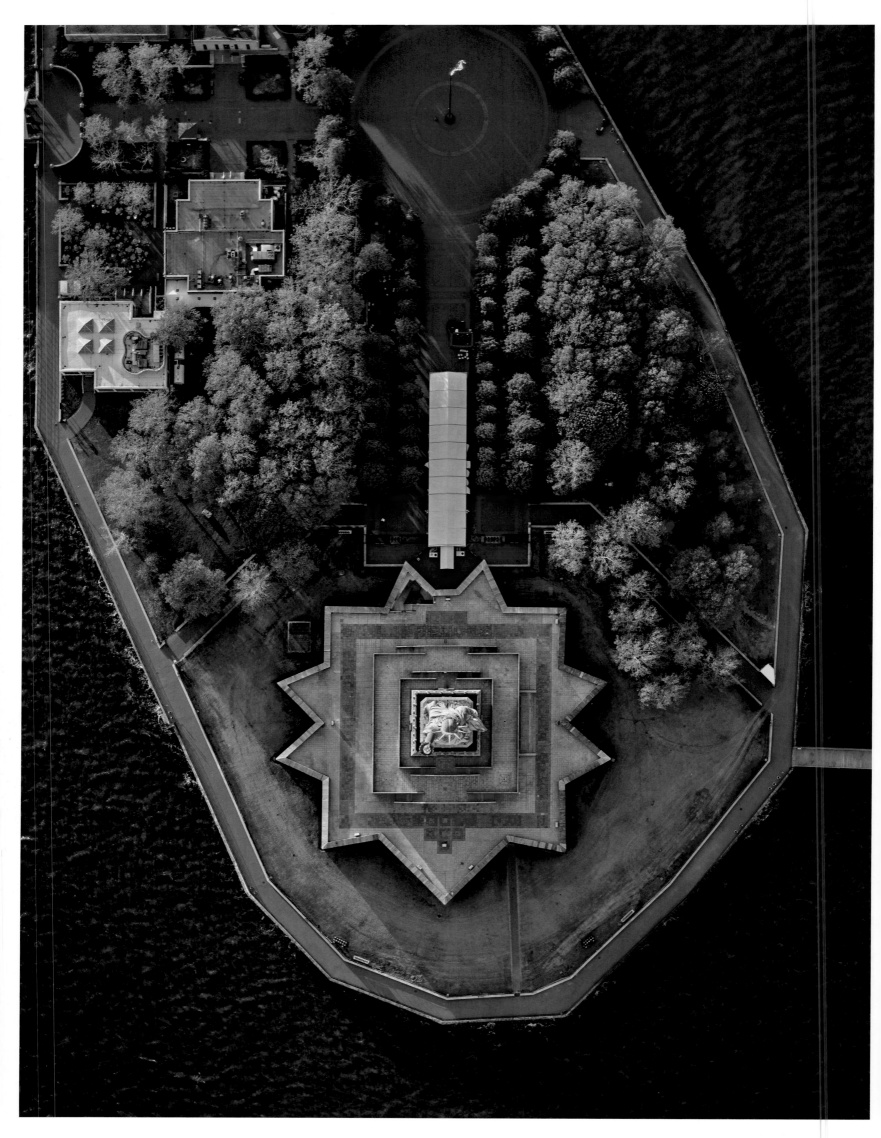

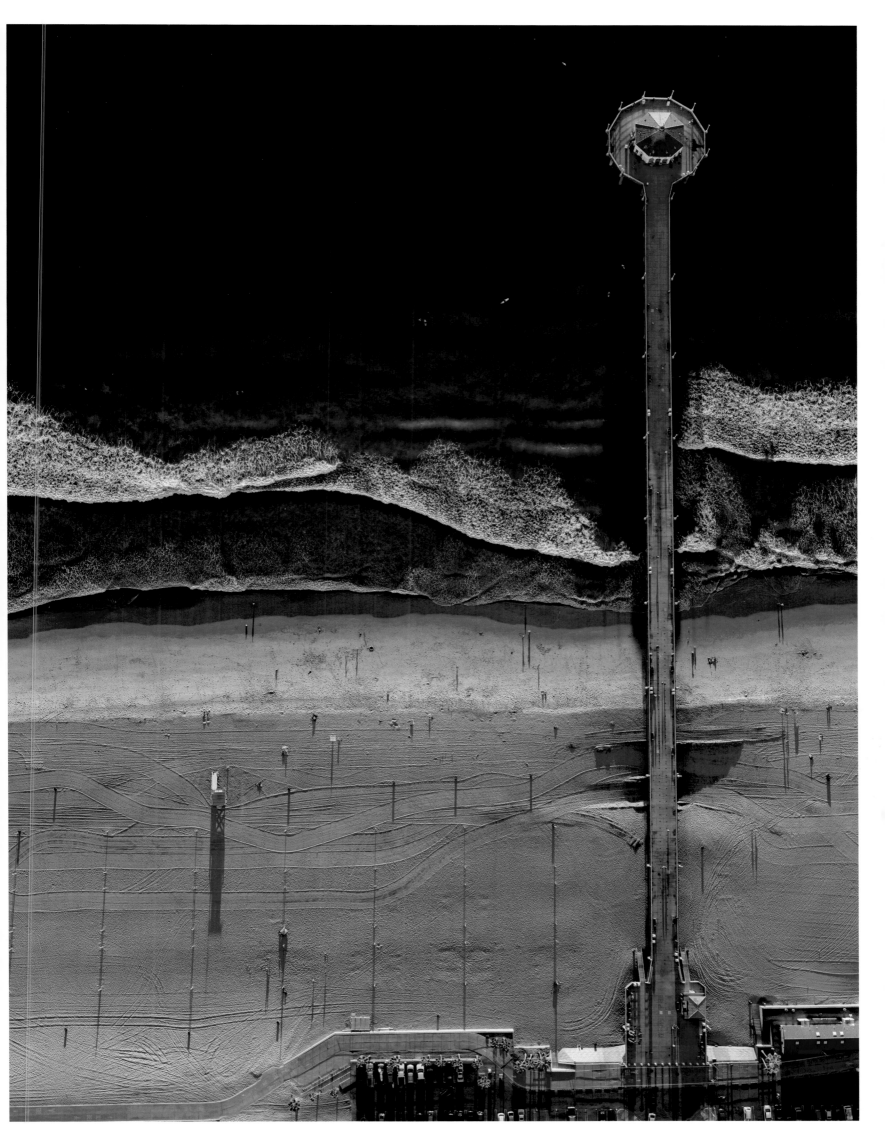

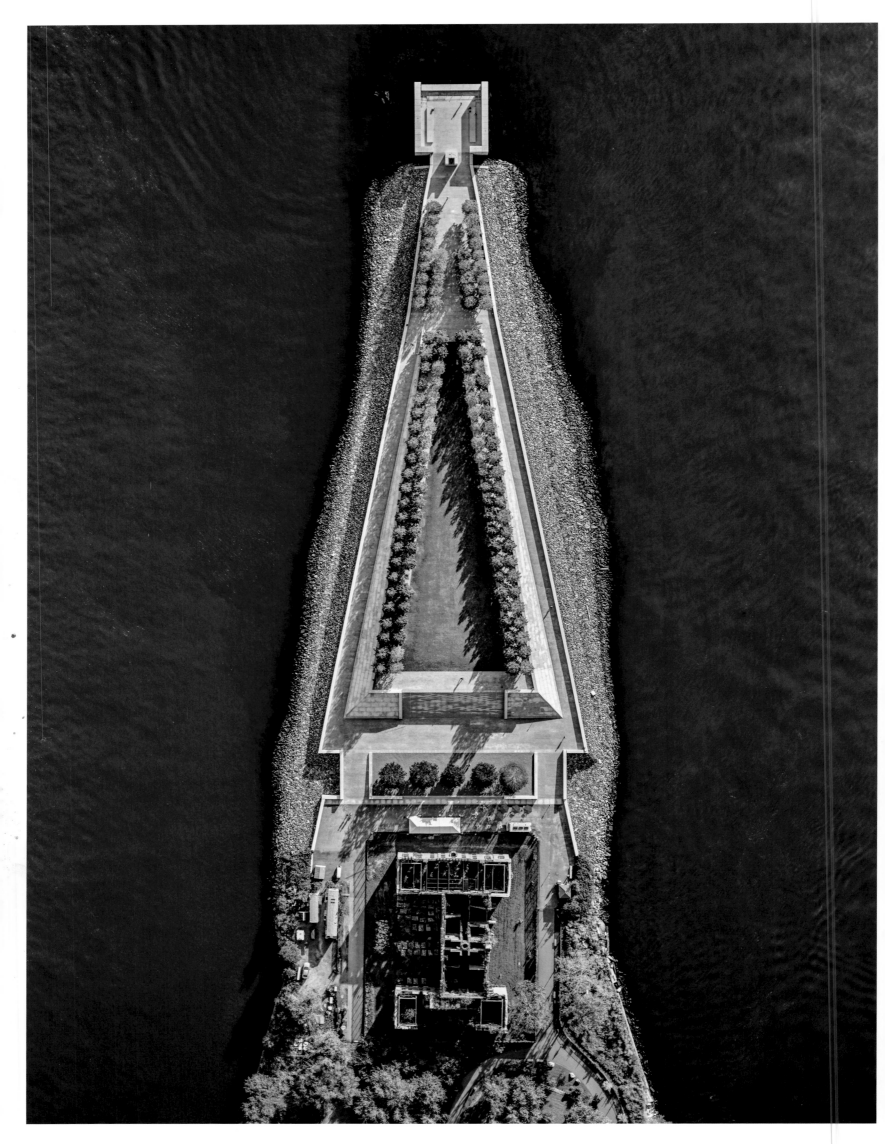

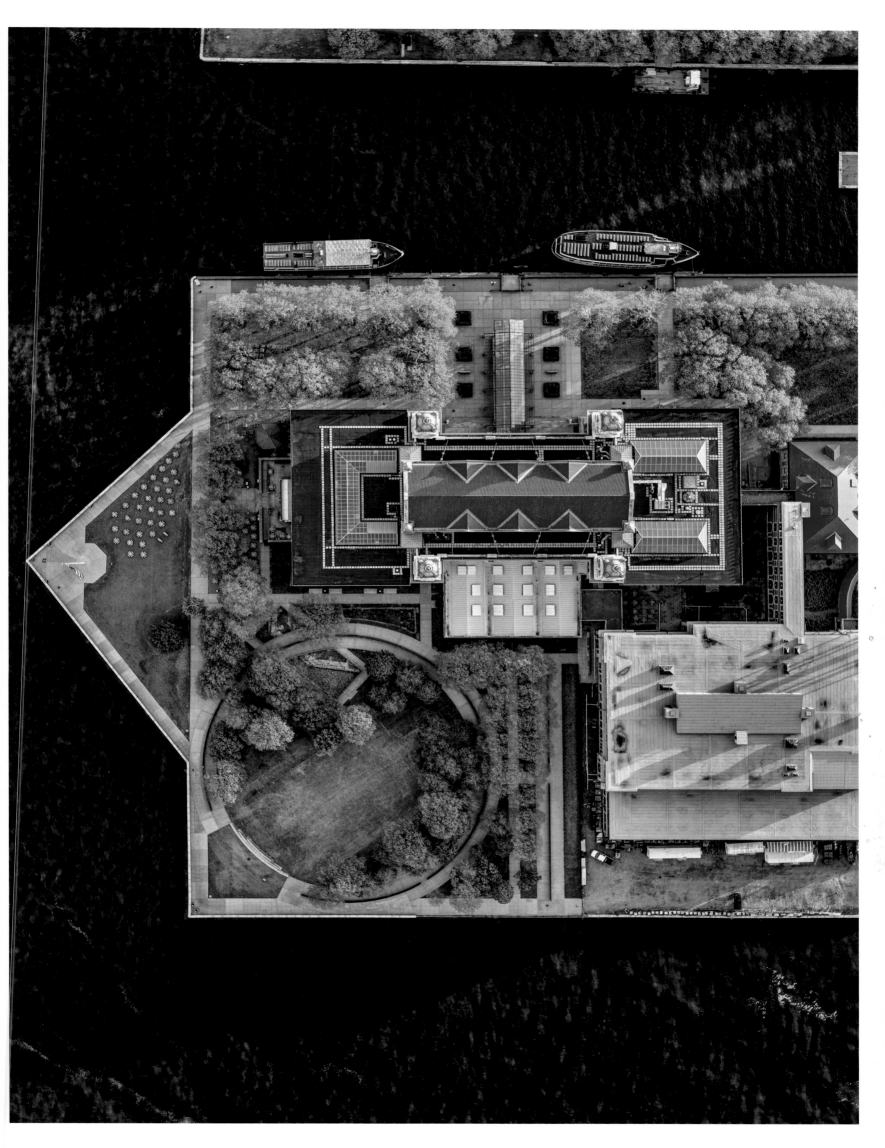

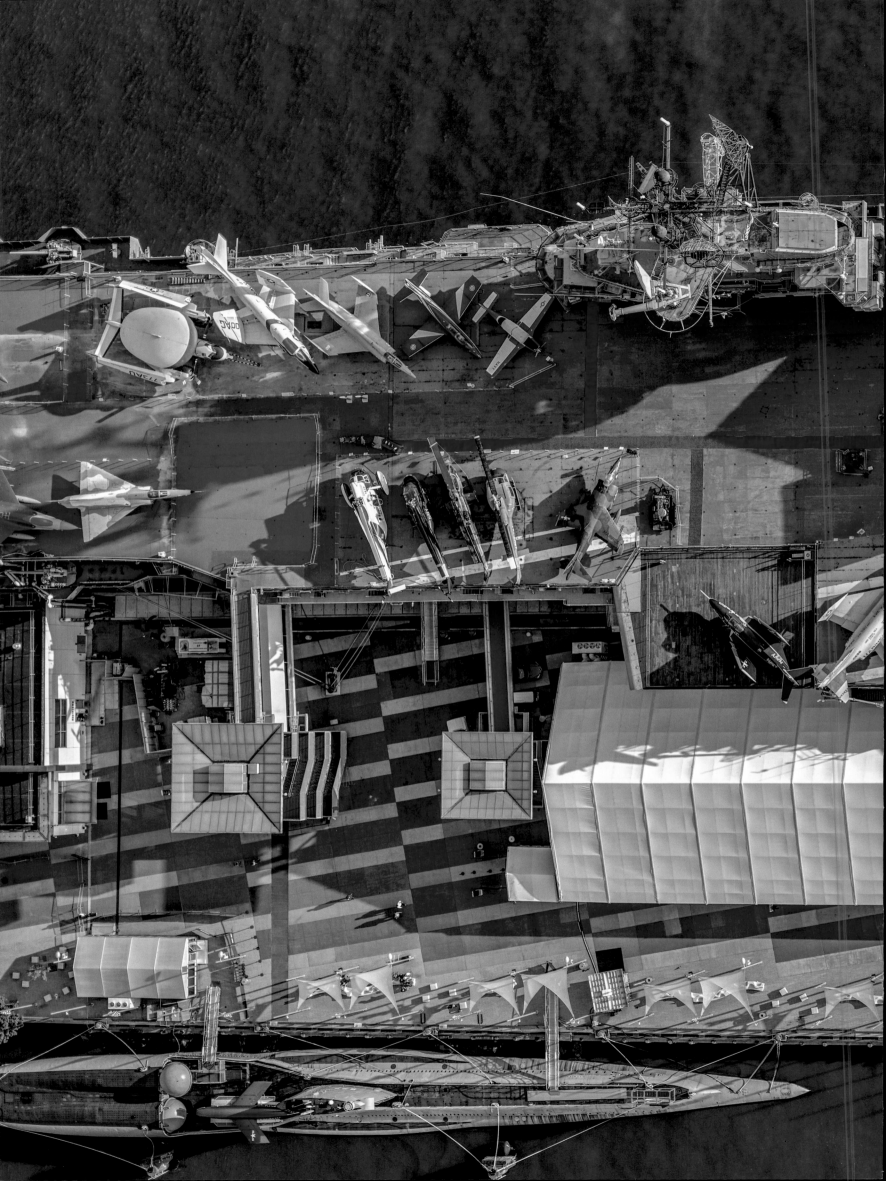

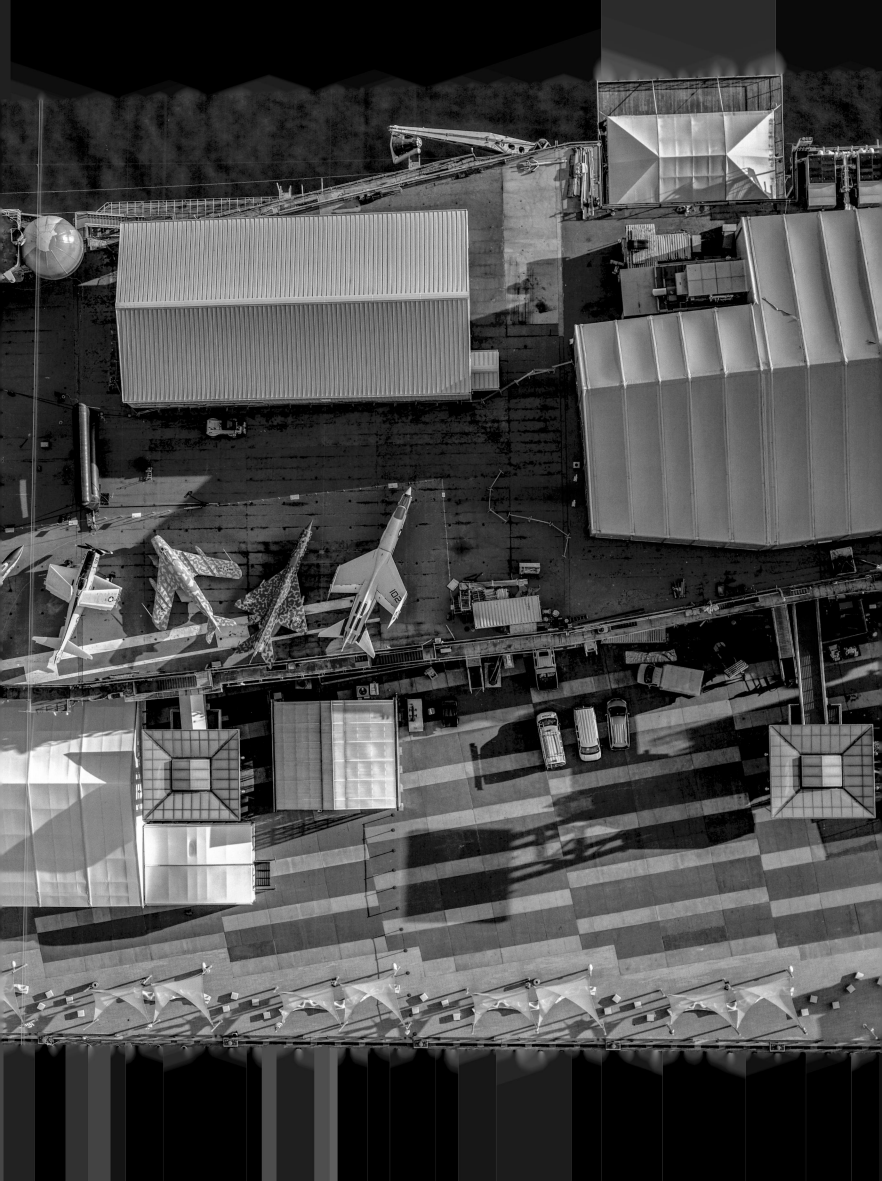

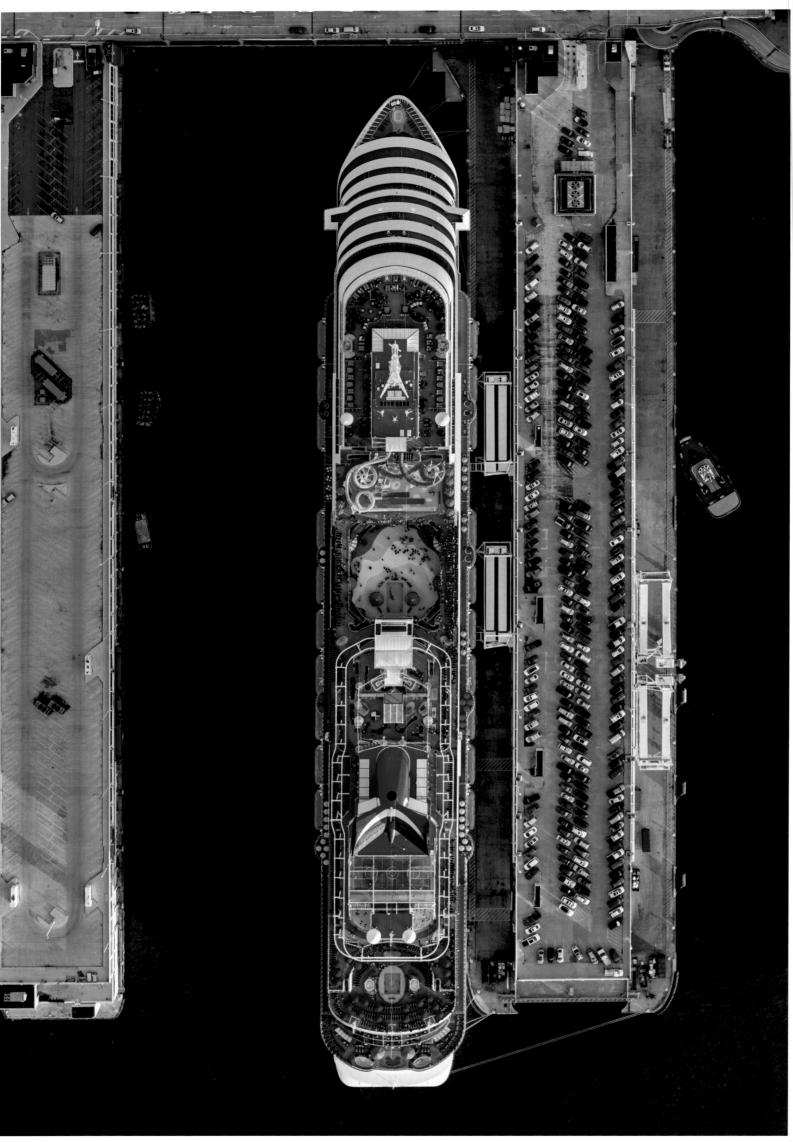

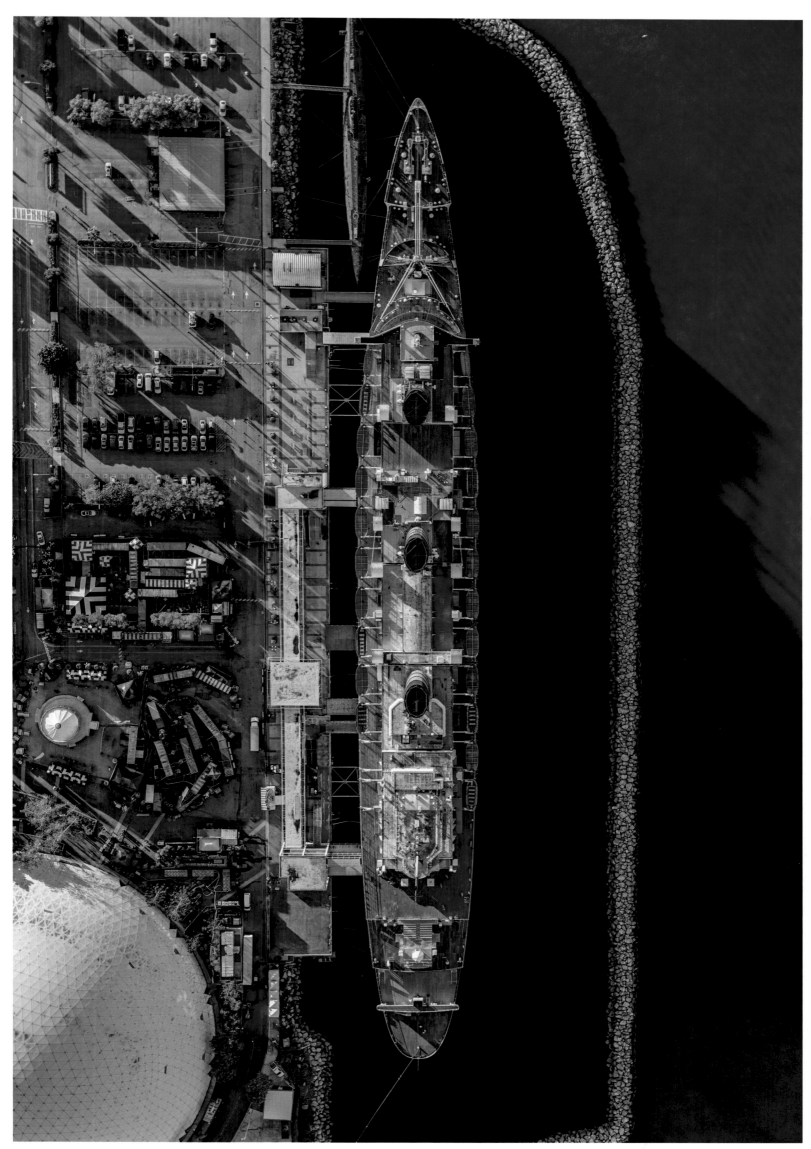

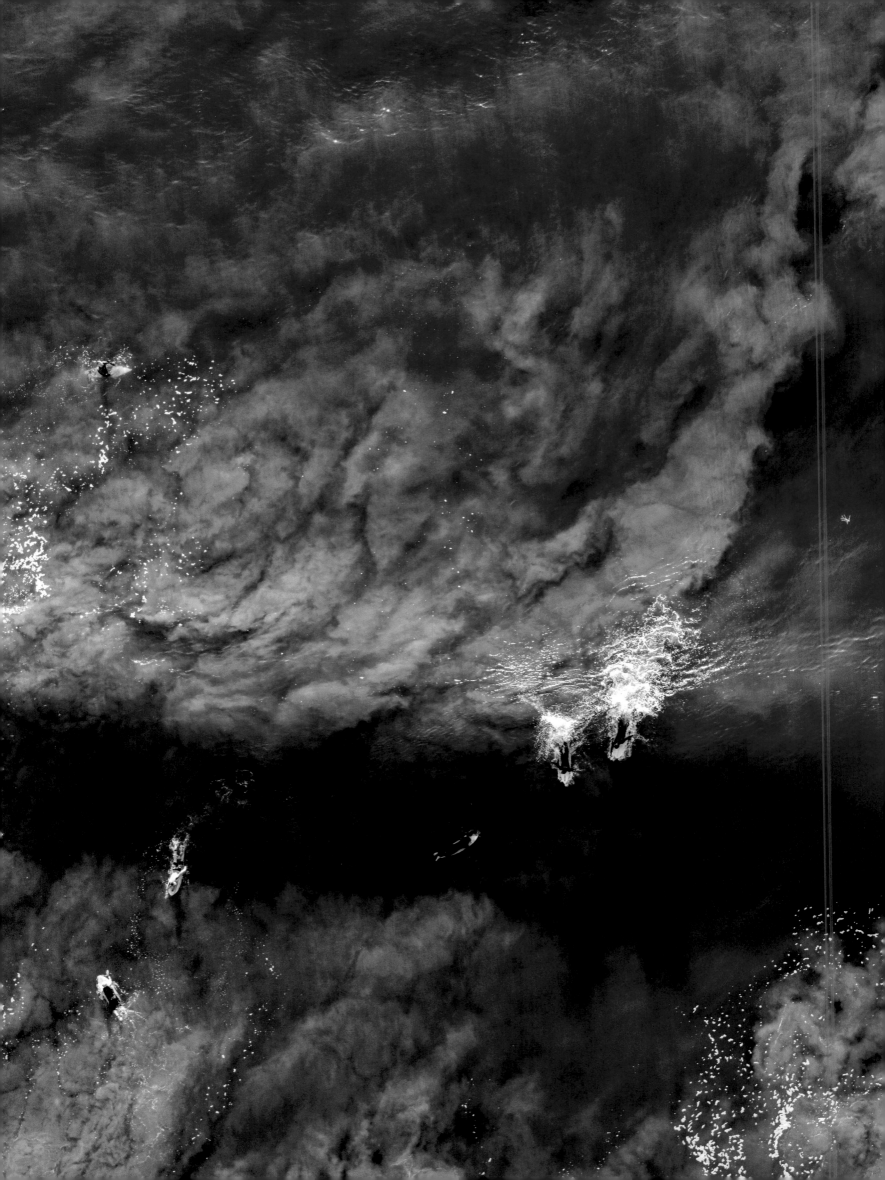

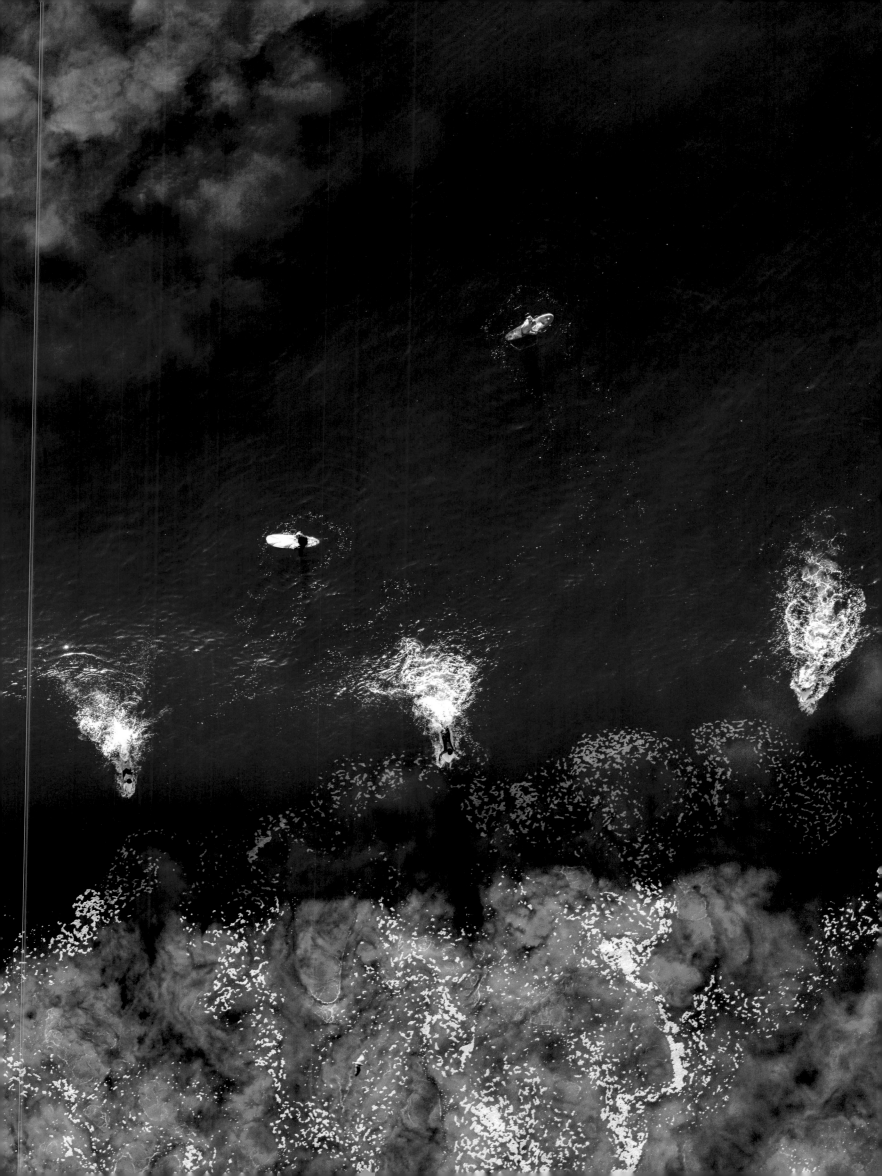

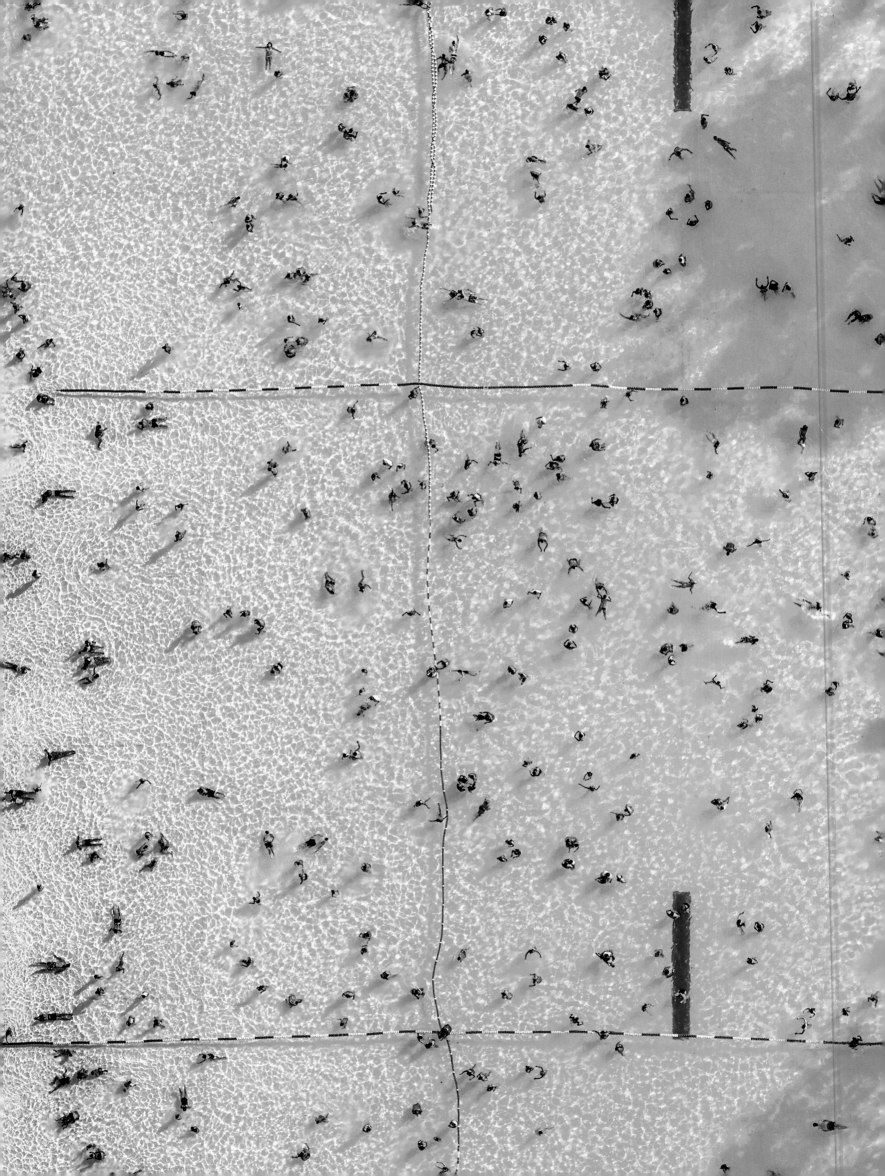

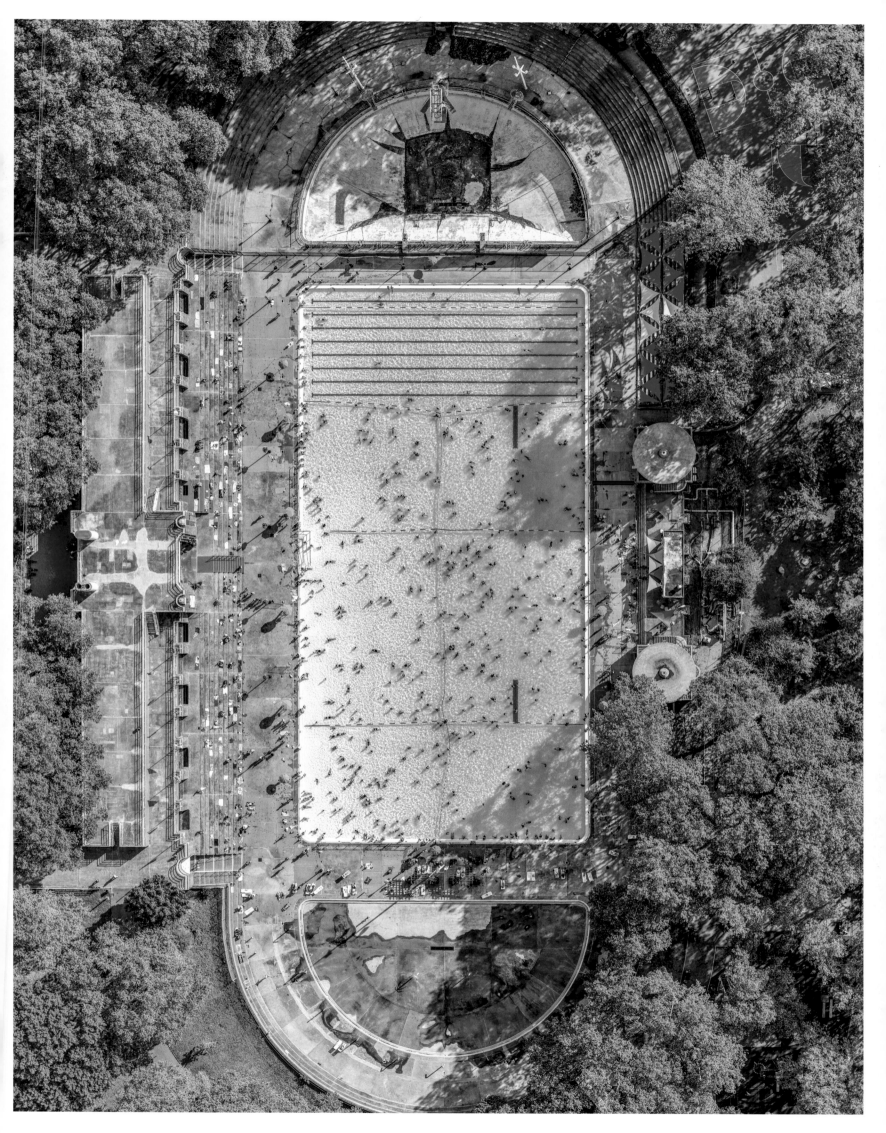

The Beach, LA

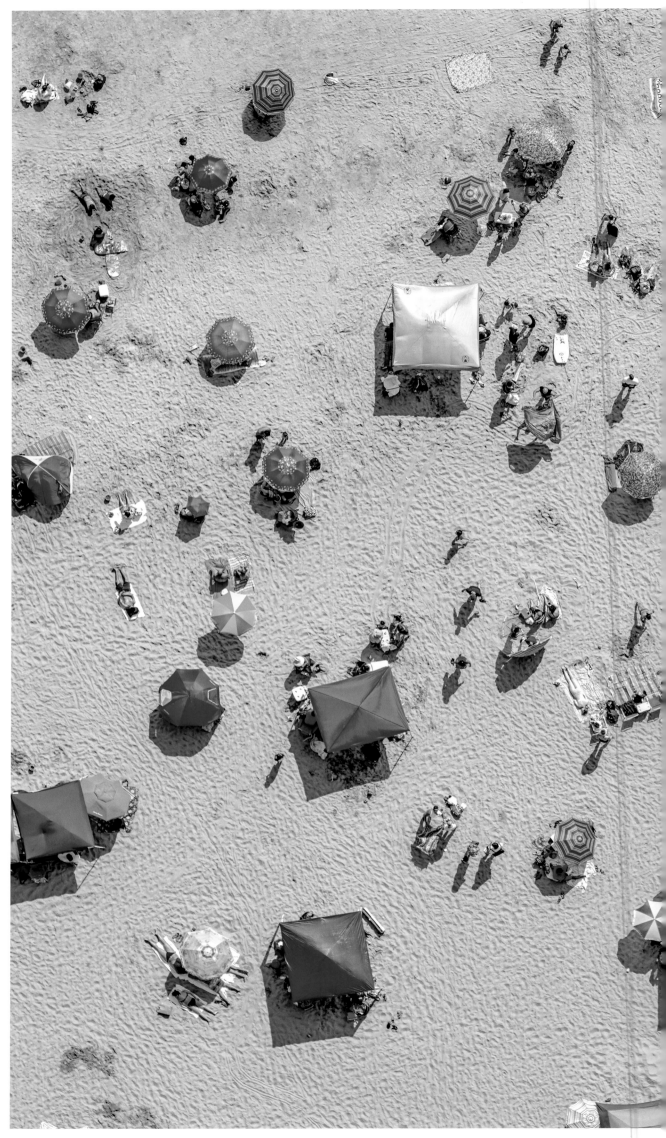

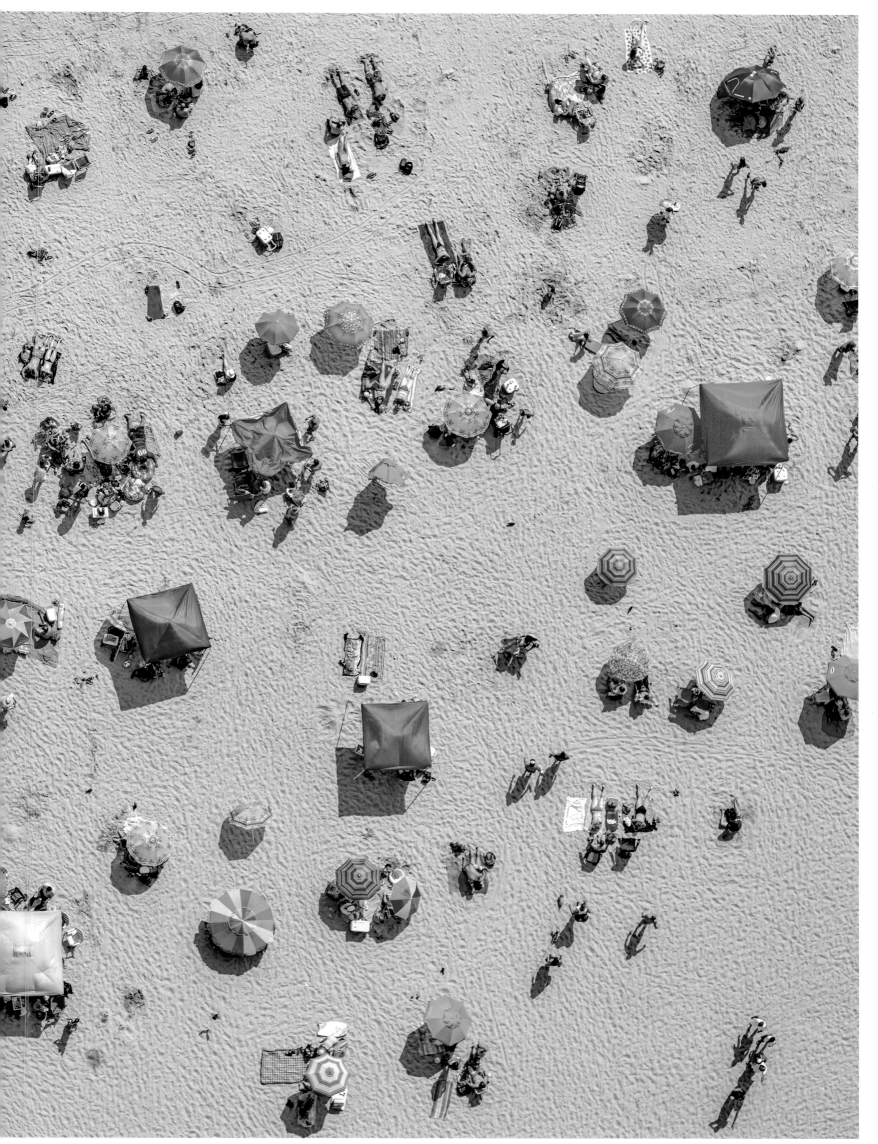

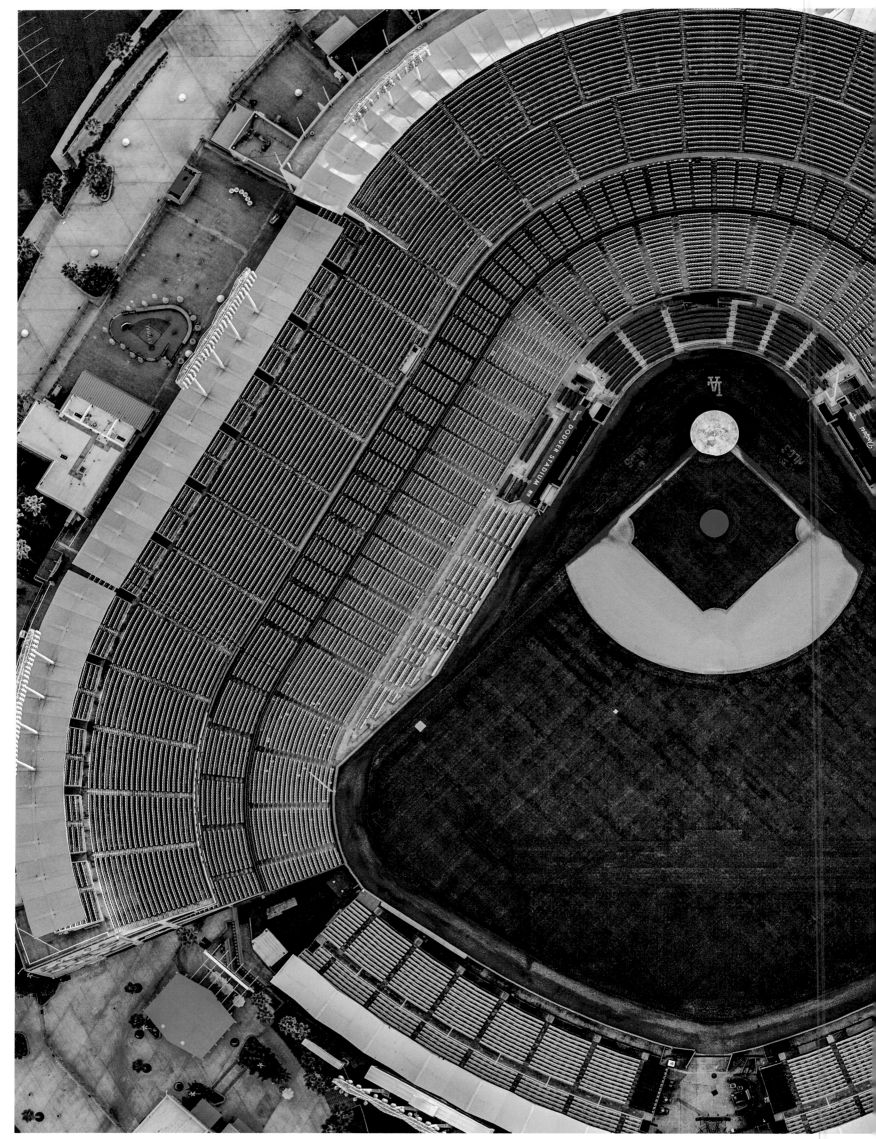

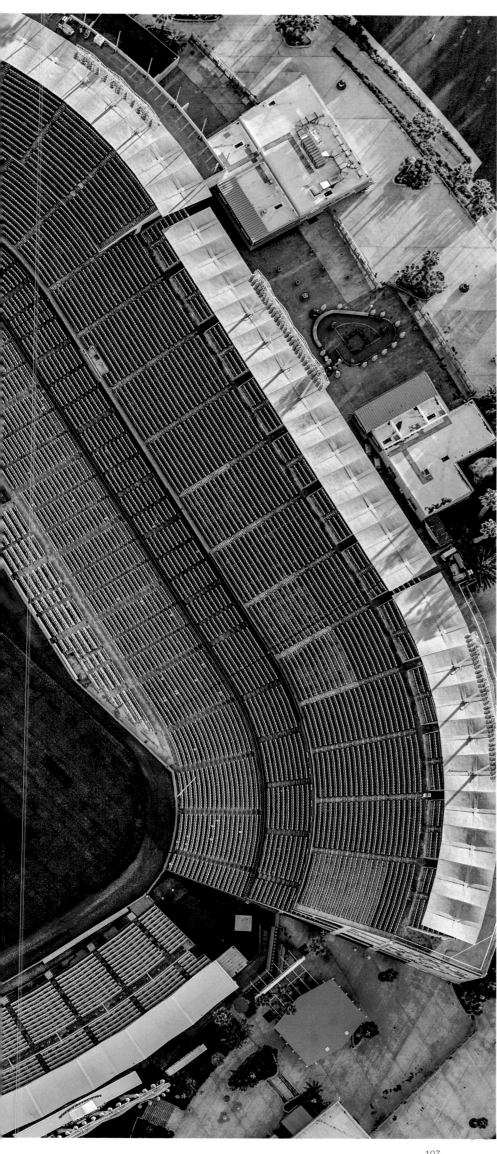

Dodger Stadium, LA

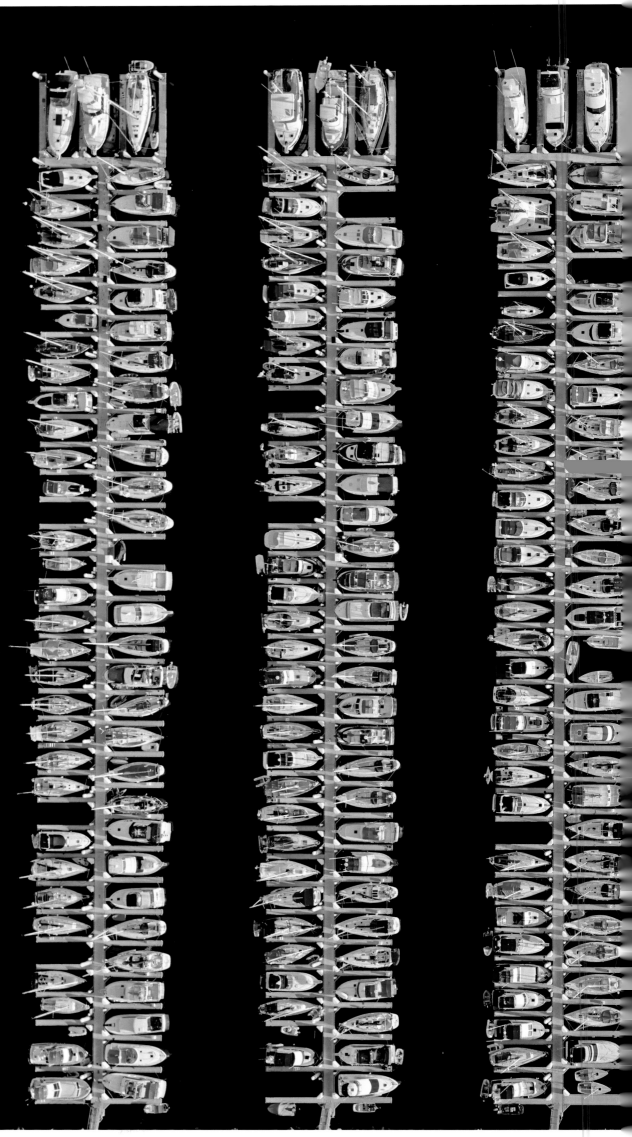

Long Beach Shoreline Marina,
Long Beach, LA

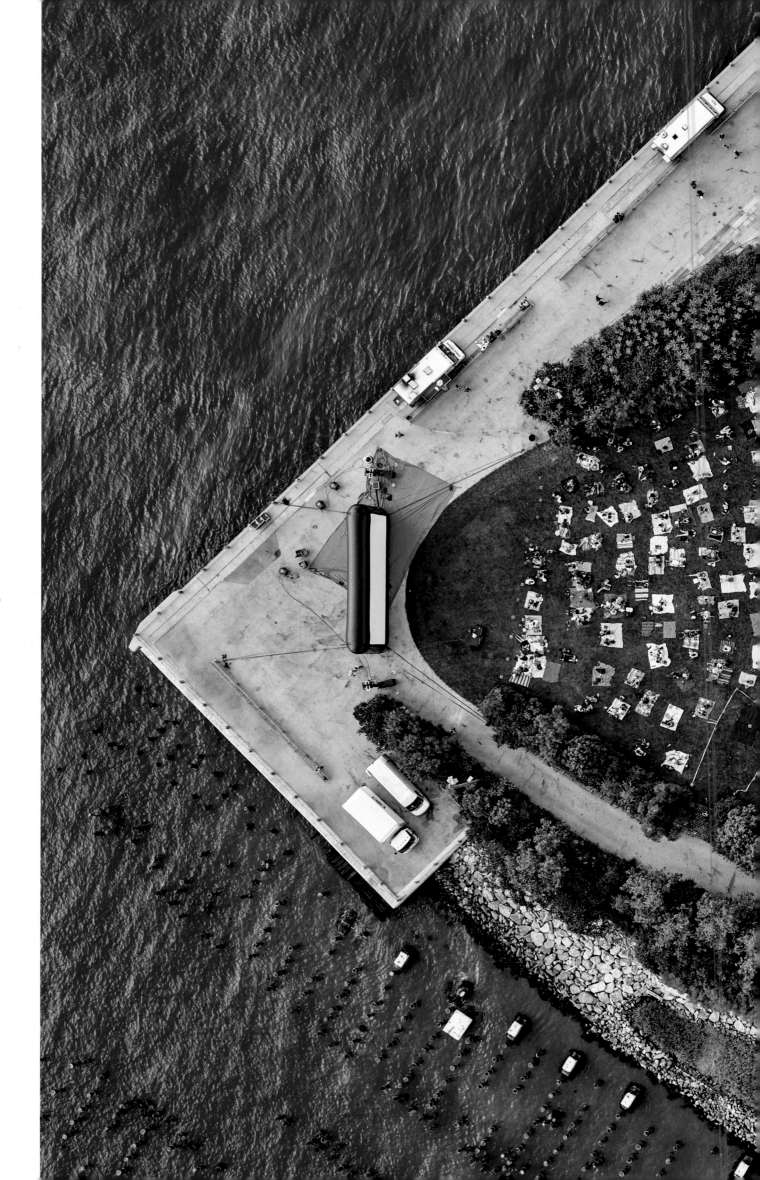

Brooklyn Bridge Park,
Brooklyn, NY

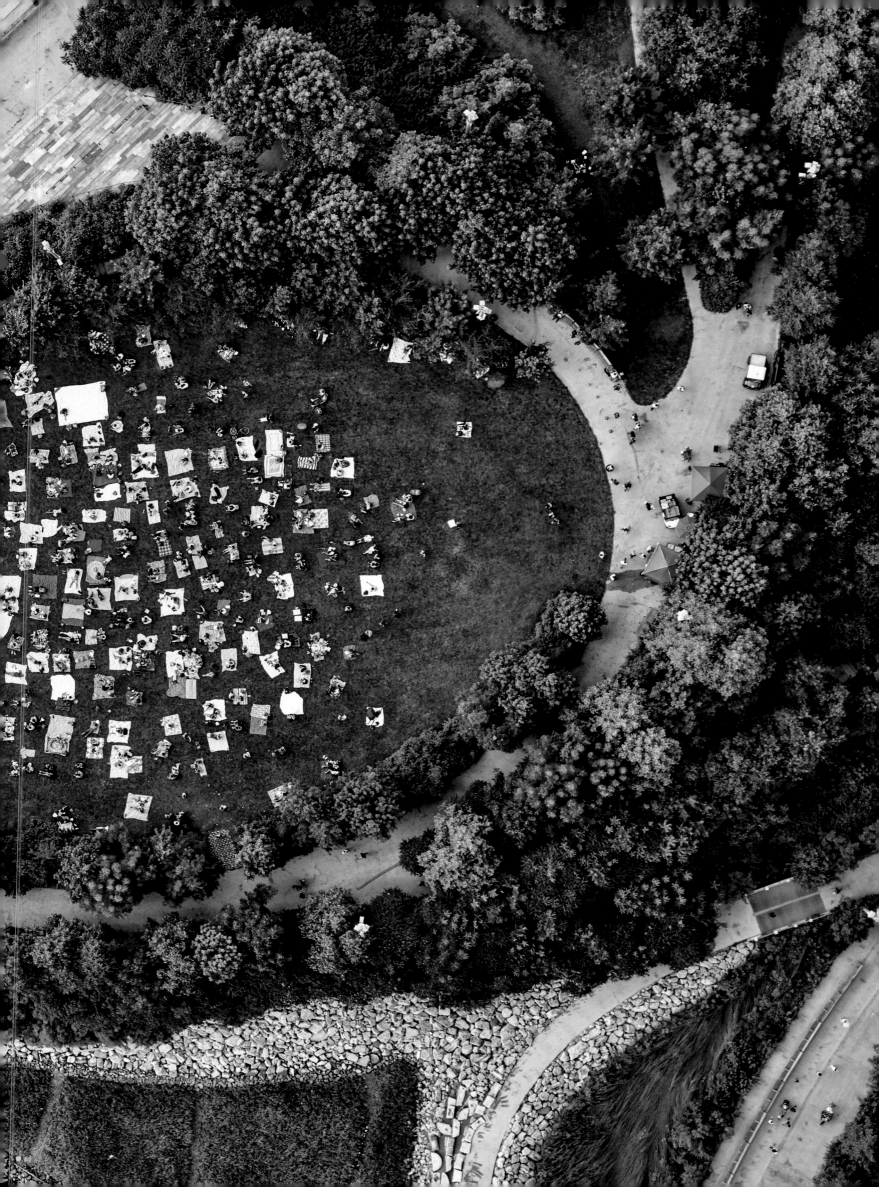

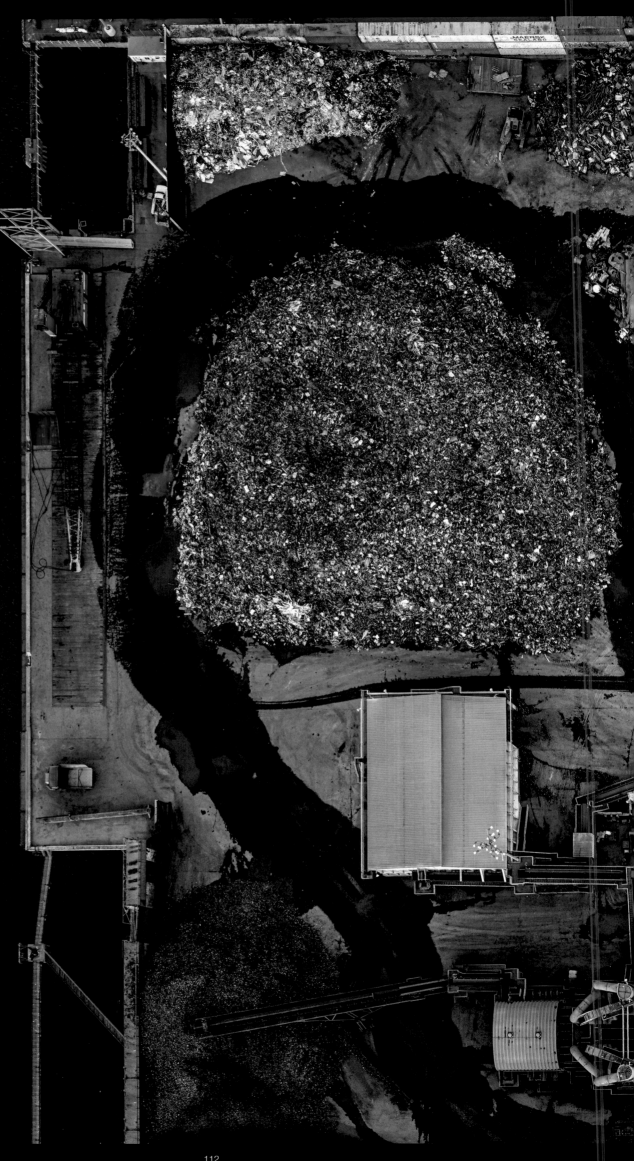

TRANSPORTATION & INDUSTRY

SA Recycling, Port of Long Beach, LA

The earth from above often appears very much like a living organism with vehicles moving along streets and highways much like blood flowing through a vast circulatory system. Both LA and NY have major seaports and airports handling a virtual cascade of goods and people in transit. New cars can be seen driving off car carrier ships at port, or lined up in tightly packed grids almost like a molecular lattice. Colorful containers are stacked up like blocks in a Tetris game, and then are lifted in and out of ships by giant cranes that operate day and night. The airports glow like jewels at night, as jet planes taxi to and from the terminal gates. The precise markings on the tarmac are an exquisite counterpoint to the structures of the terminal buildings, the sleek bodies of the airplanes, and the ragged fringe of smaller supporting vehicles.

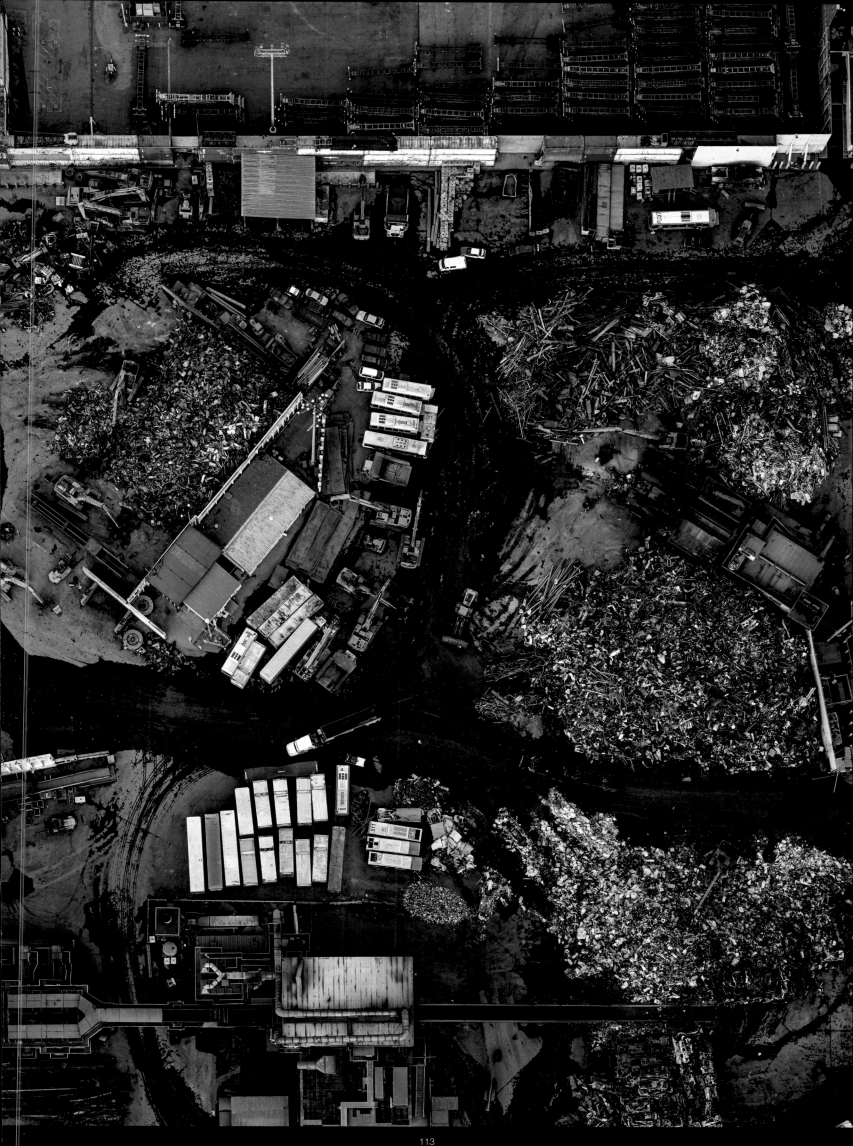

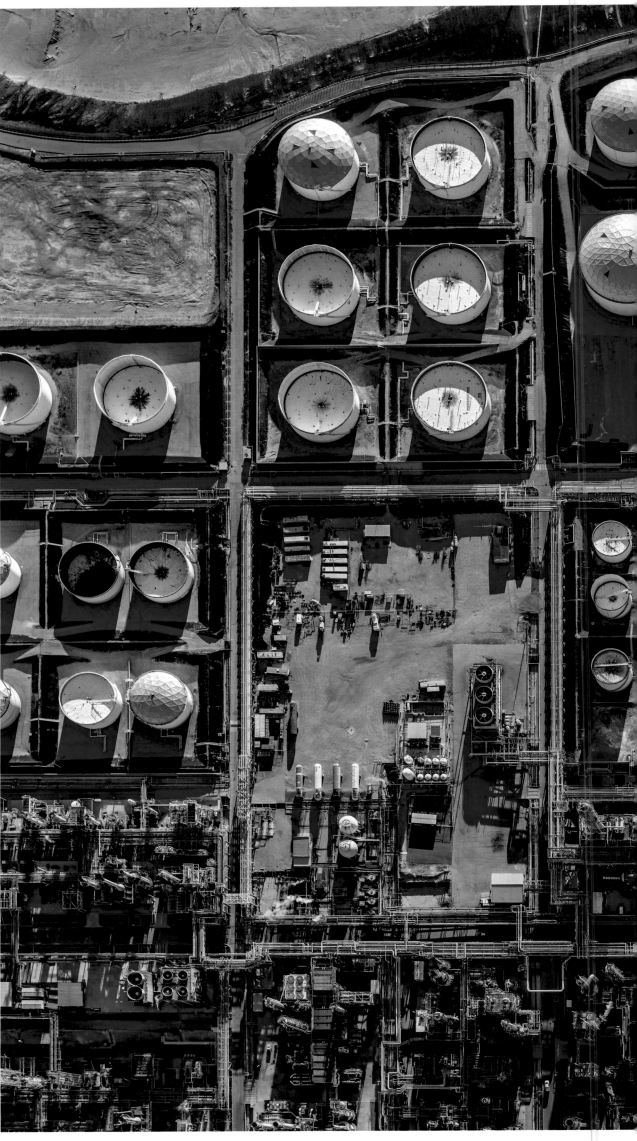

Phillips 66 Refinery, Wilmington, LA

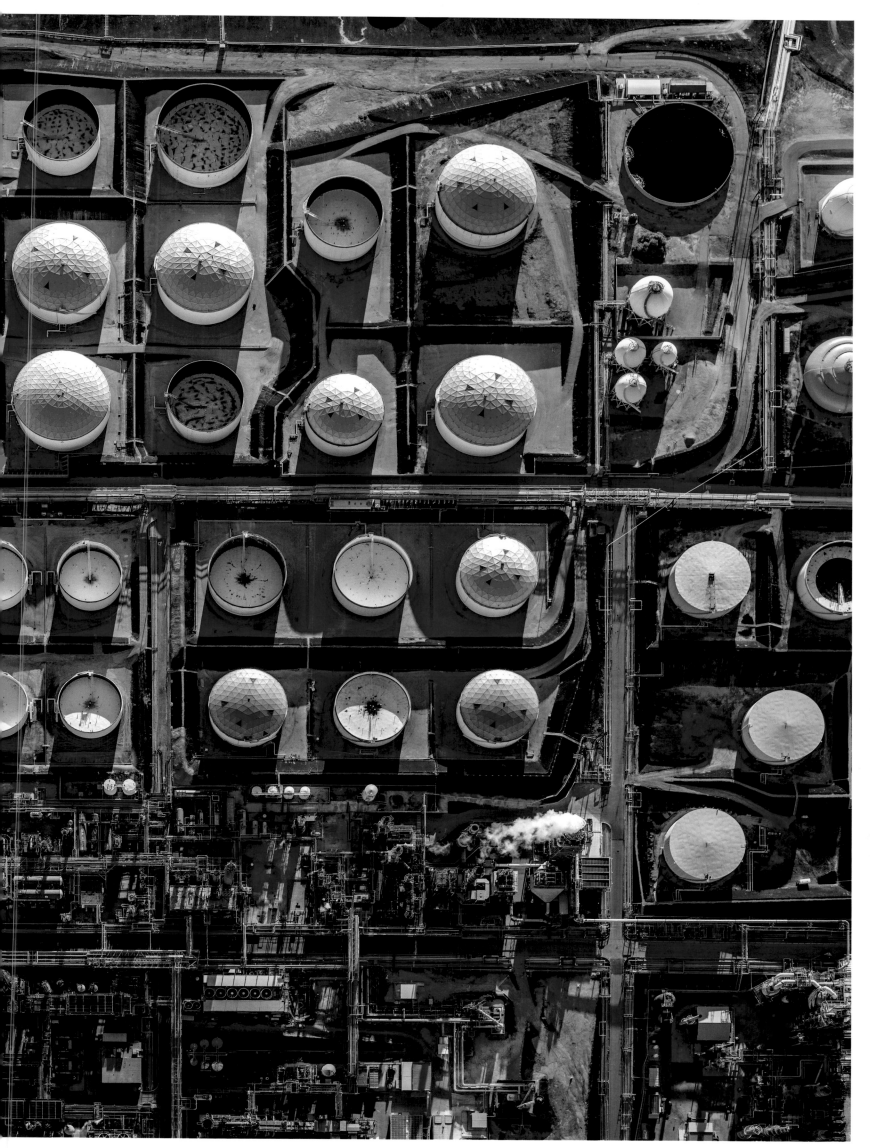

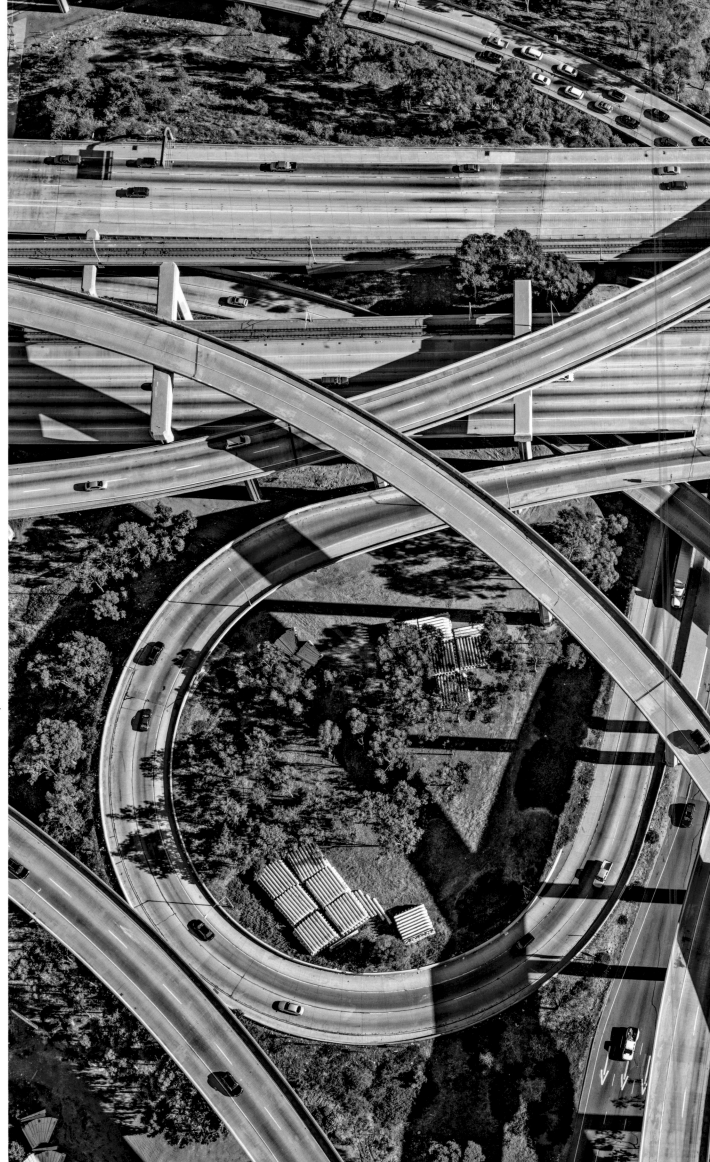

Century and Harbor Freeway
Interchange, LA

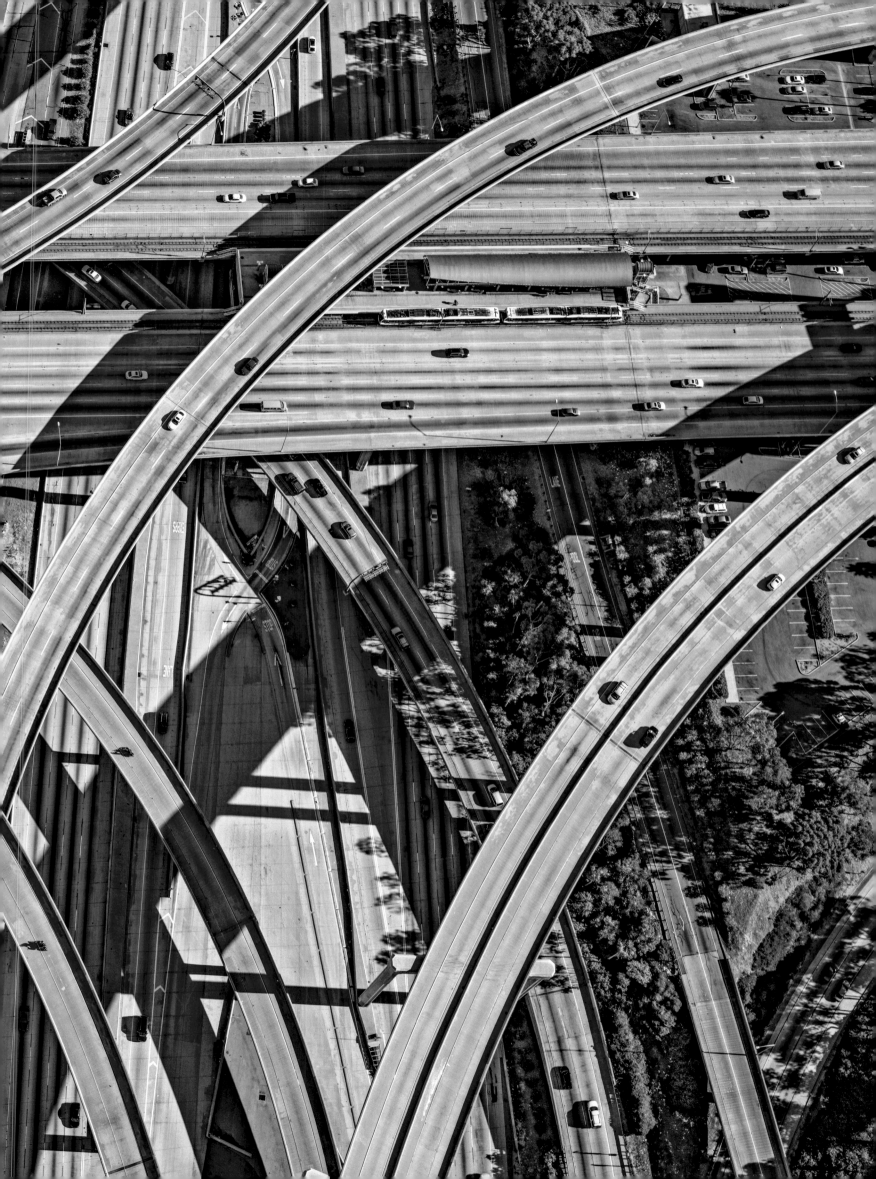

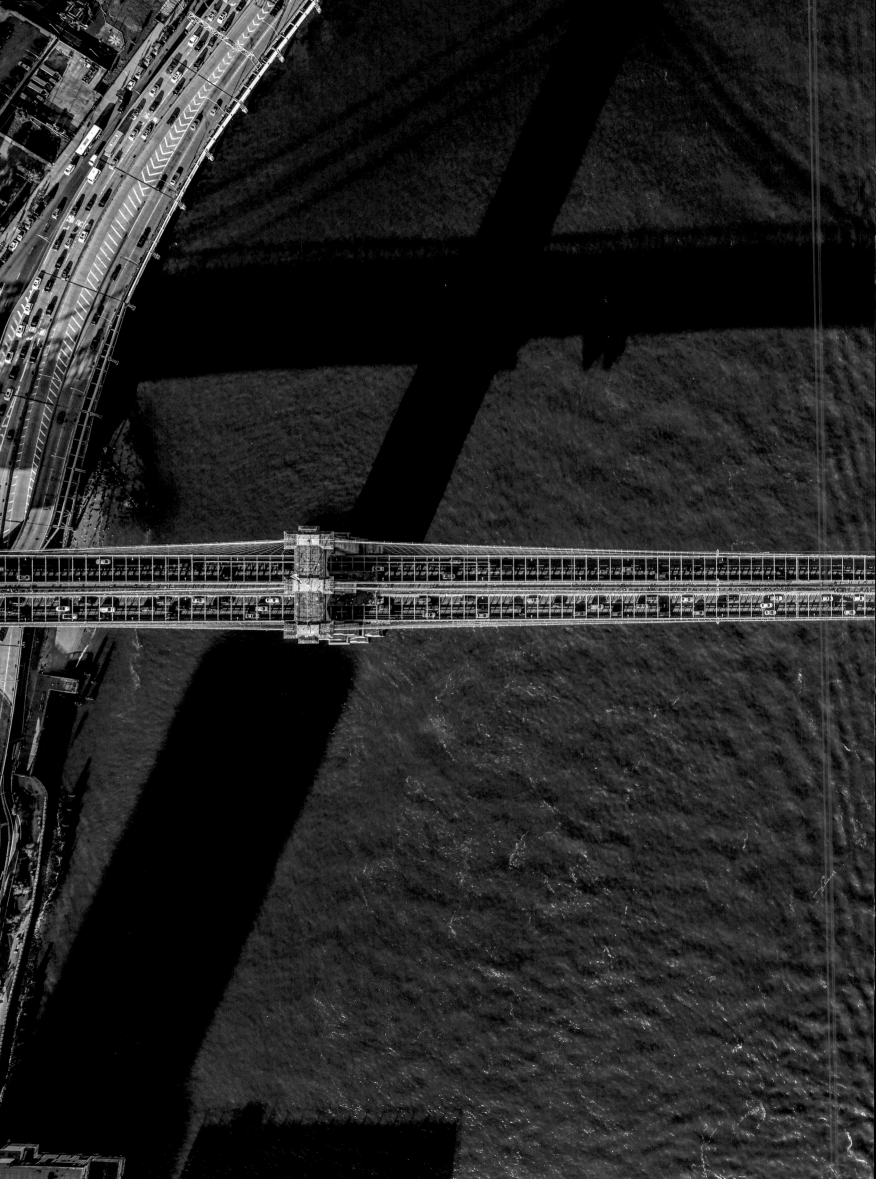

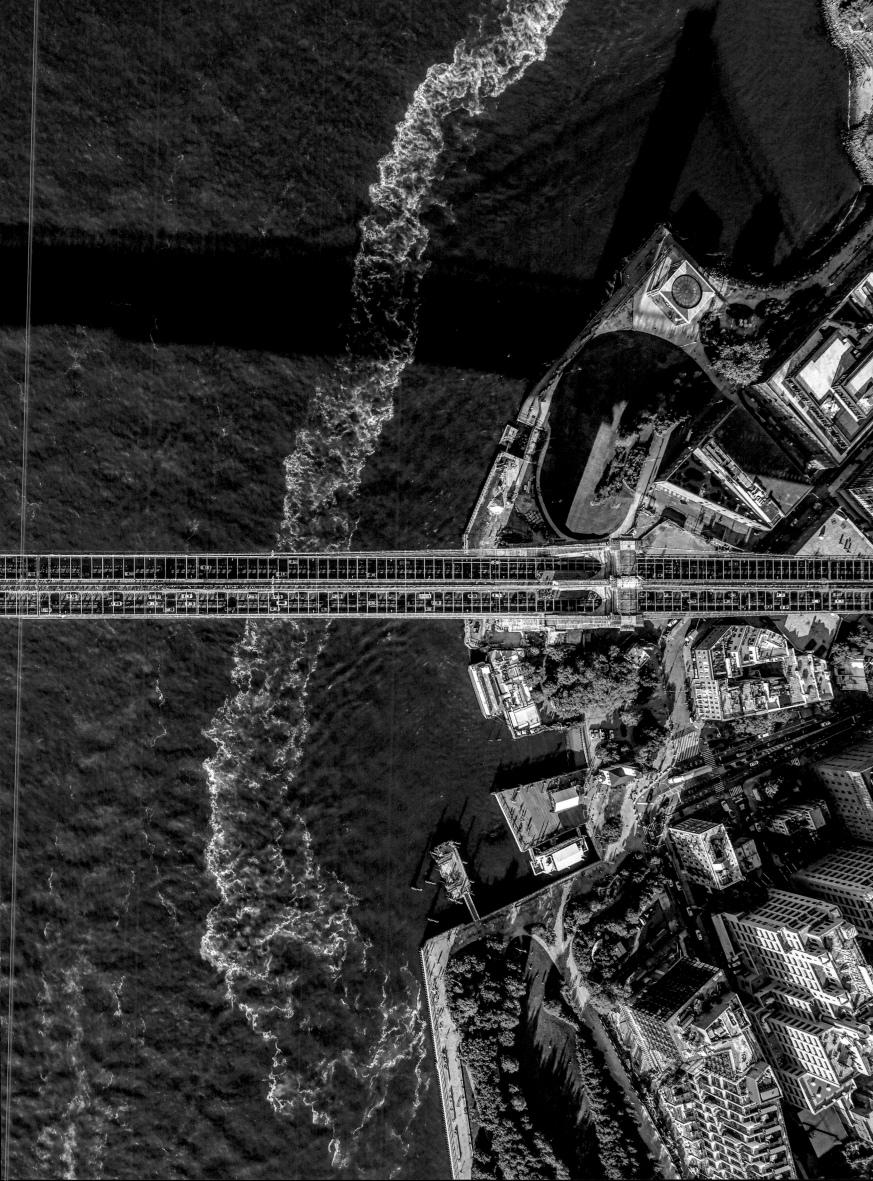

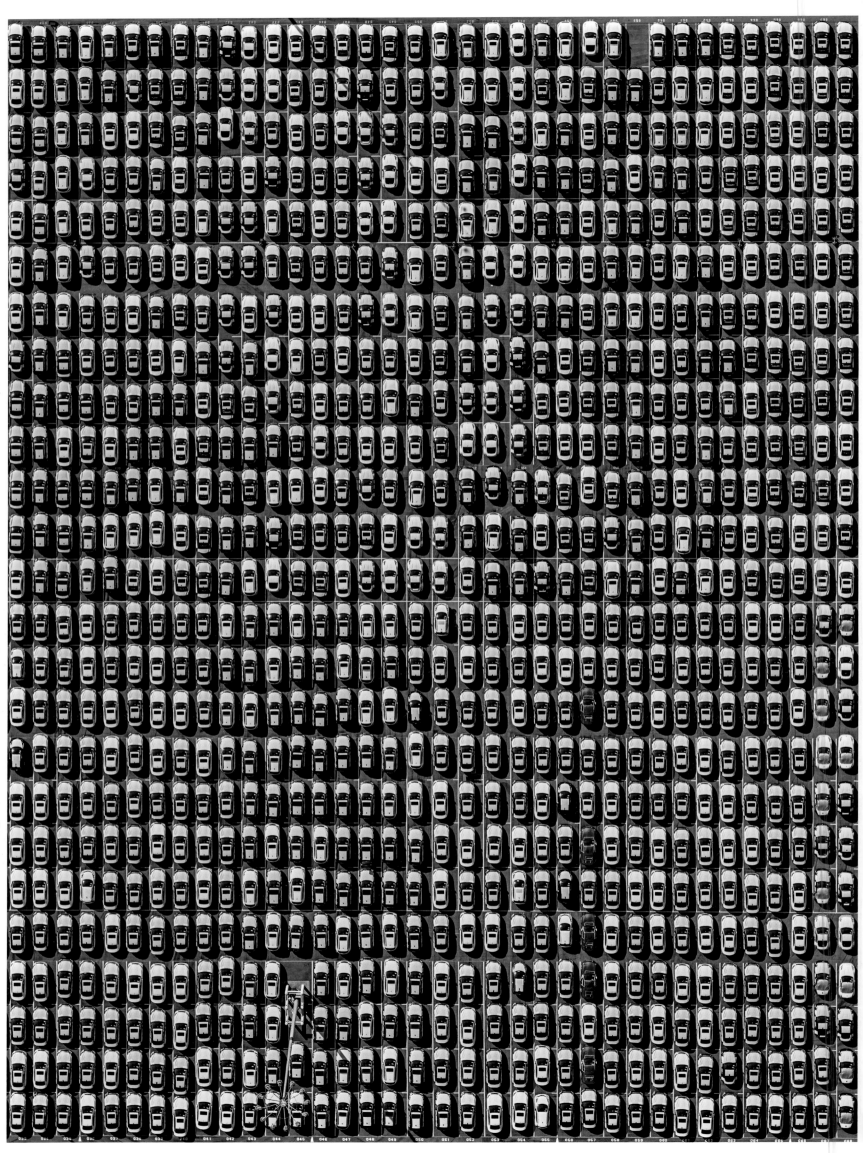

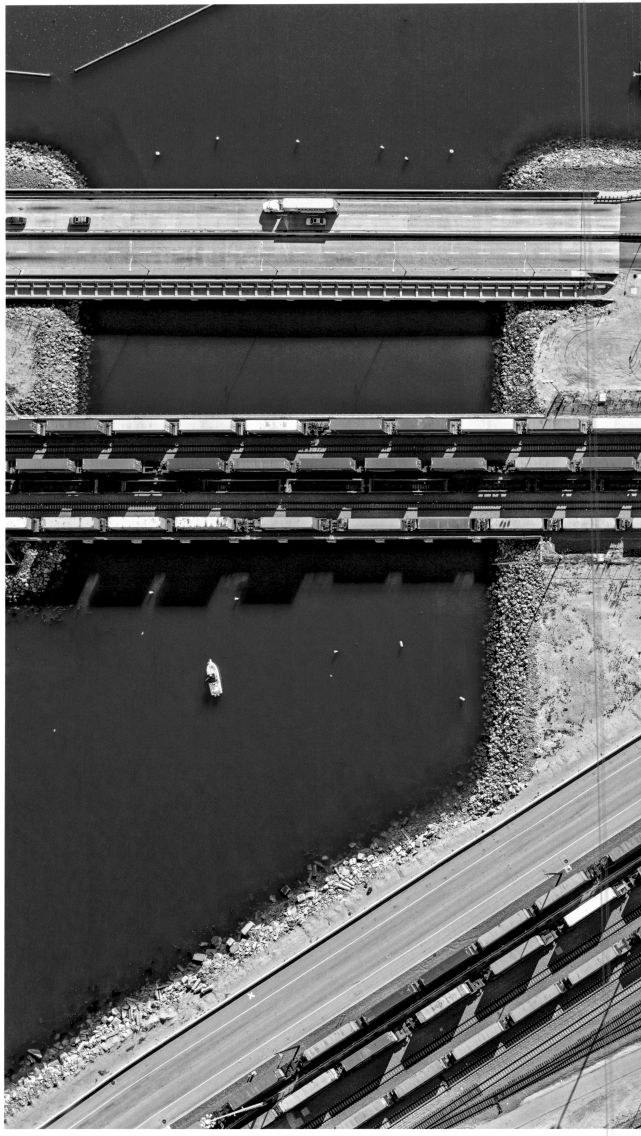

Containers on Trains, Port of Long
Beach and Port of Los Angeles, LA

PAGES 124–125
APM Terminals, Terminal Island, LA

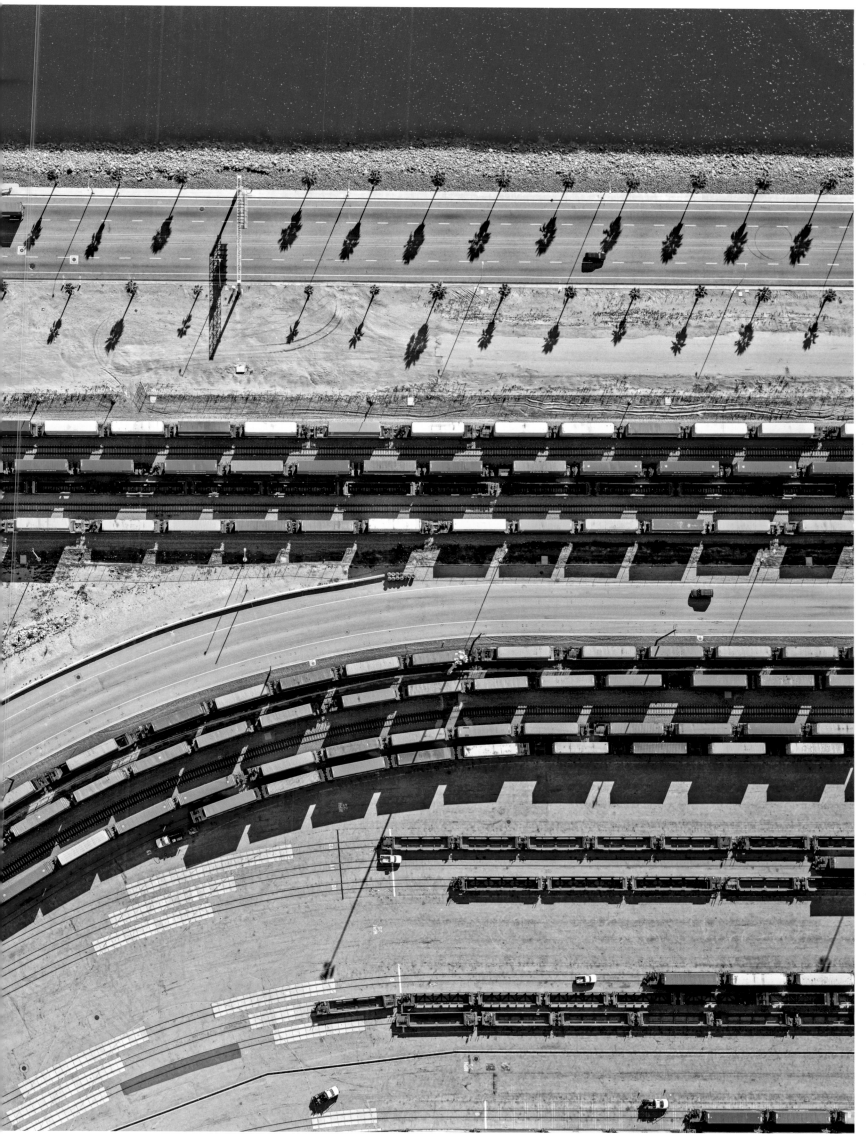

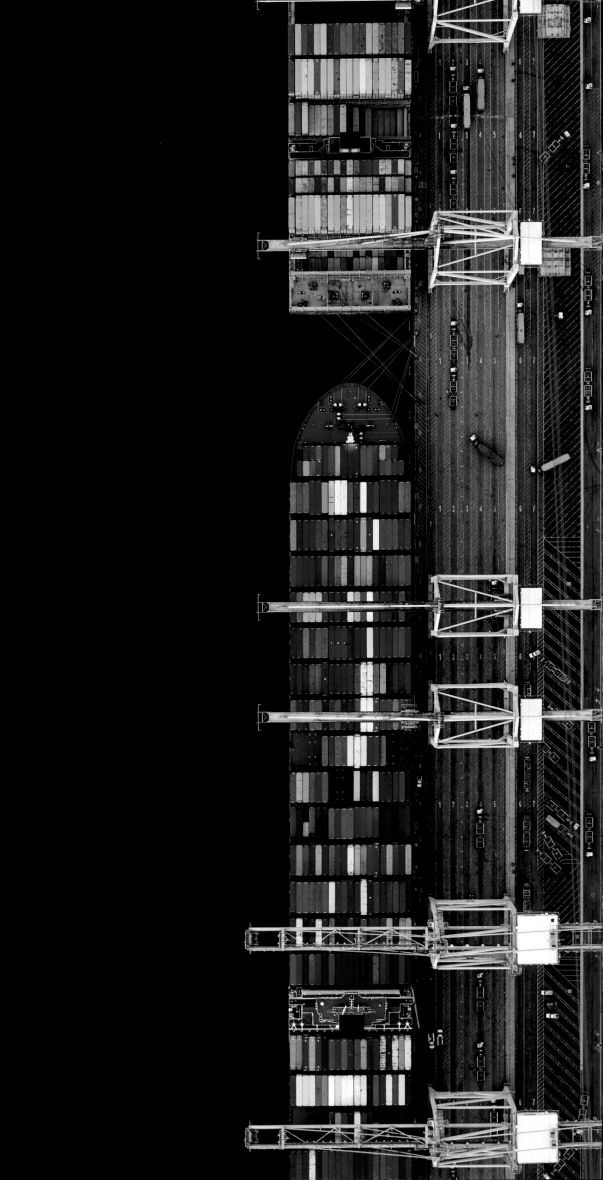

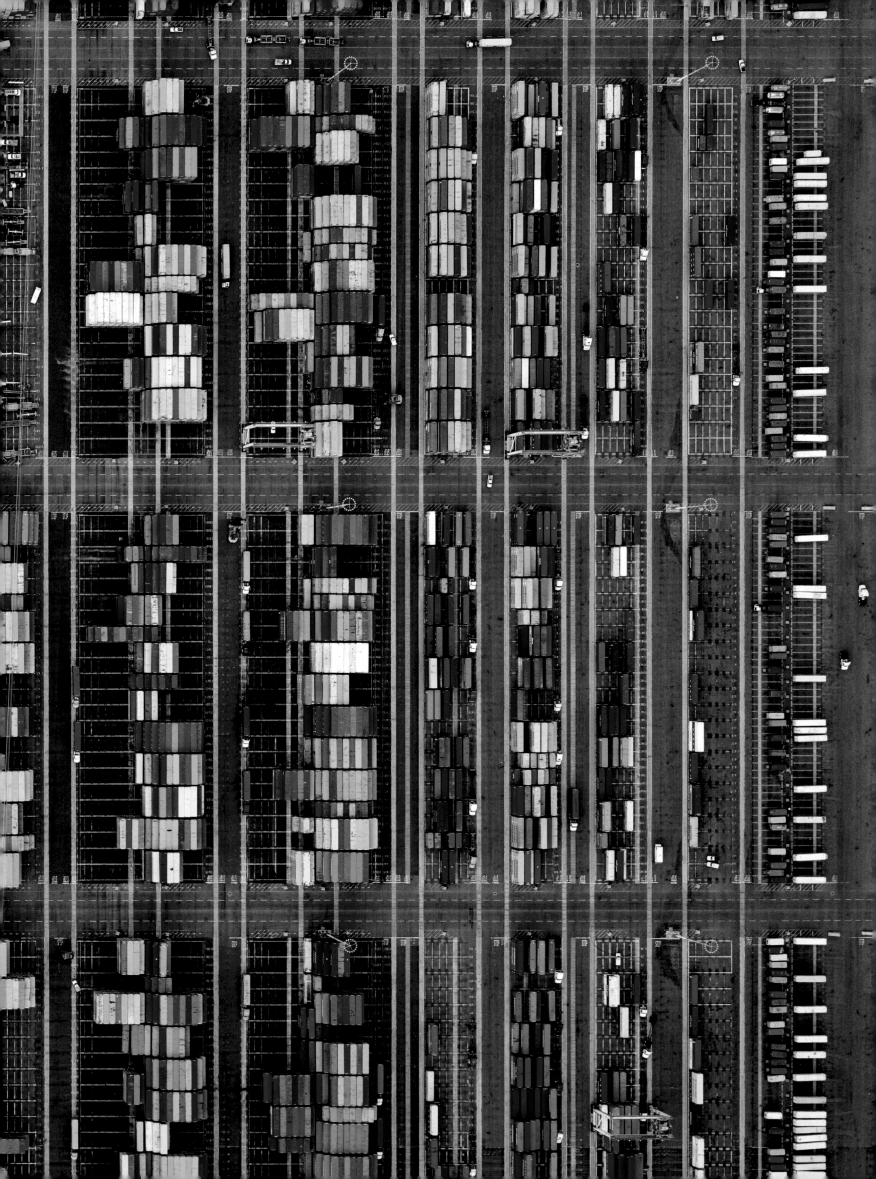

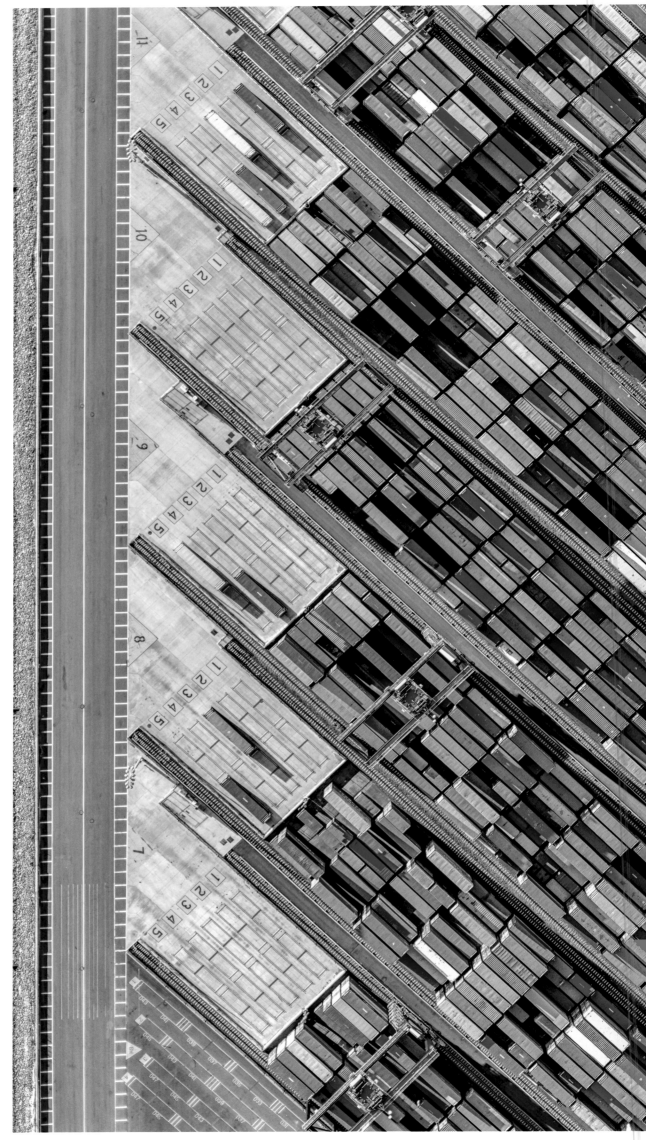

Global Terminal, Jersey City, NJ

PAGES 128–129
Roll-On/Roll-Off (Ro-Ro) Ship, Port of
Newark, NJ

Lumber Yard, Port of Long Beach, LA

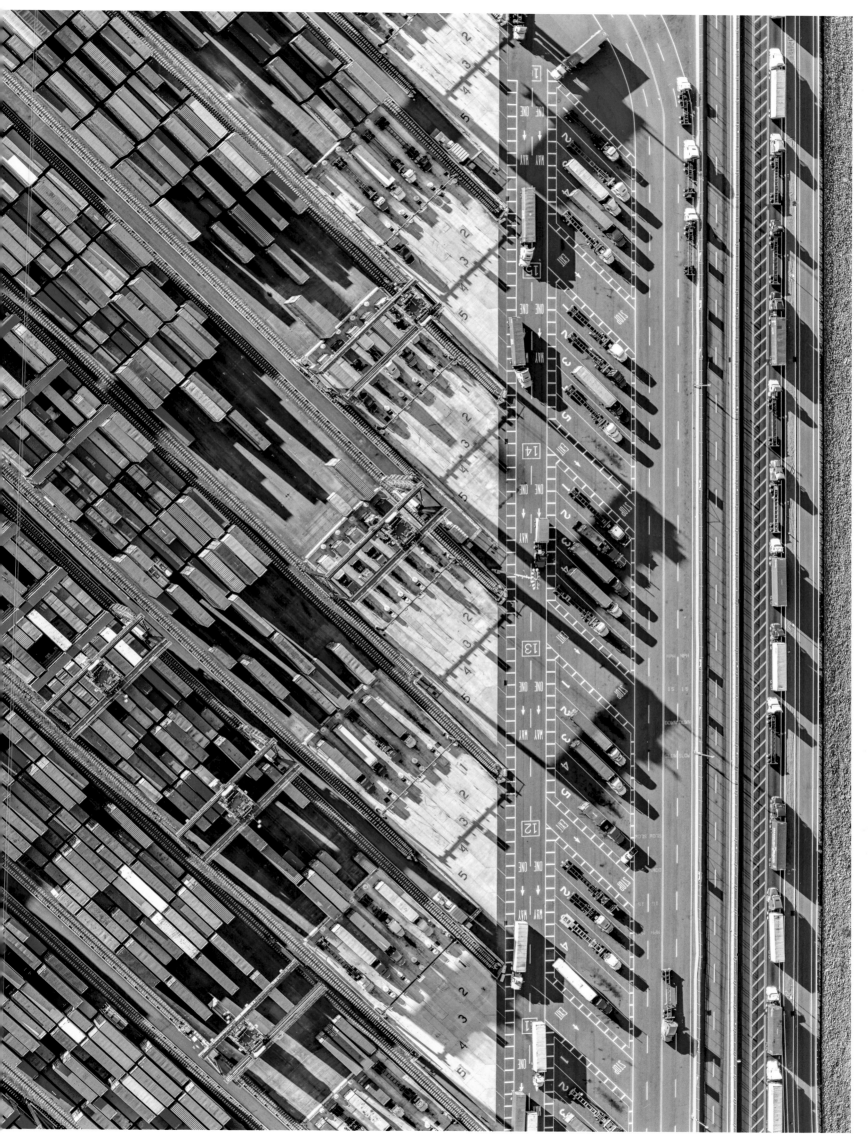

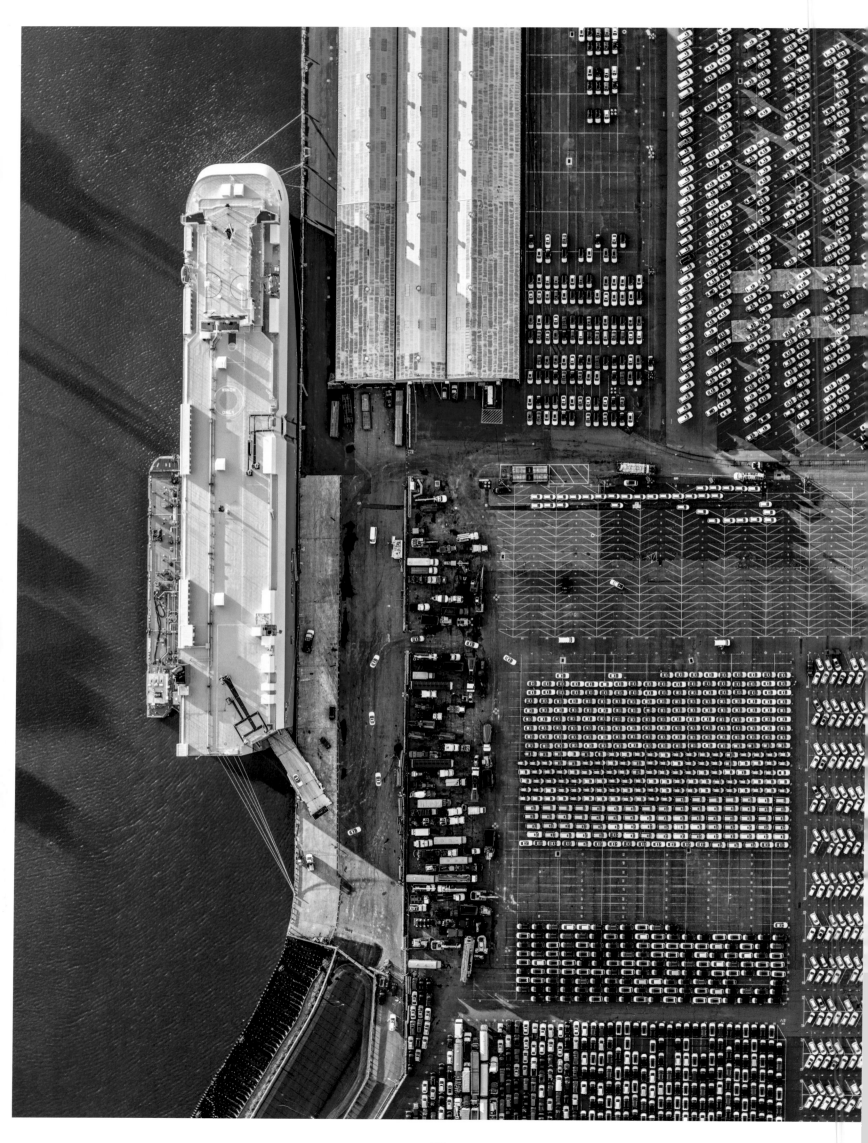

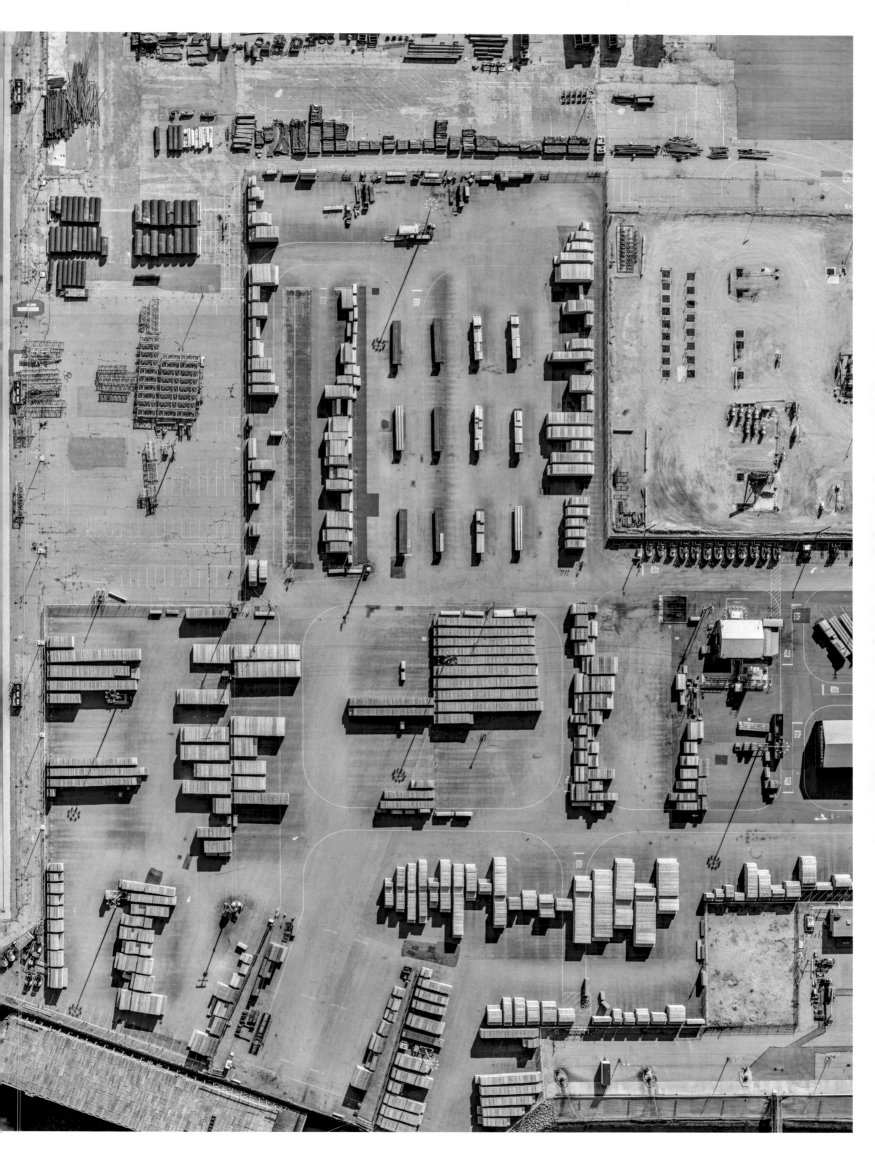

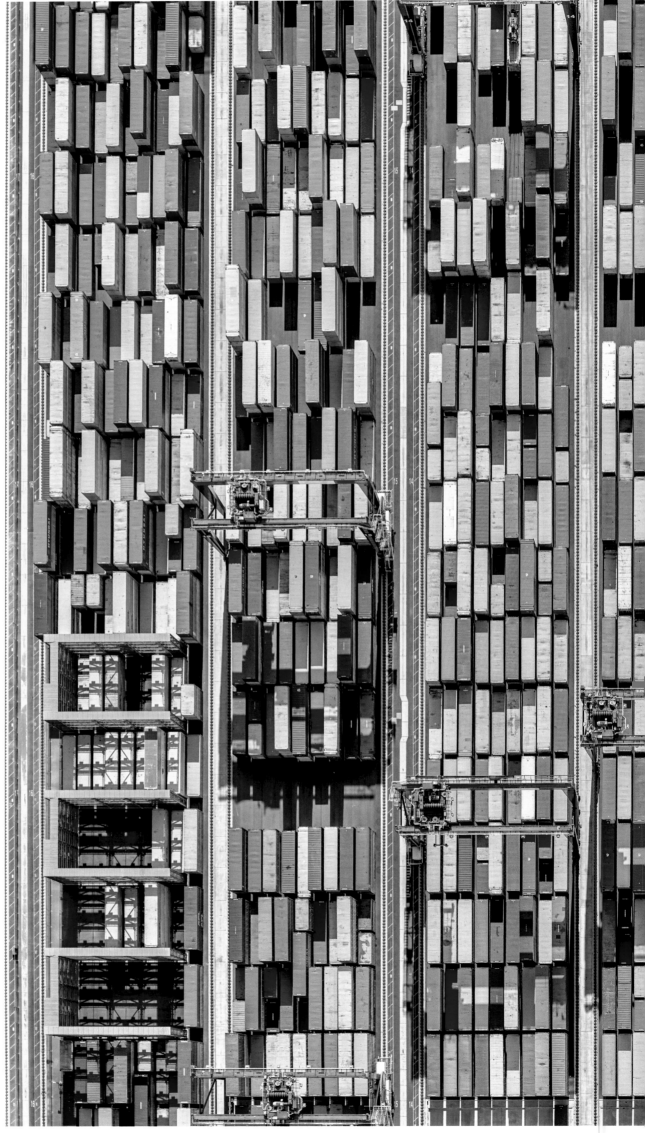

Containers, Port of Long Beach, LA

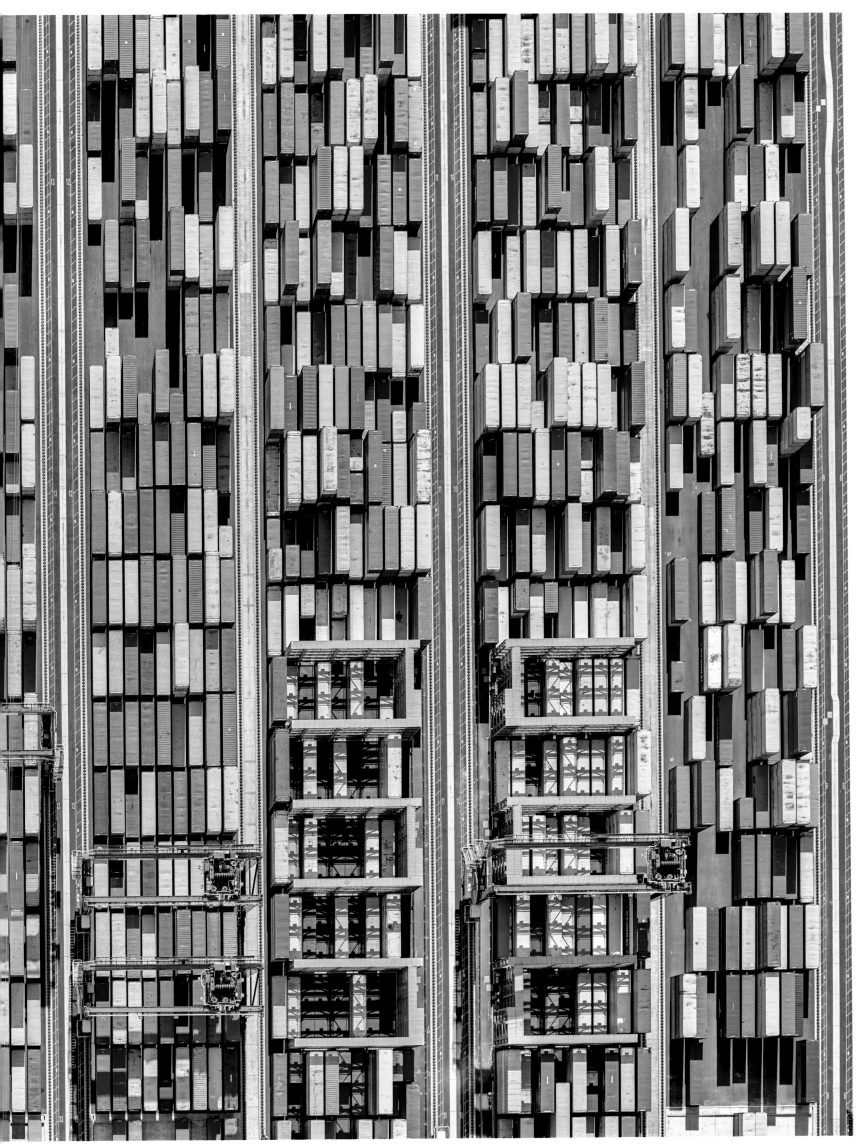

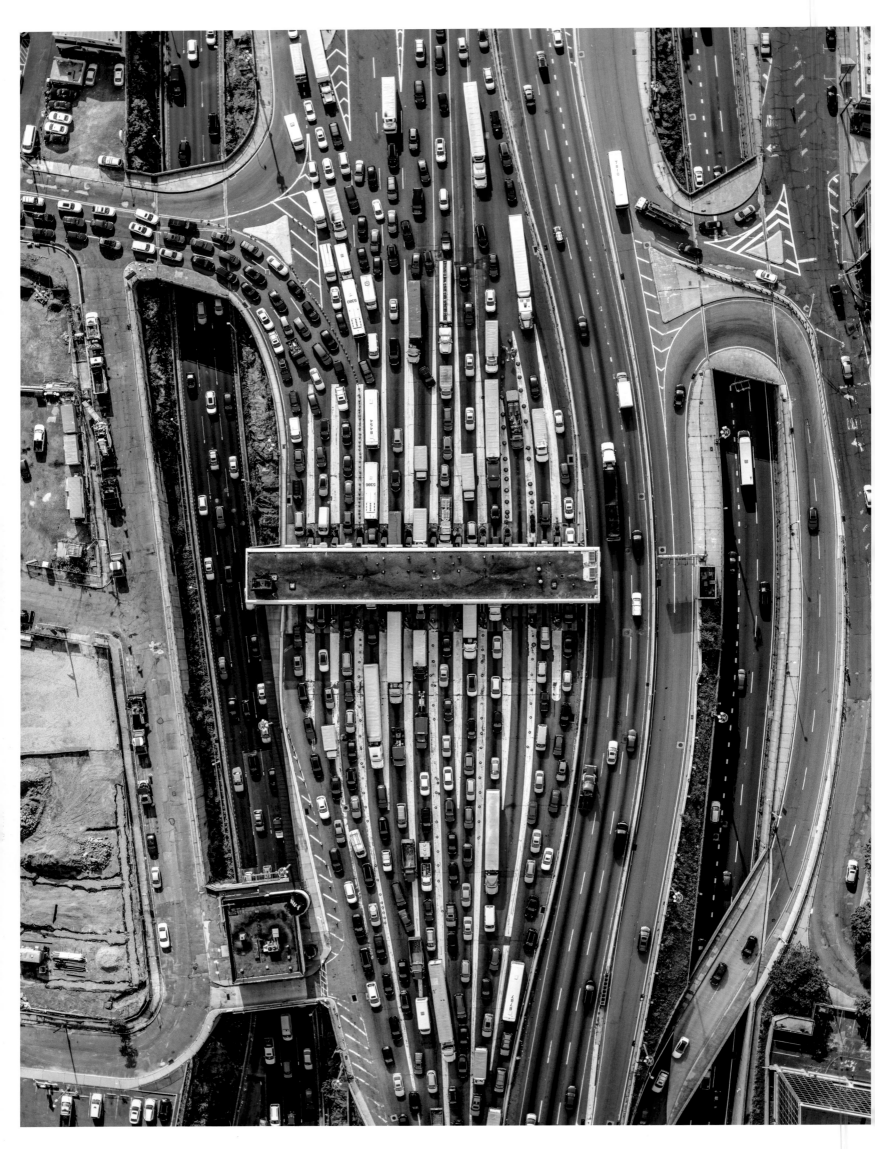

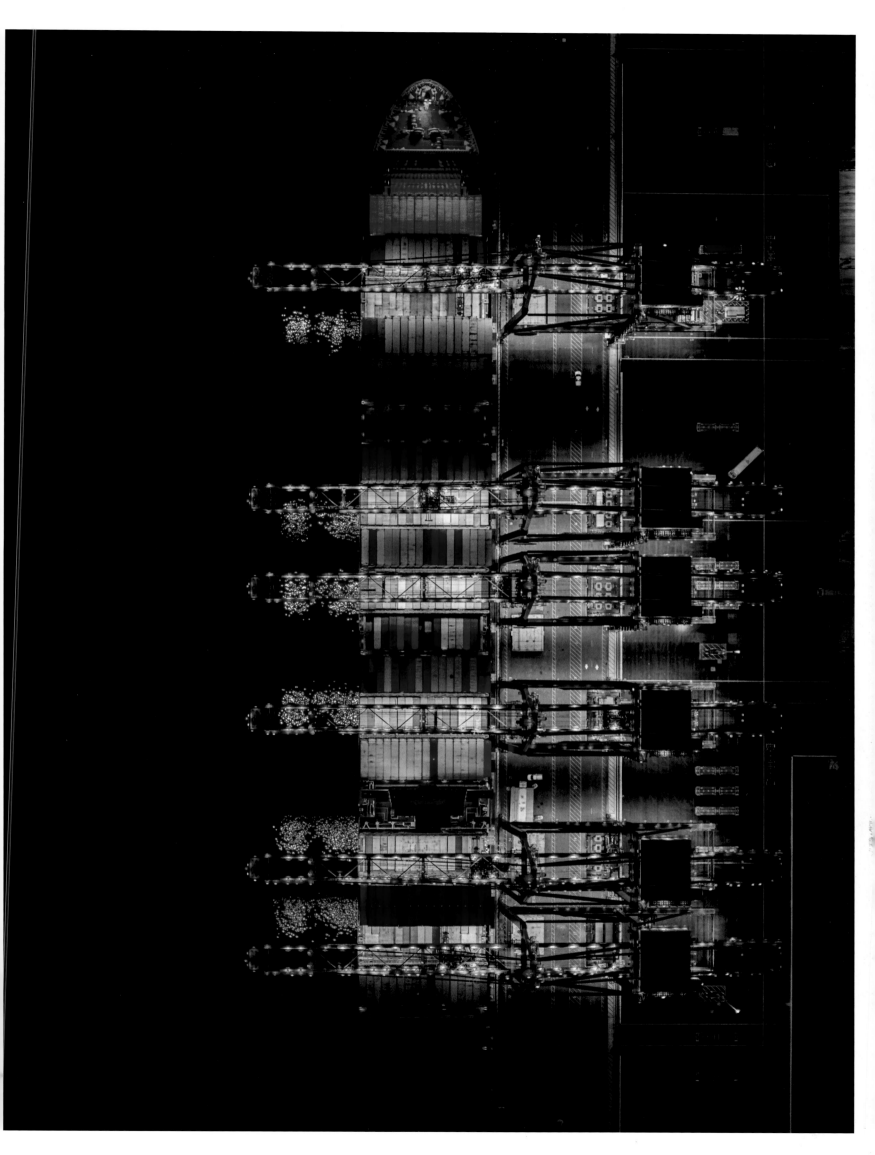

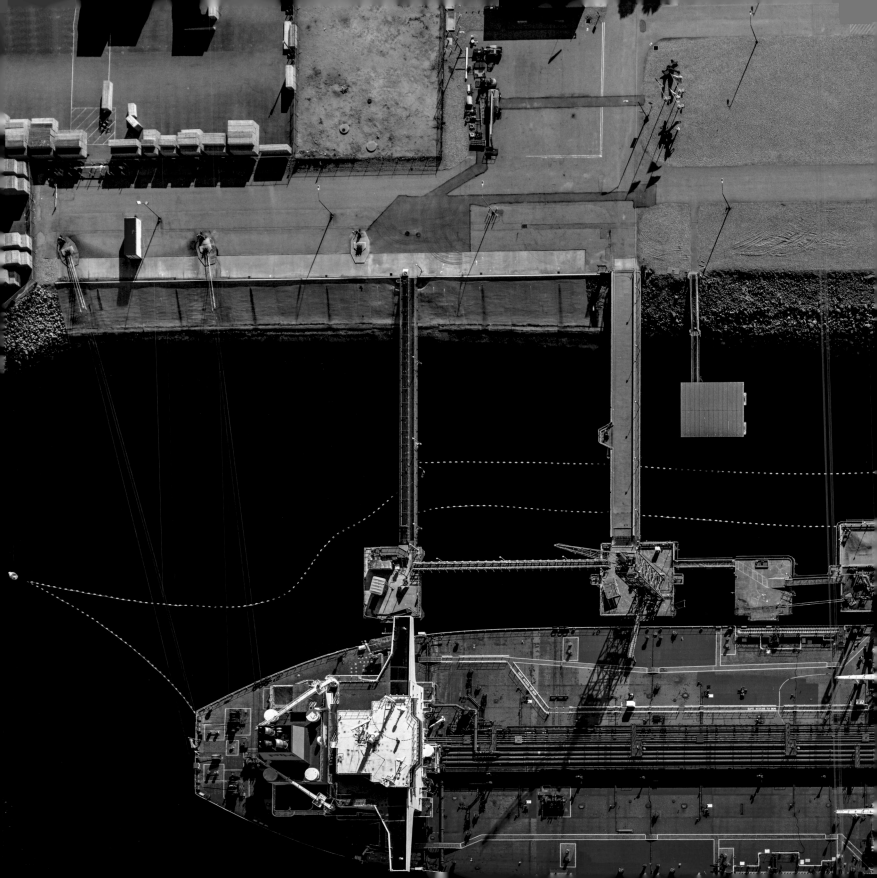

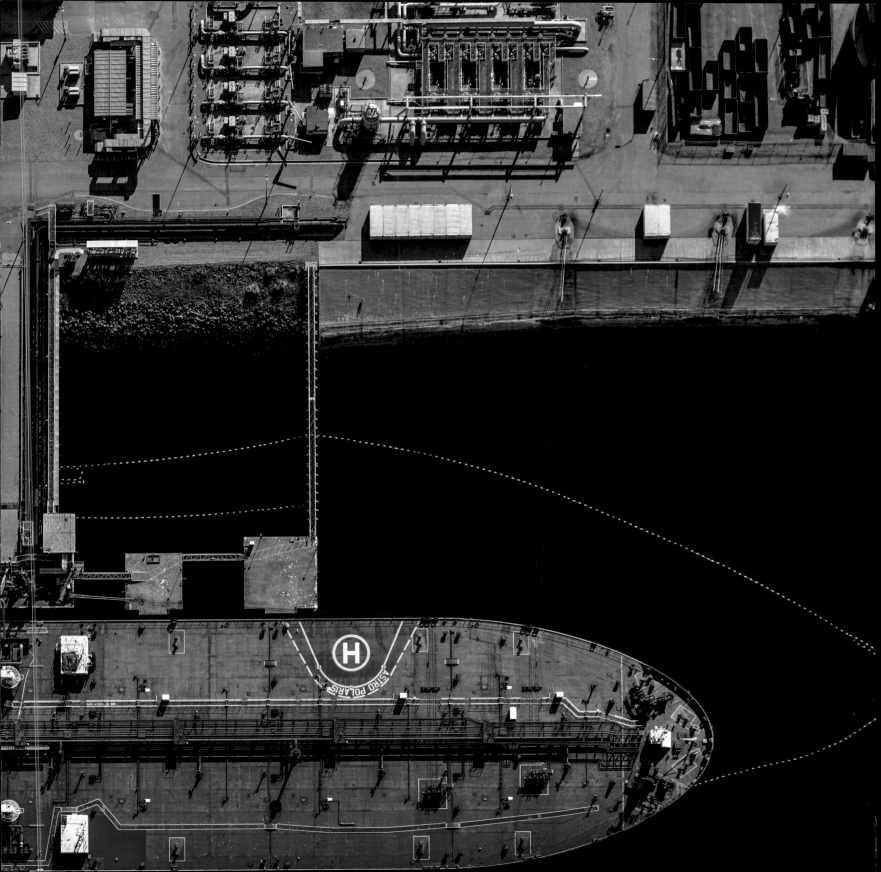

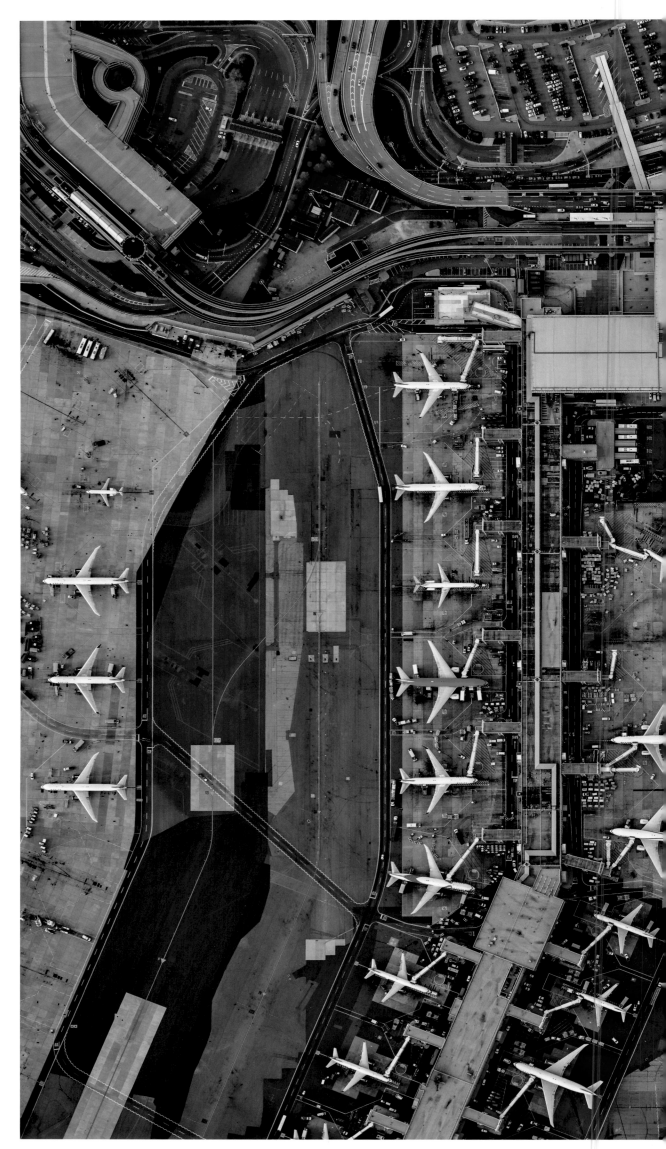

Terminal 4, John F. Kennedy
International Airport (JFK), Queens, NY

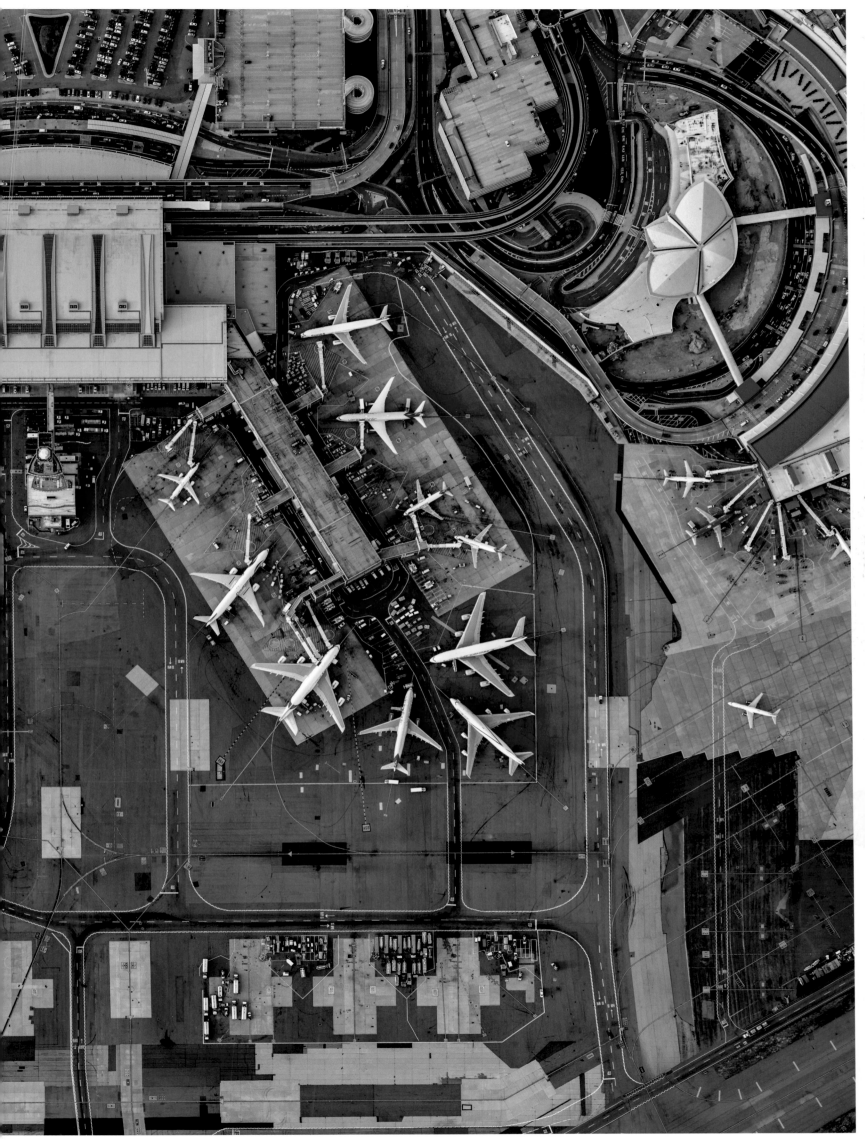

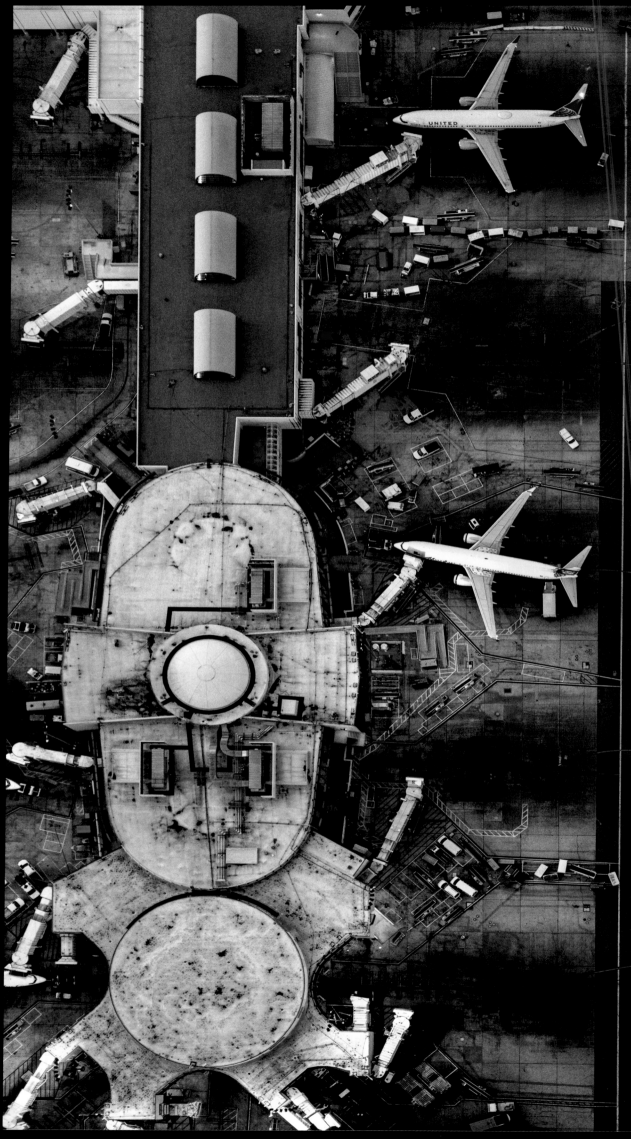

Los Angeles International Airport
(LAX), LA

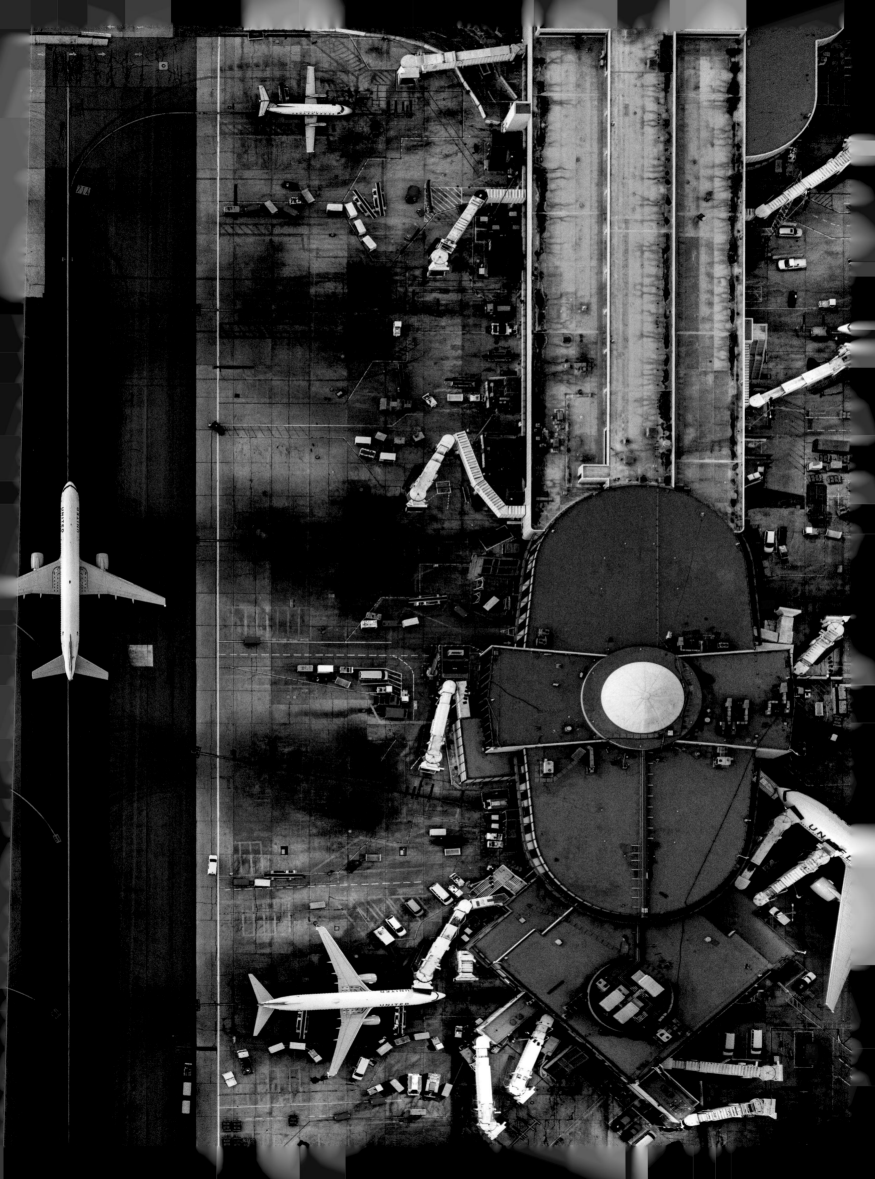

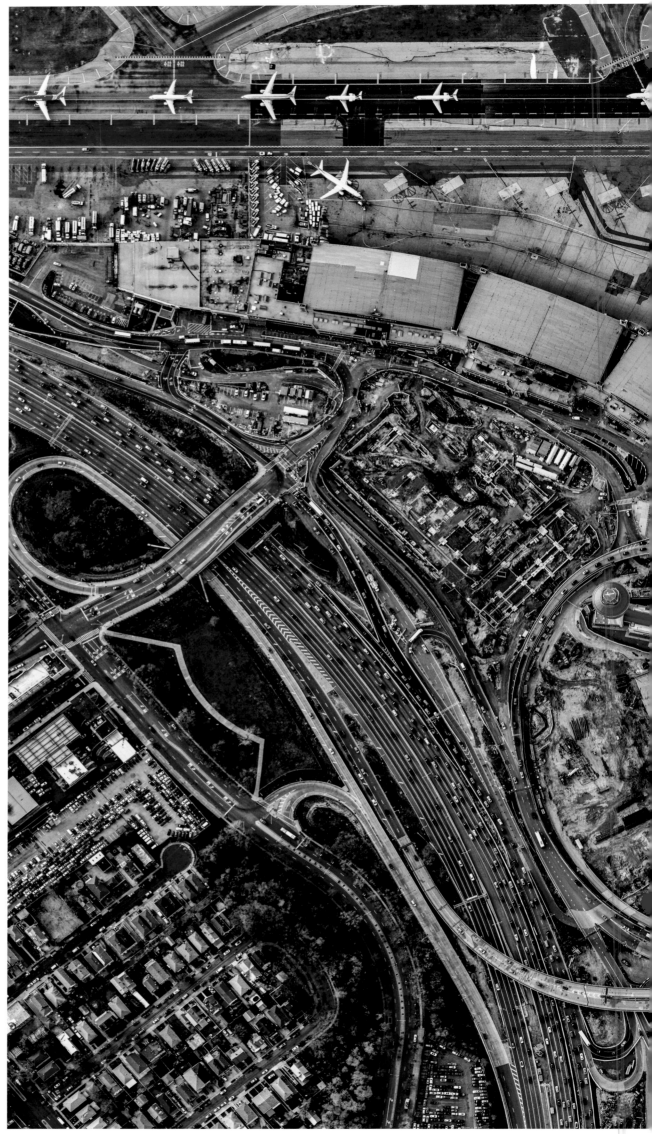

Undergoing renovations, LaGuardia
Airport (LGA), Queens, NY

PAGES 142–143
Terminal B, Newark Liberty International
Airport (EWR), Newark, NJ

Terminal 5, LAX, LA

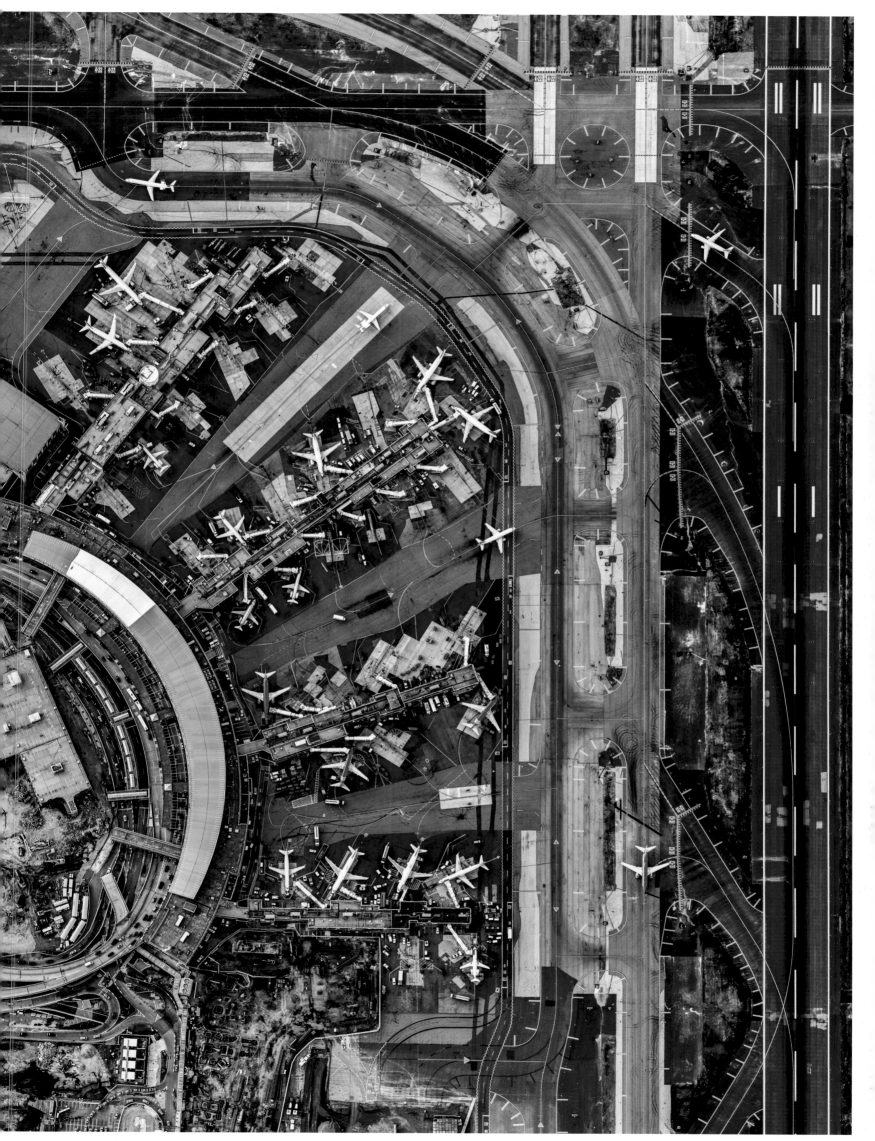

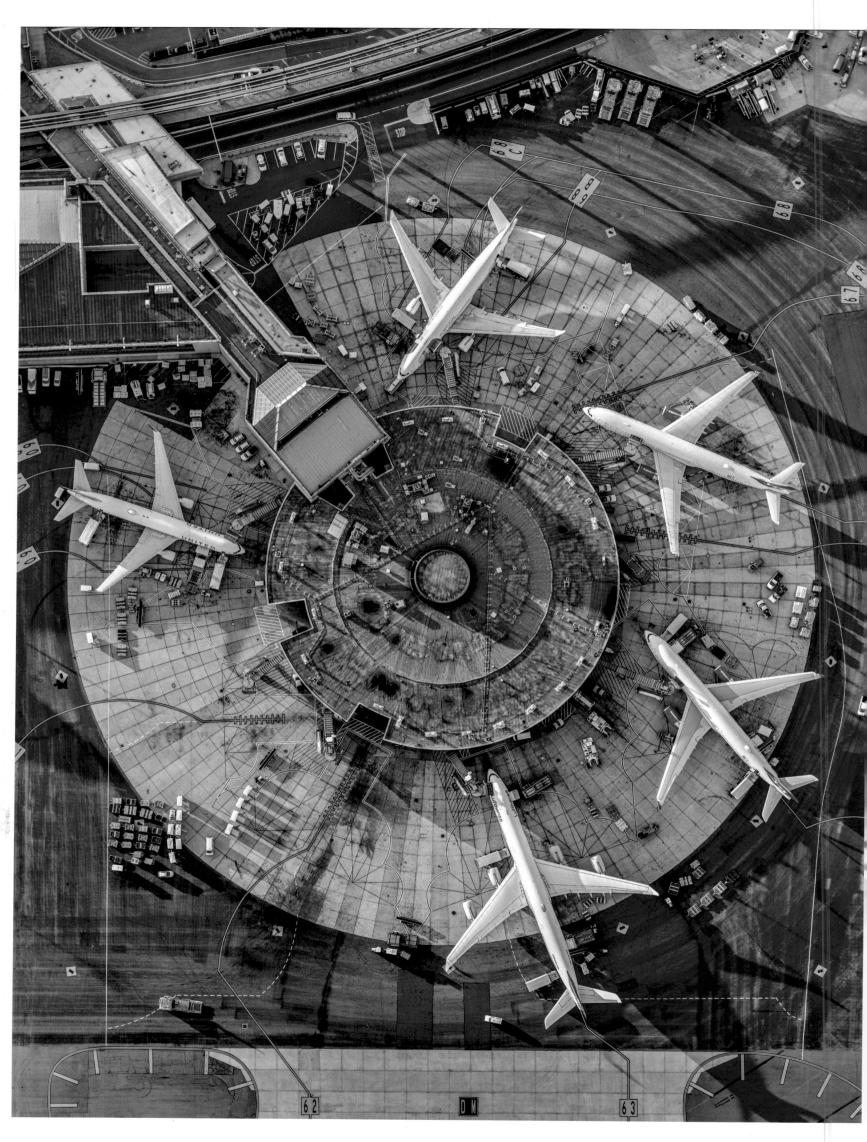

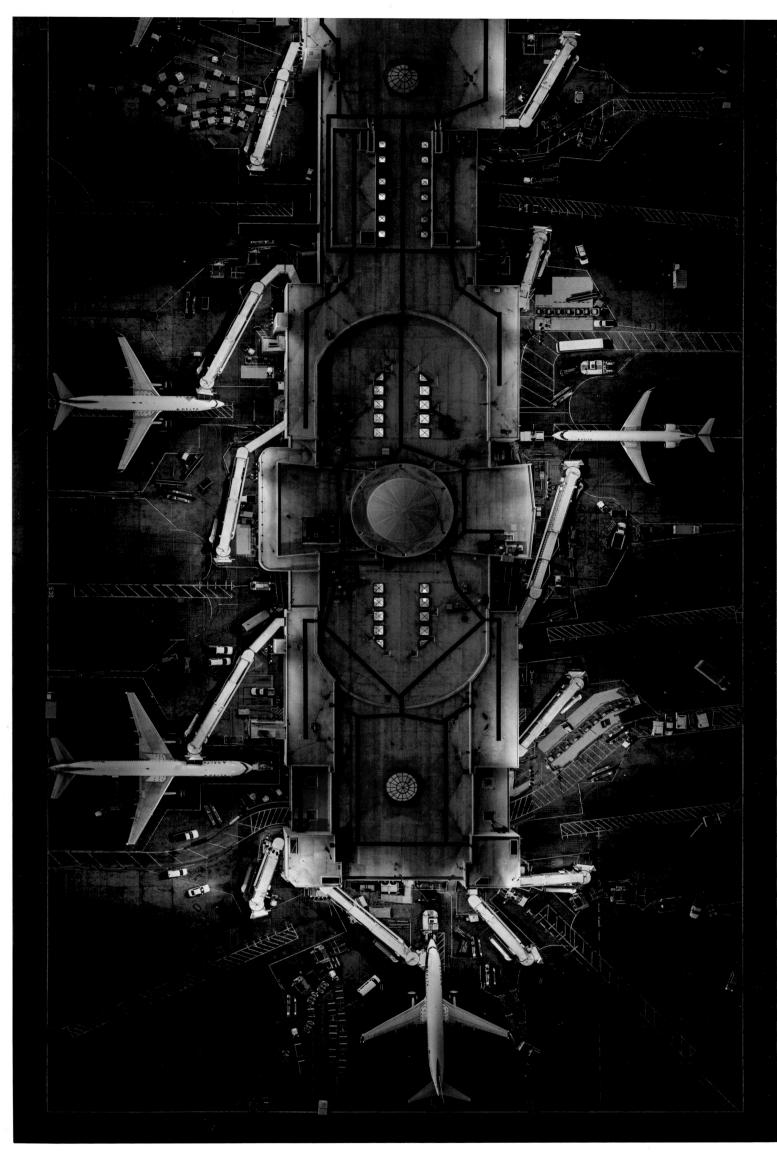

ACKNOWLEDGMENTS

I would like to thank and acknowledge the following people who have helped make my career in photography possible and who helped bring this book to light: Bob Morton, my agent; Christopher Sweet, my editor at Thames & Hudson; Jay Maisel, who inspired me to become a photographer; Kim Cantine, my muse; my gallerists: Paul Kopeikin, Kopeikin Gallery; Rachel Smith, Benrubi Gallery; Paul Huang, Bau-Xi Gallery; Hans van Enckevort, ARTITLEDcontemporary; curators Carolyn Russo and Patricia McDonnell; my helicopter pilots: Hitomi Shinohara and Dennis Leaver; my Cessna pilots: Geoffrey Ring and Gary Mulligan; my studio assistants: Helena Kaminski and Anna Clem. Also to my friends and family who have inspired and supported my work: Lucy Milstein, Val Andler, Jolie Andler Milstein, Tim and Marie Prentice, Denny Abrams, Peter and Martha Wilson. And in memory of Gabe Silverman.

Designed by Jeffrey Milstein with Abigail Sturges

Photographs and text © 2017 Jeffrey Milstein
Foreword © 2017 Jay Maisel
Introduction © 2017 Owen Hopkins

First published in the United States of America in 2017 by
Thames & Hudson Inc.
500 Fifth Avenue
New York, New York 10110

www.thamesandhudsonusa.com

Library of Congress Control Number: 2017934838

First published in the United Kingdom in 2017 by
Thames & Hudson Ltd
181A High Holborn
London WC1V 7QX

www.thamesandhudson.com

British Library Cataloguing-in-Publication Data
A catalogue record for this book is available from
the British Library

ISBN 978-0-500-54489-1

Printed and bound in China